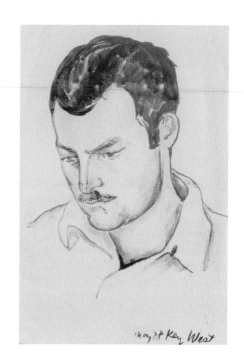

May 28 Key West

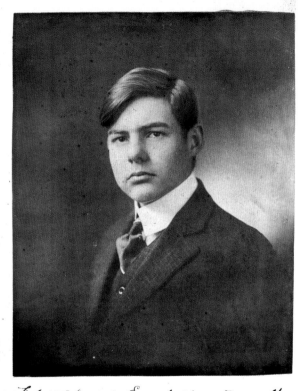

Feb 18th. 1916 Ernest 16 yrs 7mo old

The way he looks whenever his Father
speaks to him

(Form No. 240—Consular.)

CONSULT GENERAL INSTRUCTION NO. 652 WHEN EXECUTING THIS FORM.

REPORT OF BIRTH
OF CHILDREN BORN TO AMERICAN PARENTS.
AMERICAN CONSULAR SERVICE.

Toronto, Canada, December 10, 1923.
(Place and date.)

Name of child in full __John Hadley Nicanor Hemingway__ Sex __Male__

Date of birth __October__ __10th__ __1923__ __2 A.M.__
(Month.) (Day.) (Year.) (Hour.)

Place of birth __Wellesley Hospital__ __Toronto__ __Canada.__
(Number and street, or hospital or hotel.) (City.) (Country.)

Father:

Full name __Ernest Miller Hemingway__ Age __24 years.__

Occupation __Writer__

Present residence __1519 Bathurst St. Toronto, Canada.__

Birthplace __Oak Park, Illinois__

Naturalized (if foreign born) __- - -__ __- - -__
(Place.) (Date.)

Registered as American citizen __- - -__ __- - -__
(Place.) (Date.)

Passport __100585__ __November 26, 1921—Washington,D.C.__
(Number.) (Date.) (Where issued.)

Mother:

Full name __Hadley Richardson Hemingway__ Age __28 years.__

Name before marriage __Hadley Richardson__

Present residence __1519 Bathurst St. Toronto, Canada.__

Birthplace __St. Louis, Mo.__

Naturalized (if foreign born) __- - -__ __- - -__
(Place.) (Date.)

Registered as American citizen __- - -__ __- - -__
(Place.) (Date.)

Passport __100585__ __November 26, 1921__ __Washington,D.C.__
(Number.) (Date.) (Where issued.)

Number of previous children __none__ Number now living __One__

Physician or nurse __Dr. Gordon Gallie,__ __College St. Toronto, Canada.__
(Name.) (Address.)

Ernest M. Hemingway
(Signature of parent, physician, or nurse.)

DOMINION OF CANADA:

PROVINCE OF ONTARIO; ss:

CITY OF TORONTO.

Subscribed and sworn to before me at __Toronto, Canada.__

this __10th__ day of __December__, 192 __3__
(Year.)

Chester W. Martin
Chester W. Martin,
Consul __of the United States of America.__

(When reported in person, use above form.)

FEE No. 3497

COMPAGNIE NORD ATLANTIQUE

AGENTS POUR LA CUNARD LINE 14007

37, Boulevard des Capucines - PARIS

WESTBOUND SERVICE

Paris, 24/8/ 1924.

RECEIVED from Mr. E. Hemingway,

the sum of __One hundred__ francs for Cartage and

Carriage on __4__ pieces of baggage from PARIS to CHERBOURG and to be put

on board the S.S. __Berengaria__ sailing on the 26/8 1924

Check Numbers : 82/88

ERNEST HEMINGWAY

ARTIFACTS FROM A LIFE

Hemingway Collection at the
JOHN F. KENNEDY LIBRARY

Edited with an Introduction by
MICHAEL KATAKIS

Foreword by
PATRICK HEMINGWAY

Afterword by
SEÁN HEMINGWAY

Essays by
CAROL HEMINGWAY
TOM PUTNAM
SANDRA SPANIER

SCRIBNER

NEW YORK · LONDON · TORONTO · SYDNEY · NEW DELHI

Scribner
An Imprint of Simon & Schuster, Inc.
1230 Avenue of the Americas
New York, NY 10020

First Scribner hardcover edition October 2018

SCRIBNER and design are registered trademarks of The Gale Group, Inc., used under
license by Simon & Schuster, Inc., the publisher of this work.

For information about special discounts for bulk purchases,
please contact Simon & Schuster Special Sales at 1-866-506-1949
or business@simonandschuster.com.

The Simon & Schuster Speakers Bureau can bring authors to your live event.
For more information or to book an event, contact the Simon & Schuster Speakers
Bureau at 1-866-248-3049 or visit our website at www.simonspeakers.com.

Design by Jerry Takigawa, Takigawa Design
with Jay Galster

Manufactured in China

10 9 8 7 6 5 4 3 2 1

Library of Congress Cataloging-in-Publication Data is available.

ISBN 978-1-5011-4208-6
ISBN 978-1-5011-4210-9 (ebook)

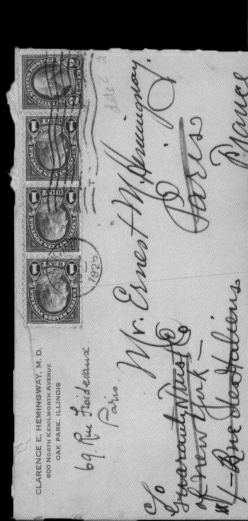

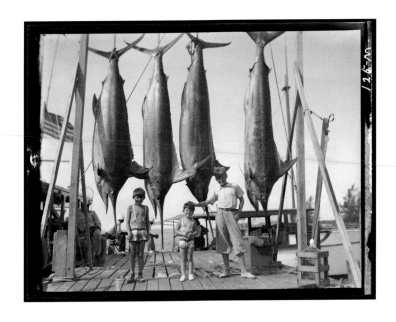

For Patrick, Gregory and Jack

and in memory of
Kris L. Hardin
George E. Katakis
Catherine Penn Katakis

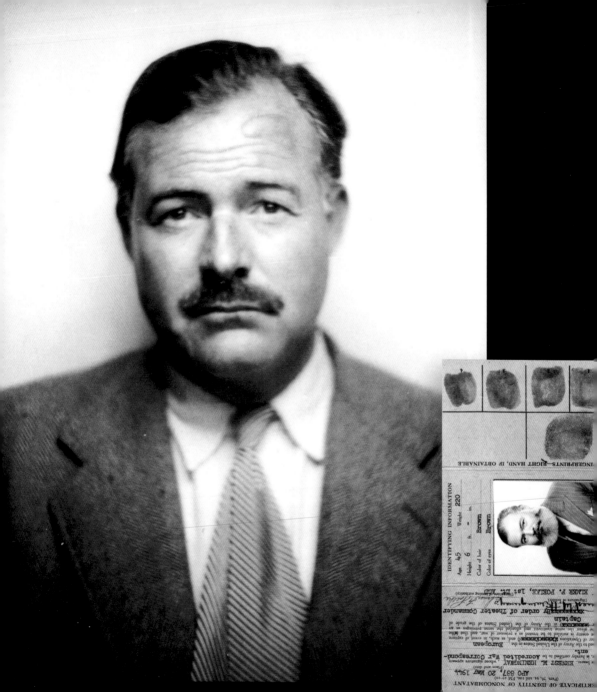

CONTENTS

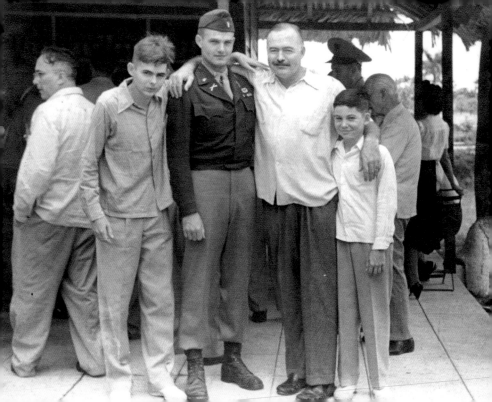

FOREWORD:
A MISSING ARTIFACT

The artifacts in the Hemingway Collection at the John F. Kennedy Library play an important role in presenting him and the period in which he wrote. Sadly, many important artifacts did not survive to make it to the Library or anyplace else. One of these, the trout fishing trunk, especially brings back memories to me of the late 1930s, when my father was still married to his second wife, Pauline, my mother.

Fly-fishing is not the only way to catch a trout. Hemingway's early masterpiece "Big Two-Hearted River," Parts 1 and 2, is about a war-shattered young man seeking sanity by going back to basics. He uses live grasshoppers for bait. So might have done the five-thousand-year-old iceman of the Alps.

My father taught me how to catch trout with two kinds of live bait, grasshoppers and what he called hellgrammites, the larval stage of the dobsonfly. The river he taught me to fish with these two live baits was the upper reaches of the Clarks Fork of the Yellowstone River, which flowed only a few yards away from our rented log cabin at the L-T dude ranch. This mountain free-stone stream was not suitable habitat for the dobsonfly, which is at home in the warmer streams of the Great Smoky Mountains National Park and eaten more by bass than trout. More likely, the creature he showed me how to catch was the larva of a stonefly, but maybe not. What I do know is who taught my father about hellgrammites: his father, Dr. Clarence Hemingway.

While he was an undergraduate at Oberlin College, along with a classmate, H. C. Beardslee, Jr., the son of Dr. Henry C. Beardslee, botanist of the state of Ohio, my grandfather collected plants in the Great Smoky Mountains during the summer of 1891.* Besides plants, my grandfather collected hellgrammites as well, which he took home to Oak Park and must have later shown to my father.

In the 1930s, there were very few if any fly shops in the northern Rocky Mountains country, so people had to buy their gear ahead of time elsewhere and bring it with them, a situation similar to what my wife and I faced when we went to fish in Chile in the 1980s. My father ordered the gear for himself and his wife from Hardy Bros. Ltd. in England, using their famous *Angler's Guide and Catalogue*. It featured high-quality illustrations of rods, reels, flies and all the other bits and pieces of gear, the prices of which were listed in pounds, shillings and pence,

* "Some, or all, of these collections became a part of the herbarium in Oberlin College." Quoted from *Trees, Shrubs, and Woody Vines of Great Smoky Mountains National Park* (1964), Introduction, page 5.

abbreviated "£sd." Along with all the collections of fly reels, rods, vests, boxes, leaders etc. retained from past years, there was new stuff ordered for the year from the current catalogue. For me the currency puzzle was only resolved a few years later when Mr. Brody, my high school Latin teacher, explained about the Roman coins that were minted from a pound of silver. That fishing trunk for me enhanced the elegant ritual of my mom and dad as they waded side by side six feet off each bank downstream, casting toward each other their terminal cluster of three wet flies, letting their lines drift and straighten out before raising their rods and casting again.

Even the finest bowl and bell will crack, and the marriage was lost in the Spanish Civil War, the trunk in the decline and fall of the Railway Express Agency after World War II.

Patrick Hemingway

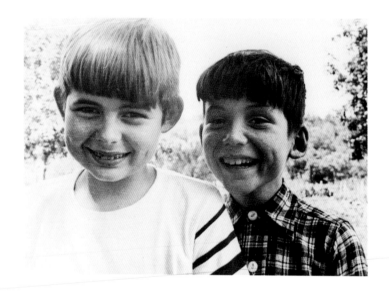

PATRICK "MOUSE" HEMINGWAY AND GREGORY "GIGI" HEMINGWAY, SMILING. "I ASKED THE TWO OF THEM TO LET ME TAKE THEIR PICTURE," 1942. COPYRIGHT JFK LIBRARY.

INTRODUCTION

 I remember the day clearly. That's why my memories are not to be trusted. Memories, like myths, lie—rounding or sharpening the edges of events so as to embellish or settle scores. It is where fact and fiction blend, evolving into a narrative we can live with.

The day is November 23, 1963. It is a cold morning. My immigrant father is backing up his large Chevrolet Bel Air out of the garage. I get in as the car idles and he and I sit in silence until the temperature gauge reaches the level my father always thought appropriate for automotive maintenance. I recall a slow drive where the images outside the fogged windows seemed dreamlike, unreal and yet real enough to disturb a small boy. We were driving on Austin Avenue past the Chinese laundry and Wagon Wheel diner. There was the Patio Theater, where just a week before I had seen a film starring Gary Cooper. The theater's grand façade was lit up with its sparkling lights, its marquee announcing John Wayne and James Stewart in *The Man Who Shot Liberty Valance*. The movie palace glittered, untouched by all that had happened, and that provided a strange comfort.

Many times during that drive I turned to look at my father but he was far away and lost, traveling in silence down familiar streets with leafless trees, paralyzed by events and a sorrow that, even as a boy, I sensed would last forever. It was in that slow-motion car that I learned that no one gets over anything.

The day before, John F. Kennedy, the thirty-fifth president of the United States, was assassinated in Dallas, Texas, and in a small room in a Chicago apartment my mother died. She had been ill for some time but my father always held out hope that by force of will he could save her. On November 22, that was but one of the many illusions that were shattered.

The television seemed to be on all the time that day, and the black-and-white pictures and solemn voices kept up a guarded hope that finally ended with Walter Cronkite holding back tears, taking off his glasses and reporting the time of President Kennedy's death. So many people have told me that they remembered exactly where they were when they heard the news. I do not. What I remember is looking through the windows of my father's car on the next day and seeing people grieving in unexpected ways. The man raking his yard when there were no leaves or the woman walking quickly with her bag of groceries suddenly stopping, looking as if she had forgotten something, before sitting on a bus bench. All the faces, none with smiles,

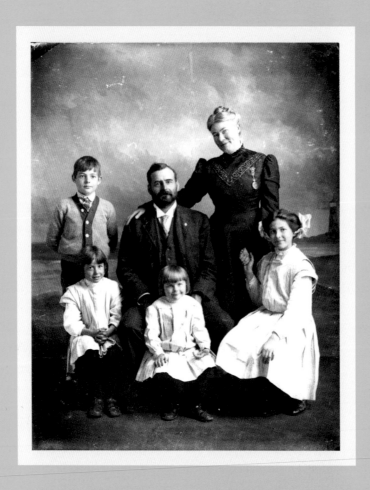

HEMINGWAY FAMILY PORTRAIT TAKEN ON THE WAY HOME FROM WINDEMERE IN AUGUST 1909. (LEFT TO RIGHT, BACK ROW) ERNEST HEMINGWAY, CLARENCE HEMINGWAY, GRACE HEMINGWAY, (LEFT TO RIGHT, FRONT ROW) URSULA HEMINGWAY, MADELAINE HEMINGWAY, MARCELLINE HEMINGWAY. ORIGINAL PRINT IS TORN SLIGHTLY ON ALL FOUR CORNERS, AND SHOWS MANY WHITE SPOTS THROUGHOUT THE IMAGE. COPYRIGHT UNKNOWN, HEMINGWAY COLLECTION, JOHN F. KENNEDY PRESIDENTIAL LIBRARY AND MUSEUM, BOSTON.

heads bowed. To a small boy it was so confusing because it felt like they were grieving for my mother as well as the president. I cannot remember if my mother died before or after the president's assassination. I suppose it doesn't matter and if it did, it would be easy enough to know by looking at her death certificate, but I have never been able to do that, for I too reside within the narrative that I can live with.

Our destination on November 23 was Oak Park, where some relatives lived. In that grand, wood-paneled home, some of the old Greek women, dressed in their most depressing black, clung to rosaries that occupied their hands but gave little comfort. Occasionally they would pause, kiss me and hold my hand. We were all locked in an impenetrable sorrow, and no one knew what to say until an uncle told me that just a few blocks away a great American writer had grown up. It was the first time that I heard the name Ernest Hemingway.

As a young man, I, like so many others, went through my "Hemingway" period. I read the books and was excited by the worlds he described and became hungry for life's adventures. I left home at seventeen and began traveling the world in search of those experiences and a hoped-for knowledge that might be acquired along the way. I traveled to Spain and ran with the bulls and then on to Paris to visit some of Hemingway's haunts, but he was nowhere to be found in those commercialized temples that had a "George Washington slept here" quality to them. He was where he had always been, in his books.

As a result of that understanding I quickly grew tired of the Hemingway legend and realized that the man's greatness lay in the work and not in his lifestyle, though the two were often intertwined. The more I learned the more I understood how disciplined and dedicated he had been to his craft and how hard he struggled to put words on a page. He may have been, as some said, a genius, but that did not mean he had discovered a shortcut to hard work.

A number of years ago, while working as editor on a book entitled *Sacred Trusts*, I contacted a number of writers, soliciting essays for the volume. I had read something about Africa written by Ernest Hemingway's middle son, Patrick, that I thought very good and wrote a detailed letter to him, not only about my hope at his possible participation, but of my experiences since leaving Chicago. A few weeks later I received a lovely letter in reply.

It was, as Bogart said to Claude Rains in *Casablanca*, the beginning of a beautiful friendship. Within a short period of time and ahead of schedule, Patrick sent me his essay "The Elephants of Tsavo." It was beautifully written, heartbreaking and sadly prescient. After the book's release I received a call from Patrick inviting me to Montana. My late wife, Kris, and I drove to Bozeman from Philadelphia and spent three days with Patrick and Carol Hemingway that were filled with laughter and wonderful conversations that danced from literature and science to mathematics, politics and religion. A short time after our return, Patrick called again and

asked if I would be interested in managing his father's literary estate. To say the least, I was taken aback.

"But I'm not a manager," I said.

"You'll get the hang of it, pal, and it won't take up much time so you'll have time for your own writing and work," Patrick answered.

I remember declining, twice, but Patrick was persuasive. Over the last nineteen years I have had the pleasure not only of Patrick's company, but of the remarkable stories and remembrances that seem to fill every hour that we have been together. I have learned much from Patrick about his father and, as one would expect, the story is far more nuanced and detailed than myth allows.

The myth of Hemingway, some of which he created himself, is too simplistic. It is the he-man tough guy who drinks hard and gets the women while talking in a clipped fashion suggesting a world-weary cynicism arrived at from war, betrayal and broken hearts. This was the beginning of his style or, more accurately, his use of the *Kansas City Star*'s style sheet that he was given in 1917 while working there as a reporter. The style sheet's number one rule was "Use short sentences. Use short first paragraphs. Use vigorous English." Some of the other rules would stimulate Hemingway into constructing sentences of fiction in a revolutionary way that seemed utterly new. "Avoid the use of adjectives," proclaimed one of the rules, and then, "eliminate every superfluous word."

What Hemingway did caught on. After the release and success of *The Sun Also Rises*, people would travel to Paris imitating the book's characters. They would sit at cafés like the Dôme and La Rotonde in Montparnasse, putting on their best Brett and Jake personas, and not just in Paris, but in cities on both sides of the Atlantic.

In the public's imagination Hemingway had become not merely a successful writer, but also a trendsetter. The word *trendsetter*, by its own implication, suggests something momentarily in fashion that passes and is finally rendered cliché. Some people may have thought that about Hemingway at the time but not many. Others, like Donald Ogden Stewart, were confused by *The Sun*'s success, believing it to be nothing more than straight reporting about a contentious time between friends at a festival in Spain, which Stewart had been part of.

There are so many competing layers of myth concerning Hemingway that it seems at times impossible to see the man. But when Hemingway is looked at through his own words, at different stages of his life, and through some of the twentieth century's most tumultuous events, the story becomes far more deep and interesting. That is why the Hemingway Collection at the John F. Kennedy Library is an invaluable resource in understanding Hemingway as an artist and a human being and how the life he lived informed his work.

Patrick Hemingway once told me that his father did not keep a journal but did keep everything else and did so as an aid to memory. The Hemingway Collection is a scrapbook

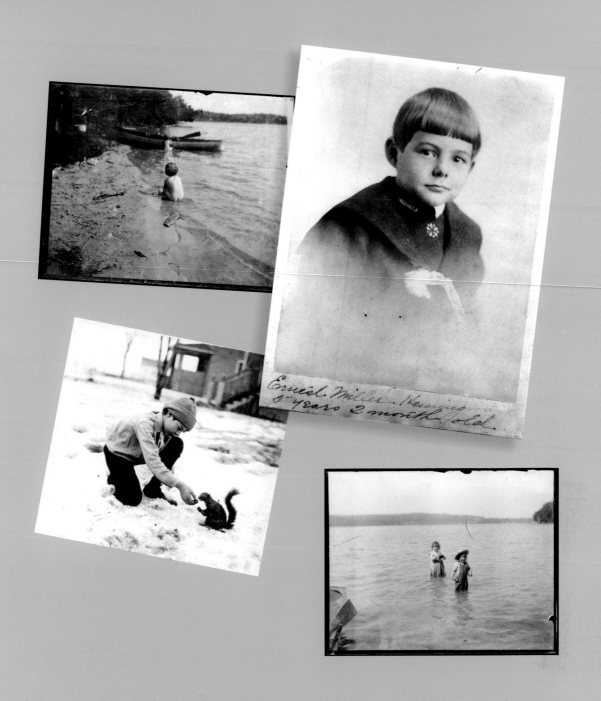

CLOCKWISE FROM TOP: 1. COPYRIGHT JFK LIBRARY. **2. PORTRAIT OF ERNEST HEMINGWAY. INSCRIBED ON PHOTO: "ERNEST MILLER HEMINGWAY 5 YEARS 2 MONTHS OLD."** COPYRIGHT UNKNOWN, HEMINGWAY COLLECTION, JOHN F. KENNEDY PRESIDENTIAL LIBRARY AND MUSEUM, BOSTON. **3.** COPYRIGHT JFK LIBRARY. **4. ERNEST HEMINGWAY FEEDING A SQUIRREL.** FROM GRACE HALL HEMINGWAY'S SCRAPBOOK 4, PAGES 14–15, HEMINGWAY COLLECTION, JOHN F. KENNEDY PRESIDENTIAL LIBRARY AND MUSEUM, BOSTON.

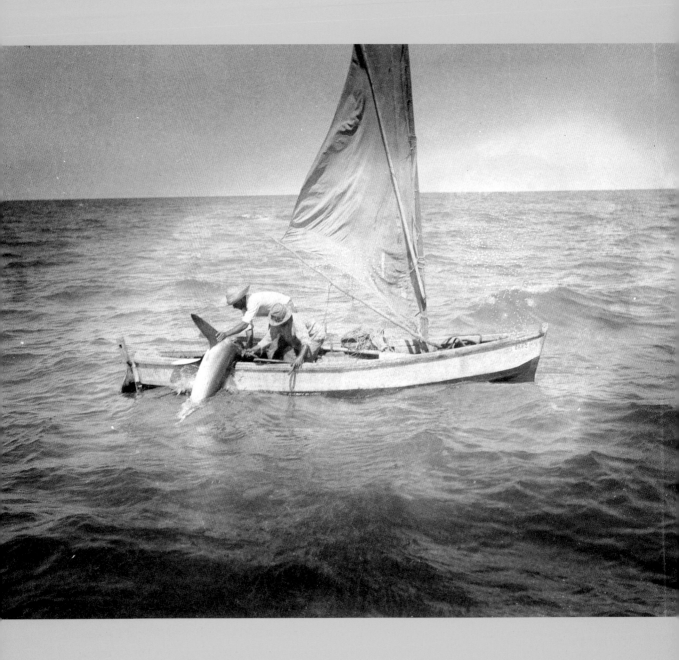

CIRCA 1934: TWO UNIDENTIFIED CUBAN FISHERMEN PULL A LARGE FISH INTO A SAILBOAT, CUBA. KEY WEST YEARS, 1928–1939.

PHOTOGRAPHER OFFICIALLY UNKNOWN. PAPERS OF HEMINGWAY COLLECTION, JOHN F. KENNEDY PRESIDENTIAL LIBRARY AND MUSEUM, BOSTON.

of one of the world's most influential and enduring writers and a rollicking trip through the twentieth century.

The many artifacts in the collection are his, and they tell a story of what he liked and valued. The thousands of letters he wrote present a funny nickname maker, a good and loyal friend, a loving father, an attentive brother and son, a competitive and jealous man and sometimes a cruel one.

While exploring Hemingway's life through his words and things, something has become very clear, and that is his powers of observation. Hemingway was making lists all the time, seemingly listening to and watching everything and storing it away to be used at some future date. One photograph that I discovered, which I believe he probably took while fishing in Cuba, shows the seeds of what years later will become *The Old Man and the Sea*. The photograph shows two old fishermen on a small boat with a short, single sail. Alongside the boat they are hauling up a large swordfish. The image is a fine one, executed with an understanding of composition and timing. He was paying attention. Close attention.

Unlike in this current age where people are recording everything and seeing nothing, Hemingway was taking life in, and he was doing so from a very young age. On June 9, 1909, age ten, Hemingway writes to his sister Marcelline in a straightforward storytelling style:

Dear Marc,
Our Room was in the field day against Miss Koontz room. Al Bersham knocked two of Chandlers teeth out in a scrap and your dear gentle Miss hood had Mr. Smith hold him while she lickt him with a raw hide strap.
Lovingly,
Ernest

Hemingway lived in an analog world, not a digital one. He traveled by ship, train and car and in planes, not jets, at least not in the beginning, and yet there he is, seemingly everywhere. World War I in Italy, Spain, Africa, Cuba, Key West, New York, the Spanish Civil War. Back to Italy, Paris as a young man, Paris as an old man, China, Sun Valley, Chicago, Wyoming and Germany. With Mussolini, with Cooper, Dietrich and Capa. He's fishing, hunting and running with the bulls and writing, always writing. There is one wife, a child, then another wife, two more children, another wife and one more after that. He is there, with Picasso and Fitzgerald, Stein, Joyce and Pound, with generals and old fishermen. He's in World War II, then the Ritz, Orwell and Salinger and on and on. Yes, Hemingway seemed to be everywhere, but the age he lived in, its pace at the start of the century, was conducive to poets and observers. Hemingway was suited to the early twentieth century and was spared "that agent of superficiality" that Peter Fleming declared was modern plane travel.

There are over eleven thousand photographs, bullfighting tickets and scraps of paper with lists of what books a struggling writer should read. There are airline, train and steamship tickets that are so lovely they seem a page from an illuminated manuscript and demonstrate how much beauty there once was in the artifacts of daily commercial exchanges. As I went through his things I realized how much tactile aesthetic has been sacrificed and replaced with a severe digital practicality.

There are the letters, thousands of them, from the JFK and other collections, that record the goings-on in his and his friends' lives. Receipts from bookstores in New York, Paris and Spain revealing what he was reading and when. The telegram from Senator John F. Kennedy asks Mr. Hemingway about his definition of courage as Kennedy works on his own book that will become the 1957 Pulitzer Prize–winning *Profiles in Courage*. Years later, another telegram from the now young president-elect to the Mayo Clinic, where Hemingway was undergoing shock treatment, asking him to be at his inaugural followed by the heartbreaking and repeated drafts of a response that Hemingway attempts to write six months prior to his suicide. Those drafts, in his struggling hand, reveal the end of things because in spite of all of his passions, it was writing that sustained him.

There are materials stamped "Restricted," one by the command of General Dwight Eisenhower, which had me wonder if Hemingway had access to classified information during World War II. Interesting, seeing that he was a reporter. Or was he? More treasure for future researchers.

There are two receipts for checks written by Hemingway in the amounts of $750 each that were for the custom-made ambulance that he was contributing to the Spanish Civil War effort with the accompanying list of how the ambulance should be constructed and what it should contain. One can see the connection between what he learned as an ambulance driver in World War I and what he was asking for in 1937.

Traveling through Hemingway's artifacts, I have come to recognize the man, his early hopes and dreams, his determination to be one of the "great writers," his fears of physical and mental illness and, finally, death. Like him I am from the Midwest, Chicago, and I identify with the hungry young man who was determined to take on the world, and who, at a young age, was already too big for Oak Park's quiet Sundays and perfect lawns.

The letters of Hemingway to friends and relatives while he was recuperating from his war wounds in Italy were of particular interest. His letters show his excitement at surviving and at being decorated and finding the girl he thinks he will spend the rest of his life with.

SOLD TO *Mr E. Hemingway* 31 OCTO 1937
 c/o American Embassy
Ledger A *Madrid*

Sept 30	To Account rendered		1.395	25
Oct 30	New Yorker	2 Nos 4/9 - 30/10	80	
"	Time	" 6/9 - 25/10	98	
"	Night - Day	" 9/9 - 28/10	66	
"	News Week	" 21/8 - 9/10	66	
"	Cavalcade	11/9 - 30/10	10	
"	N.Y. Times D.S.	27/8 - 26/10	327	
"	Field - Stream	Oct not	20	
"	Esquire	"	60	
"	New Republic	25/9 30/10	38	75
"	Nation	"	38	75
"	New Statesman	15 " 23 30/10	21	75
"	Outdoor Life	"	6	
"	Vogue Am.	1. 15/10	42	
			Frs 2.289	50

rear wheels
84°

SPECIFICATIONS FOR AMBULANCES

1. Ford Chassis Inside Measurements
 Full vestibule
131 inch wheel base
9 feet in length
Outside Measurements
64½ inches in width
53 inches in height, clear inside

 Applied to body

2. Patients' Compartment Enclosed from chauffeur, instant
 communication, if necessary thru
 partition of sliding glass in back
 of driver's seat.
 Rear construction - double rear doors
 door checks
 Ventilation - windows at rear and thru
 driver's compartment.
 Attendant's seat each side of inside at
 rear, folded unless occupied, exterior
 panels.
 Stretcher level to automobile steel sheets
 Specially coated against moisture on both
 sides.
 Backed with 3 ply ply wood with layers of
 fabric padding between (for insulation
 against heat or cold)

3. Rear Compartment Fully lined hed in white enamel
 Drivers' Com th lazy
 back and
 leatherett
 Vestibule
 in felt ch
 Slope type
 timous h
 Automobile
 mirror.
 Shatter-pr
 Body will
 rounded.

4. Equipment Includes
 body whi
 attached
 not in
 vert am
 alties.
 2 stret

Complete price - $1500
net, each

He is at the beginning of his great adventure. The experiences he describes show, with the benefit of time, the template for what was to become the world's "new" literature. In some of the letters we first meet a young man in love with Agnes von Kurowsky, a Red Cross nurse who cared for him after being wounded and who would play a major role in the "new" literature to come. In just a few letters we see a young man go from hopeful and in love to a hurt and self-protected individual. He begins to sound like the characters of his future work who persevere in the face of heartbreak and death, understanding that "the world breaks everyone."

TO HIS SISTER MARCELLINE ON NOVEMBER 23, 1918, HE WRITES FROM MILAN

Dear Old Sister-;
. . . I don't know what I've written you about my girl but really, Kid Ivory I love her very much. Also she loves me. In fact I love her more than anything or anybody in the world or the world it-self.

TO BILL SMITH, DECEMBER 13, 1918 (FROM MILAN)

Dear Jazzer-;
. . . But listen what kind of girl I have: Lately I've been hitting it up-about 18 martinis a day. . . . We went in the staff car up to Treviso where the Missus is in a Field Hospital. She had heard about my hitting the alcohol and did she lecture me? She did not. She said, "Kid we're going to be partners. So if you are going to drink I am too. Just the same amount." And she'd gotten some damn whiskey and poured some of the raw stuff out and she'd never had a drink of anything before except wine and I know what she thinks of booze. . . . Bill this is some girl and I thank God I got crucked so I met her.

TO WILLIAM D. HORNE, JR., DECEMBER 13, 1918

Caro Guililmus-;
. . . Bill I am undoubtedly the most lucky bum in the world. The temptation comes to rave-but I won't.

AND, ON FEBRUARY 3, 1919 (FROM CHICAGO)

Dear Bill,
. . . Ag writes from Toro Di Mosta beyond San Dona-Piave that she and Cavie are going to be there all winter. I gave her your love. Bill I'm so darn Lonesome for her I don't know what to do. All Chicago femmes look like a shot of Karo Corn Syrup compared to 83 Burgundy.

AND THEN THE NEWS AND THE CHANGE. TO WILLIAM D. HORNE, JR., MARCH 30, 1919

Caro Amico,

It's kind of hard to write it Bill. Especially since I've just heard from you about how happy you are. . . . She doesn't love me Bill. She takes it all back. A "mistake" one of those little mistakes you know. Oh Bill I can't kid about it and I can't be bitter because I'm just smashed by it. And the devil of it is that it wouldn't have happened if I hadn't left Italy. For Christ's sake never leave your girl until you marry her. I know you can't "Learn about wimmen from me" just as I can't learn from anyone else. . . . But Bill I've loved Ag. She's been my ideal and Bill I forgot all about religion and everything else-because I had Ag to worship. . . . All I wanted was Ag and happiness. And now the bottom has dropped out of the whole and I'm writing this with a dry mouth and a lump in the old throat and Bill I wish you were here to talk to. The Dear Kid! I hope he's the best man in the world. Aw Bill I can't write about it. 'Cause I do love her so damned much.

TO JAMES GAMBLE, APRIL 18 AND 27, 1919

Dear Jim,

. . . There is a good deal of news which should be retailed to you tho. First I am a free man. . . . I did love the girl, though I know now that the paucity of Americans doubtless had a great deal to do with it. And now it's over I'm glad, but I'm not sorry it happened because, Jim, I figure it does you good to love anyone. Through good fortune I escaped matrimony so why should I grumble? . . . At any rate I'm now free to do whatever I want. Go wherever I want and have all the time in the world to develop into some kind of writer. And I can fall in love with any one I wish which is a great and priceless privilege.

TO HOWELL G. JENKINS, JUNE 15, 1919

Dear Fever-:

. . . Had a very sad letter from Ag from Rome yesterday. She has fallen out with her major. She is in a hell of a way mentally and says I should feel revenged for what she did to me. Poor damned kid I'm sorry as hell for her. But there's nothing I can do. I loved her once and then she gypped me. And I don't blame her. But I set out to cauterize out her memory and I burnt it out with a course of booze and other women and now it's gone. She's all broken up and I wish there was something I could do for her tho. "But that's all shut up behind me-Long ago and far away. And there aint no busses runnin' from the Bank to Mandalay."

TO WILLIAM D. HORNE, JR., JULY 2, 1919

Dear Bill,

. . . Now for the last month and a half I've been up North here and "Ag" doesn't recall any image to my mind at all. It has just been burnt out. So that is finite per sempre.

Hemingway would take the fears, guilt and heartbreaks of his life and turn them into words that would become literature. Years after being jilted by the woman he loved, Hemingway would write a page in *A Farewell to Arms* that F. Scott Fitzgerald, after being invited by Hemingway in June 1929 to read it in typescript, wrote on the left-hand margin of the page, "This is one of the most beautiful pages in all English literature." What Hemingway had experienced, heard and felt years before was now transformed into art:

"If people bring so much courage to this world the world has to kill them to break them, so of course it kills them. The world breaks everyone and afterwards many are strong at the broken places. But those that will not break it kills. It kills the very good and the very gentle and the very brave impartially. If you are none of these you can be sure it will kill you too but there will be no special hurry."

I have come to understand through the years of discussions with Patrick, and now through the things Hemingway left behind, that Hemingway believed the world a "swell place" and expressed how sad it would be when he would have to leave it. Death and suicide are woven through a good deal of Hemingway's work and that's not surprising, given the century he lived through and what he had seen.

Among Ernest Hemingway's many endings to *A Farewell to Arms* I was drawn to one he had rejected. The words seemed oddly his own, not one of his characters'. He wrote,

"That is all there is to the story. Catherine died and you will die and I will die and that is all I can promise you."

I reflected on those words and thought of all the people I have loved, cared for and lost and how those of us who have more yesterdays than tomorrows can't help but think, in spite of its troubles, how beautiful the world is and how sad it will be to leave it.

"Madame, all stories, if continued far enough, end in death," wrote Hemingway in *Death in the Afternoon*, "and he is no true story-teller who would keep that from you."

On July 2, 1961, Ernest Hemingway took his life, seemingly ending his own story. But thanks to the Hemingway Collection at the John F. Kennedy Library, his story goes on with much more to be discovered and learned.

Finally, it seems oddly full circle from my beginnings in Chicago when on a day after the assassination of a president, and the death of a parent, I heard the name of a writer whom I would come to know through his son and through the writer's artifacts that now reside in the fallen president's library.

Michael Katakis
Paris

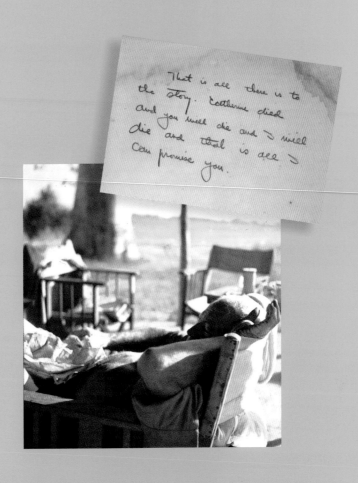

That is all there is to the story. Catherine died and you will die and I will die and that is all I can promise you.

CIRCA 1954: ERNEST HEMINGWAY LYING DOWN, HIS BLISTERED HAND AND INJURED STOMACH VISIBLE, RECOVERING IN AFRICA AFTER A PLANE CRASH. COPYRIGHT JFK LIBRARY.

Beginnings

His talent was as natural as the pattern that was made by the dust on a butterfly's wings. At one time he understood it no more than the butterfly did and he did not know when it was brushed or marred. Later he became conscious of his damaged wings and of their construction and he learned to think and could not fly any-more because the love of flight was gone and he could only remember when it had been effortless.
—Ernest Hemingway,
A Moveable Feast

The great enemy of truth is very often not the lie—deliberate, contrived and dishonest—but the myth—persistent, persuasive and unrealistic. Too often we hold fast to the clichés of our forebears. We subject all facts to a prefabricated set of interpretations. We enjoy the comfort of opinion without the discomfort of thought.
—John F. Kennedy,
Yale commencement address, June 11, 1962

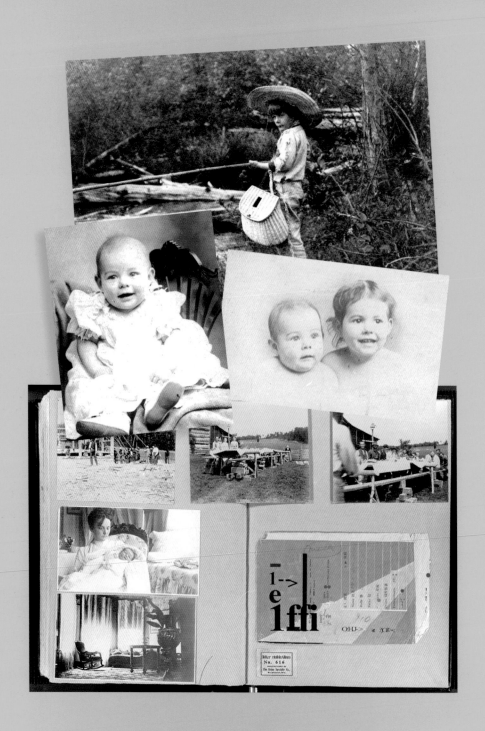

BEGINNINGS

On July 21, 1899, Ernest Miller Hemingway was born in Oak Park, Illinois. At the time, Oak Park was a conservative suburb of Chicago. Comprised primarily of upper-middle-class Protestants, it was in stark contrast to the churning liberal city of Chicago just a few miles away. Visiting relatives who resided there as a boy, I was always struck by how it felt as if I had traveled to a strange and foreign land. The perfect, deserted lawns in front of the lovely homes did not suggest privilege as much as boredom, and its quiet Sundays always seemed to me unbearably pious. Oak Park remained virtually unchanged, both visually and philosophically, between Hemingway's time and my own experiences there decades later.

Hemingway's father, Clarence, was a doctor and his mother, Grace Hall Hemingway, was a musician and music teacher. Both his parents were educated and the entire family, which included his four sisters, Marcelline, Ursula, Madelaine and Carol, and his brother, Leicester, born in 1915, lived a comfortable life that exemplified the midwestern values of family, God, hard work and self-sacrifice. Hemingway's father had a love of and means to enjoy the pleasures of outdoor life, which he passed on to his family and in particular to his son. The family cottage, Windemere, on Walloon Lake in Michigan, gave the Hemingway children a magical childhood filled with animals, boats, fishing, hunting and swimming. The other pursuit the family could afford was photography. Clarence, along with others, took many photographs throughout the years documenting what appears to have been a happy family life. So much of Hemingway's later life and writing will be informed by those beginnings, and the early stories will be set in the country and with experiences that Hemingway knew well. He would follow that pattern again and again. Observe, listen and then take the experiences from his life and turn them into literature. But that is further down the line. This is the beginning of Hemingway's own story. A story that begins with the coming of a new century, where Sigmund Freud will publish his *The Interpretation of Dreams*; Joseph Conrad, *Lord Jim*; and the first Nobel Prize will be awarded. President McKinley will be assassinated in 1901. The Wright Brothers have their first powered flight in 1903. In 1905 the Fauvist exhibition takes place in Paris and Einstein presents his theory of relativity to the world.

Michael Katakis

TO CLARENCE HEMINGWAY, EARLY JULY 1907

Dear papa.
I saw a mother duck with seven little babies.
How big is my corn?
Ursula saw them first
We went strawberry piking and got enough to make three short-cakes.

Ernest Hemingway

TO CLARENCE HEMINGWAY, JULY 23, 1909

Dear papa,
Today Mama and the rest of us took a walk
We walked to the school house.
Marcelline ran on ahead.
Wile we stopt at Clouse's
In a little wile she came back.
She said that in the Wood Shed of the Scool house there was a porcupine.
So we went up there and looked in the door, the porcupine was asleep.
I went in and gave I[t] a wack with the axx.
Then I cave I[t] anthor and another.
Then I crald in the wood.
Wrane to Mr. Clous and he got his gun and Shot It.

Hear some of the quills

TO CLARENCE HEMINGWAY, SEPTEMBER 11, 1910

Dear Daddy,
Last night mother got Mrs. Hutchinson to play for her and sang to the people at Sannie's grandly. How is my weasel? I can get an albatross foot here for two dollars for the aggassiz. Is it worth it?

Your Loving son Ernest H.

Mr. Chales C. Spink & Son
Gentlemen-
Enclosed find $.35 for which send me the following baseball action pictures-
Mathewson-Mordeci Brown. Sam Crawford. Jas. P. Archer. Frank shulte. Owen Bush. Fred Snodgrass.
Yours Truly
Ernest Hemingway
600 N. Kenilworth
Oak Park, Ill.

A YOUNG MAN AND A CENTURY ON THE MOVE

In 1912 Woodrow Wilson is elected twenty-eighth president of the United States. The great ocean liner *Titanic*, a symbol of modern twentieth-century advances, sinks after striking an

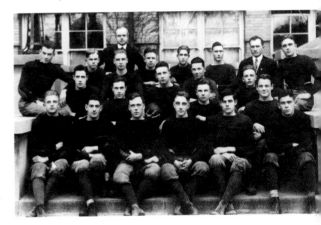

iceberg on its maiden voyage from Southampton to New York with fifteen hundred people lost. Thomas Mann's *Death in Venice* is published and New Mexico becomes the forty-seventh state of the United States.

Hemingway starts his freshman year at Oak Park High School in 1913. He is a fine student and fair sportsman in boxing and football. On August 4, 1914, Britain declares war on Germany, and on August 15 the Panama Canal is opened. James Joyce's book *The Dubliners* is published, as is Edgar Rice Burroughs's *Tarzan of the Apes*.

TO CLARENCE HEMINGWAY, MAY 11, 1913

My conduct at the Coloseum yesterday was bad and my conduct this morning in church was bad my conduct tomorrow will be good.

Ernest Hemingway
May 11, 1913

ERNEST HEMINGWAY AND HIS HIGH SCHOOL FOOTBALL TEAM. COPYRIGHT: PUBLIC DOMAIN.

THE CLASS PROPHET

In his famous 1958 interview for *The Paris Review*, George Plimpton asked: "Can you recall an exact moment when you decided to become a writer?" Hemingway replied: "No, I always wanted to be a writer."

Hemingway began writing and publishing in his teens, his first fiction appearing in *Tabula*, his high school magazine. In 1916 Hemingway is editor of his high school paper *The Trapeze*, and James Joyce's *A Portrait of the Artist as a Young Man* is published. In 1917 the United States declares war on Germany, the Russian Revolution begins and Ernest Hemingway graduates from high school. He begins his job as a cub reporter at the *Kansas City Star*, where he learned the essentials of good writing from the newspaper's style sheet. Hemingway remained with the *Star* for a relatively short period, from October 1917 until he enlisted in April 1918. —DK and MK

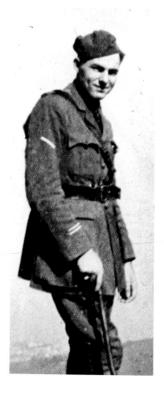 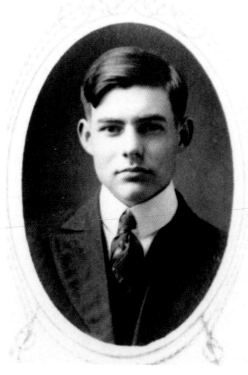

1. ERNEST HEMINGWAY POSED IN MILITARY UNIFORM. LAGO MAGGIORE, MOTTARONE, ITALY. COPYRIGHT UNKNOWN. HEMINGWAY COLLECTION, JOHN F. KENNEDY PRESIDENTIAL LIBRARY AND MUSEUM, BOSTON. 2. ERNEST HEMINGWAY CARD PORTRAIT. HEMINGWAY COLLECTION, JOHN F. KENNEDY PRESIDENTIAL LIBRARY AND MUSEUM, BOSTON.

TO MARCELLINE HEMINGWAY, MAY 5, 1915

You poor bonus caput how in the name of all things just and unjust did you get in the story club. If I couldn't write a better story than you I'd consign myself to purgatory. Congratulations
Thine eternally
Ernestum

Ernest Hemingway travels by train from Chicago to Kansas City, Missouri, on October 15, 1917, to begin work as a reporter at the *Kansas City Star*. He secures the job through his uncle Tyler, an Oberlin College classmate of Henry J. Haskell, the paper's chief editorial writer. J. Charles "Carl" Edgar, whom Hemingway nicknamed "Odgar," was a summer friend from Horton Bay, Michigan.

The Letters of Ernest Hemingway 1907–1922, ed. Sandra Spanier and Robert W. Trogdon (Cambridge University Press, 2011).

TO HEMINGWAY FAMILY, OCTOBER 17, 1917, FROM KANSAS CITY

Dear Folks-.
I suppose you have got my first letter by now. I had a good trip and got in OK. Carl Edgar met me the first evening I was here and I sure am glad he is here. He sends his love to all the kids. Today I had 3 Stories in the star. It seems like a pretty good paper. They have a very big plant.
 I start work at 8 AM and quit at 5 P.M. and have the Sabath off . . .
With Love,
Ernie

TO A FRIEND AT THE *KANSAS CITY STAR*, JUNE 9, 1918

Having a wonderful time!!! Had my baptism of fire my first day here, when an entire munition plant exploded. We carried them in like at the General Hospital, Kansas City. I go to the front tomorrow. Oh, Boy!!! I'm glad I'm in it. They love us down here in the mountains.

Appearing in an article headlined "WOUNDED ON ITALIAN FRONT: ERNEST M. HEMINGWAY Formerly Was Reporter for the *Star*," the excerpt is preceded by this explanation: "Friends at *The Star* received half a dozen postal cards from Hemingway yesterday, the same day the message arrived telling of wounds. An extract from the cards, dated Milano, Italy, less than a month ago."

The Letters of Ernest Hemingway 1907–1922.

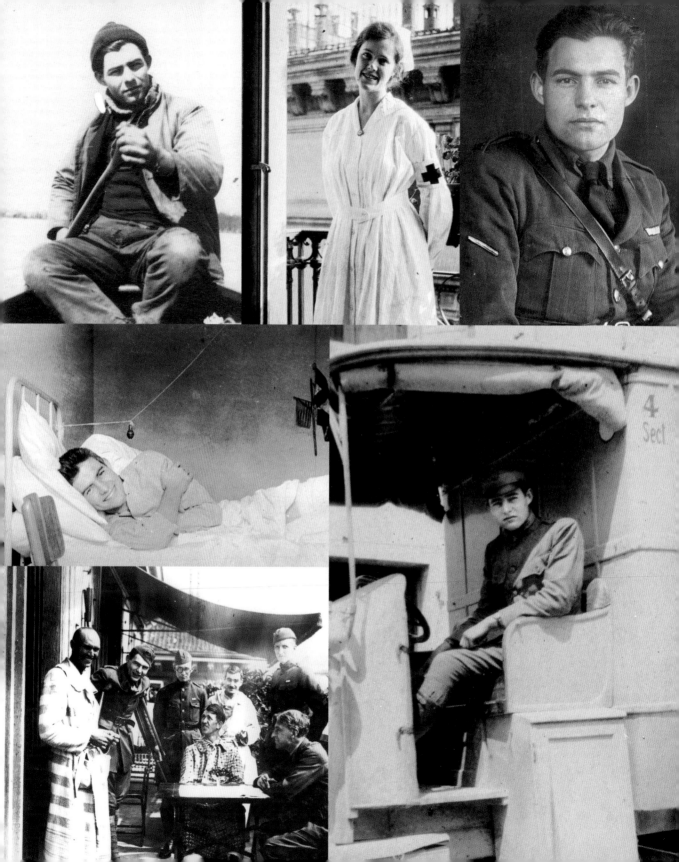

WORLD WAR I

"The reason you are so sore you missed the war," Hemingway told F. Scott Fitzgerald in 1925, "is because war is the best subject of all. It groups the maximum of material and speeds up the action and brings out all sorts of stuff that normally you have to wait a lifetime to get." Hemingway's participation in World War I was brief but its impact on his writing career was profound. In the spring of 1918 Hemingway enlists in the American Red Cross and arrives in Italy on June 4. Little over a month later he is severely wounded. After a series of operations to remove 227 shrapnel fragments and bullets from his legs, Hemingway celebrates his nineteenth birthday while convalescing in the summer and fall at the Red Cross hospital in Milan.

In addition to being decorated with the Italian Croce al Merito di Guerra (War Merit Cross), Hemingway is also awarded the Silver Medal of Military Valor, the official citation for which states that he "gave proof of courage and self-sacrifice. Gravely wounded by numerous pieces of shrapnel from an enemy shell, with an admirable spirit of brotherhood, before taking care of himself, he rendered generous assistance to the Italian soldiers more seriously wounded by the same explosion." He returns to the United States in January 1919.

Hemingway's experience as a war casualty, in combination with his deep study of conflict, would shape numerous short stories as well as *The Sun Also Rises* and *A Farewell to Arms*. As biographer Michael Reynolds remarked, when Hemingway returned home "he had experienced the quintessential modern experience—the violence of war. There would be no peace in his time." —DK and MK

TO HEMINGWAY FAMILY, JULY 16, 1918 (CABLE)

Wounded in legs by trench mortar; not serious; will receive valor medal; will walk in about ten days.

CLOCKWISE FROM TOP: 1. ERNEST HEMINGWAY ROWING IN A CANOE. STARVED ROCK, OAK PARK, ILLINOIS. ON THE BACK: "HEMING STEIN 17 HARD LOOKING EGG." COPYRIGHT JFK LIBRARY. 2. AGNES VON KUROWSKY, MILAN, ITALY. COPYRIGHT UNKNOWN. HEMINGWAY COLLECTION, JOHN F. KENNEDY PRESIDENTIAL LIBRARY AND MUSEUM, BOSTON. 3. ERNEST HEMINGWAY'S AMERICAN RED CROSS PORTRAIT. COPYRIGHT JFK LIBRARY. ERMENI STUDIO, MILAN. HEMINGWAY COLLECTION, JOHN F. KENNEDY PRESIDENTIAL LIBRARY AND MUSEUM, BOSTON. 4. ERNEST HEMINGWAY IN UNIFORM IN THE DRIVER'S SEAT OF A POSSIBLE AMERICAN RED CROSS AMBULANCE. ITALY. COPYRIGHT JFK LIBRARY. HEMINGWAY COLLECTION, JOHN F. KENNEDY PRESIDENTIAL LIBRARY AND MUSEUM, BOSTON. 5. ERNEST HEMINGWAY ON CRUTCHES WITH OTHER SOLDIERS AT THE RED CROSS HOSPITAL IN MILAN, ITALY, DURING WORLD WAR I. COPYRIGHT JFK LIBRARY. PHOTOGRAPHER UNKNOWN, IN THE JOHN F. KENNEDY PRESIDENTIAL LIBRARY AND MUSEUM, BOSTON. 6. ERNEST HEMINGWAY, AMERICAN RED CROSS, RECOVERS FROM WOUNDS SUFFERED NEAR FOSSALTA, ITALY, DURING WORLD WAR I, MILAN, ITALY, RED CROSS HOSPITAL, VIA MANZONI. PHOTOGRAPH COPYRIGHT DMITRI VILLARD, HEMINGWAY COLLECTION, JOHN F. KENNEDY PRESIDENTIAL LIBRARY AND MUSEUM, BOSTON.

Dear Ivory-;

. . . In regard to the question you asked I will reply. Yes. She is a Cross Red Nurse. Further more I cannot state I am of a dumbness. However, Frances Coates, A. DeV. And all others can take a back seat.

However from long experience with families etc., I don't talk about things anymore. So guess anything you want to. But I don't wear my heart on my sleeve anymore. But all Oak Park damsels are going to have to show something. I'm off of them the whole bunch. I'm afraid to come home and have 'em pulling this blooming 'live stuff. All the fair maidens that wouldn't give a damn about me before you write what a drag I have. Child, I'm going to stay here until my girl goes home and then I'll go up North and get rested before I have to go to work in the fall. The Doc says that I'm all shot to pieces, figuratively as well as literally. You see my internal arrangements were all battered up and he says I wont be any good for a year.

Well Kid, have a good time and take care of yourself and steer clear of the Flu and I love you a lot Kid. Also you wont know me. I'm about an 100 years older and I'm not bashful and I'm all medalled up and shot up.

So So Long Ivory Old Kid,

Yours (partially) ever.

Ernie.

THEY ARE FOREVER

In September 1918, during his convalescence at the American Red Cross Hospital in Milan, Hemingway meets and falls passionately in love with his nurse, Agnes von Kurowsky. She is the daughter of a Polish count and seven years older than Hemingway. The couple become engaged and

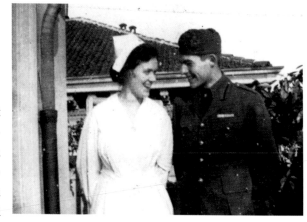

Agnes promises to return to the United States after the war and marry him. However, on March 7, 1919, Hemingway receives Agnes's letter breaking off their engagement. Later that month he writes a heartbroken letter about the end of the romance to his close friend Bill Horne, who had served alongside him in Italy. Horne's thoughtful response was, "Even though she may pass, the truths that she represented can not. . . . they are forever." —DK

Dear Old Sister-;

. . . Really Kid I'm immensely older. So when I say that I'm in love with Ag it doesn't mean that I have a

AGNES VON KUROWSKY AND ERNEST HEMINGWAY. HEMINGWAY COLLECTION, JOHN F. KENNEDY PRESIDENTIAL LIBRARY AND MUSEUM, BOSTON.

case on her. It means that I love her. So believe me or not as you wish. Always I've wondered what it would be like to really meet the girl you will really love always and now I know. Furthermore she loves me-which is quite a miracle in it's self. So don't say anything to the folks because I'm confiding in you. . . .

And I still love you Ivory Old Jazz.
The W.K. Brother.
Antique Brutality

TO LAWRENCE T. BARNETT, APRIL 30, 1919 (POSTED FROM CHICAGO)

Dear Lawrey,
. . . First let me tell you Barney that All bets with any women either wild or tame are off definitely. I am a free man! That includes them all up to and including Ag. My Gawd man you didn't think I was going to marry and settle down did you? Also just got out of the hospital here. Had another operation and everything is going great. And I'm leaving for upper Michigan in about three weeks, or two weeks, to get in two or three months of fishing . . .
CIAOU KID
Stein

Hemingway receives a letter from his friend Bill Horne telling him about his own romantic breakup. In Hemingway's response, one can read the developing views of the writer both personally and in regards to the world. He also refers to the shortness of one's lifetime.

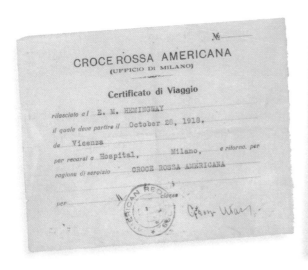
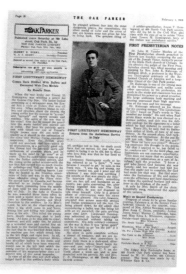

1. COPYRIGHT JFK LIBRARY. 2. *THE OAK PARKER* ARTICLE: "FIRST LIEUTENANT HEMINGWAY COMES BACK RIDDLED WITH BULLETS AND DECORATED WITH TWO MEDALS," PAGE 12. COPYRIGHT JFK LIBRARY.

TO WILLIAM D. HORNE, JR., AUGUST 7, 1919

Dear old Bill-;

I'm so damned sorry Bill. That doesn't do any good-but Bill I feel all broken about it. Why? Why? Do such things happen.

There's something wrong with us Bill- we're Idealists. And it makes us a deal of trouble and it hurts us. But we're that way and we can't help it.

Mine were bent under the storm and some of them broken and it seemed a sorry mess. But out of the wreck I'm sticking to the same things.

Passing The Love of Women I cant be the same. For me there are some things that when they are killed stay dead. . . .

Sua Amico

Hemmy

TO CLARENCE HEMINGWAY, OCTOBER 28, 1919

Dear Dad,

. . . This afternoon I worked out the new front part of the "Woppian Way" that Balmer wanted me to do and will have it in shape to start on it's travels as soon as I am settled in Petoskey. It was snowing a little this evening and the only amusement offered is an Evangelical revival. There is some doubt as to whether I will attend.

Since leaving Oak Park I have read a volume of stories by Guy de Maupassant one by Balzac, The Larger Testament of Francois Villon, Richard Yea and Nay by Maurice Hewlett and Little Novels of Italy also by Hewlett. These are all things that are further along in college than Marcelline ever achieved so you see I have not been entirely idle.

Thank you very much for helping me so much and give my love to mother and the kids,

Lovingly

Ernie

Hemingway begins work at the *Toronto Star* in 1920. Warren Harding is elected president, the United States does not ratify the Treaty of Versailles and women win their struggle for the vote. F. Scott Fitzgerald's *This Side of Paradise* is published.

TO *CHICAGO DAILY TRIBUNE*, NOVEMBER 29, 1920

C122 Tribune: No attempt will be made to write a trick letter in an effort to plunge you into such a paroxysm of laughter that you will weakly push over to me the position advertised in Sunday's Tribune.

You would probably rather have what facts there are and judge the quality of the writing from published signed articles that I can bring you.

I am twenty four years old, have been a reporter on the Kansas City Star and a feature writer on the Toronto Star and the Toronto Sunday World.

Am chronically unmarried.

War records are a drug on the market of course but to explain my lack of a job during 1918-served with the Italian Army because of inability to pass the U.S. physical exams. Was wounded July 8 on the Piave River-decorated twice and commissioned. Not that it makes any difference.

At present I am doing feature stuff at a cent and a half a word and they want five columns a week. Sunday stuff mostly.

I am very anxious to get out of the newspaper business and into the copy writing end of advertising. If you desire I can bring clippings of my work on the Toronto Star and Toronto Sunday World and you can judge the quality of the writing from them. I can also furnish whatever business and character references you wish.

Hoping that I have in a measure overcome your sales resistance-
very sincerely
1230 N. State Street
Chicago-Illinois

The Letters of Ernest Hemingway 1907–1922.

This is Hemingway's response to an advertisement in the "Wanted-Male Help" section of the November 28, 1920, *Chicago Daily Tribune*: "ADVERTISING WRITER EXPERIENCE NOT NECESSARY. Prominent Chicago advertising agency offers unusual opportunity to men capable of expressing themselves clearly and entertainingly in writing. A real opportunity to enter the advertising profession and be promoted as rapidly as ability warrants. State age, education, experience, if any, whether married or single, what you have been earning, and, in fact, anything or everything which will give us a correct line on you. All communications considered strictly confidential. Address C122 Tribune." Whether Hemingway received a response to his application letter remains unknown.

Ernest Hemingway marries Hadley Richardson in 1921. They had intended to go to Italy but after Sherwood Anderson tells them that Paris is the current literary center, not to mention cheap, they change their plans and sail for France.

1. COPYRIGHT JFK LIBRARY. 2. ERNEST HEMINGWAY, ELIZABETH HADLEY RICHARDSON AND UNIDENTIFIED CHILD AT HORTON BAY. COPYRIGHT JFK LIBRARY. 3. THE *KANSAS CITY STAR* STYLE BOOK, COVER INSCRIBED FROM PETER WELLINGTON TO ERNEST HEMINGWAY. HEMINGWAY COLLECTION, JOHN F. KENNEDY PRESIDENTIAL LIBRARY AND MUSEUM, BOSTON.

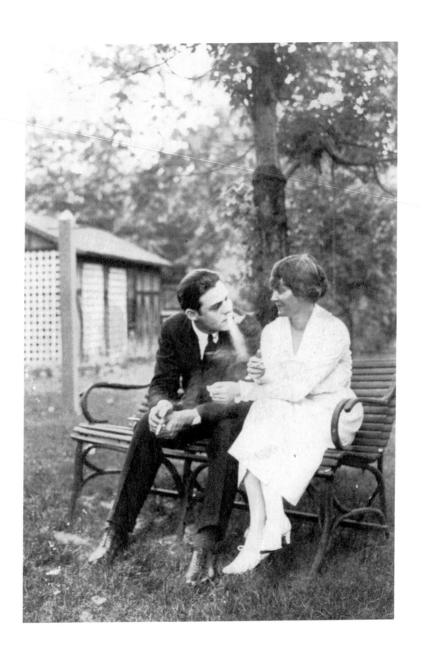

ERNEST HEMINGWAY SMOKING NEXT TO ELIZABETH HADLEY RICHARDSON ON BENCH AT HORTON BAY. HEMINGWAY COLLECTION, JOHN F. KENNEDY PRESIDENTIAL LIBRARY AND MUSEUM, BOSTON.

TO HADLEY RICHARDSON, JULY 7, 1921

Miss E. Hadley Richardson
5739 Cates Avenue
St. Louis Missouri-
Nothing better than you coming. Stop. Cheer up. Stop. Bill heart broken over Georges Carpentier. Stop.
Not me-Stop. Please come. Stop. Stay here. Stop. All my Love.
E.M.H.

Hemingway wrote this on the back of a July 7, 1921, telegram from Hadley that reads, "WANT SO MUCH TO SEE YOU BUT AFRAID OF MAKING THINGS HARDER COULD COME FRIDAY NIGHT SEEING YOU SATURDAY AND SUNDAY CAN EASILY GIVE IT UP JUST WANT TO SEE YOU VERY MUCH KNOW IT IS PROBABLY NOT PRACTICAL ON ACCOUNT OF THROAT AND WORK VERY DEAR LOVE/E.H.R."

The Letters of Ernest Hemingway 1907–1922.

TO GRACE QUINLAN, LATE JULY 1921

Dearest Old G-
. . . Good chance that it'll be just two people that love each other being able to be together and understand each other and bum together and help each other in their work and take away from each other that sort of lone-liness that's with you even when you're in a crowd of people that are fond of you. Think marriage might be a terrible fine thing you know-Anyhow Hash and I are going to have a very fine try at it-

TO GRACE QUINLAN, AUGUST 7, 1921

Dearest G-
. . . Know how you feel about my being too young to be married. Felt exactly the same way until Hash and I realized that life would be about as interesting as this splendid hotel unless we could have each other to love with. So in circumstances like those you hafta make allowances.
 I never wanted to be married before, in spite of having faced it on numerous occasions. . . .
 . . . Enclosed is a picture of Hadley in her wedding dress. Very improper to circulate prior to wedding I believe but you're my sister- aren't you?
 Good night old Dearest-I love you very much.
Always yours Bro.
Stein

Dear Sherwood and Tennessee-
Well here we are. And we sit outside the Dome Café, opposite the Rotunde that's being redecorated,
warmed up against one of those charcoal brazziers and it's so damned cold outside and the brazier
makes it so warm and we drink rum punch, hot, and the rhum enters into us like the Holy Spirit.

Bones is out in it now and I've been earning our daily bread on this write machine. In a couple of
days we'll be settled and then I'll send out the letters of introduction like launching a flock of ships. So
far we haven't sent 'em out because we've been walking the streets, day and night, arm through arm,
peering into courts and stopping in front of little shop windows. The pastry'll kill Bones eventually I'm
afraid. She's a hound for it. Must have always been a suppressed desire with her I guess.

Sherwood's note was here at hotel when we got in. It was awfully damned nice of you to send it.
We were feeling a little low and it busked us up terrifically.

The Jacob is clean and cheap. The Restaurant of the Pre aux Clercs at the corner of the Rue
Bonaparte and the Rue Jacob is our regular eating place. Two can get a high grade dinner there, with
wine, a la carte for 12 francs. We breakfast around. Usually average about 2.50 F. for breakfast. Think
things are even cheaper than when you all were here.

We came via Spain and missed all but a day of the big storm. You ought to see the spanish coast.
Big brown mountains looking like tired dinosaurs slumped down into the sea. gulls following behind the
ship holding against the air so steadily they look like property birds raised and lowered by wires.
Light house looking like a little candle stuck up on the dinosaurs shoulder. The coast of Spain is long and
brown and looks very old.

Then coming up on the train through Normandy with villages with smoking manure piles and
long fields and woods with the leaves on the ground and the trees trimmed bare of branches way
up their trunks and a roll of country and towers up over the edge. Dark stations and tunnels and 3rd
class compartments full of boy soldiers and finally everyone asleep in your own compartment leaning
against each other and joggling with the sway of the train. There's a deathly, tired silence you can't get
anywhere else except a railway compartment at the end of a long ride.

Anyway we're terrible glad we're here and we hope you have a good Christmas and New Year and
we wish we were all going out to dinner tonight together.

[Hadley begins:]

Every word he says is true, especially the wishes for the jolliest kind of a Xmas season. It feels like
anything but a strange place here at the Jacob, what with your note of welcome and the feeling that
you two have lived here so lately. We like it very much and also we think this is best neighborhood
we've seen. We're going out now, across this river to purvey for each others Xmas stockings. I will try
to keep from buying pastries for Ern. Here we go pausing for an affectionate moment in passing to sign
ourselves
Ernest and Bones

1. PORTRAIT OF ERNEST HEMINGWAY WITH SCAR, PARIS, 1928. PHOTOGRAPH BY HELEN BREAKER, JOHN F. KENNEDY PRESIDENTIAL LIBRARY AND MUSEUM, BOSTON. 2. FRENCH IDENTITY PAPERS WITH PHOTOGRAPH OF PAULINE PFEIFFER. PHOTOGRAPH BY HELEN BREAKER, JOHN F. KENNEDY PRESIDENTIAL LIBRARY AND MUSEUM, BOSTON.

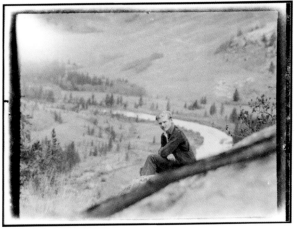

1. GREGORY "GIGI" HEMINGWAY DUCK HUNTING IN IDAHO. ROBERT CAPA © INTERNATIONAL CENTER OF PHOTOGRAPHY / MAGNUM PHOTOS. HEMINGWAY COLLECTION, JOHN F. KENNEDY PRESIDENTIAL LIBRARY AND MUSEUM, BOSTON. 2. COPYRIGHT JFK LIBRARY. 3. JACK HEMINGWAY. COPYRIGHT JFK LIBRARY.

PARIS

"Paris was the place," said Gertrude Stein, "that suited us who were to create the twentieth century art and literature." Hemingway takes up residence in Paris in January 1922. Ostensibly there to write feature stories on European affairs for the *Toronto Star*, he arrives with letters of introduction to Stein, Ezra Pound, and Sylvia Beach. He would later acknowledge that he "learned a lot" from Stein, "though not half as much as he learned from Ezra Pound or one tenth as much as he learned from James Joyce."

Hemingway covers the Greco-Turkish War in September–October 1922, and from that time begins to regularly publish his poetry and short stories in literary magazines. That same year James Joyce's *Ulysses* is published by Sylvia Beach as well as T. S. Eliot's *The Waste Land* and Sinclair Lewis's *Babbitt*. Benito Mussolini becomes prime minister of Italy and there is a resurgence of the Ku Klux Klan in America. In Paris, Hemingway transformed himself from a journalist into a writer of fiction and, in doing so, forged a new style in literature. When *In Our Time* was published in 1925, the *New York Times* commented that "his language is fibrous and athletic, colloquial and fresh, hard and clean, his very prose seems to have an organic being of its own."

TO HEMINGWAY FAMILY, LATE JANUARY 1922

Dear Family-
. . . Hash just came in and read this over my shoulder an says to send lots of love to you and tell you about our apartment. It is at 74 Rue duCardinal Lemoine. And is the jolliest place you ever saw. We rented it furnished for 250 francs a month, about 18 dollars and have a femme de ménage who cooks dinner for us every night. I think I wrote you about it, so I won't go on, You can send mail there and it will reach us. It is the most comfortable and cheapest way to live and Bones has a piano and we have all our pictures up on the walls and an open fire place and a peach of a kitchen and a dining room and big bed room and dressing room and plenty of space. It is on top of a high hill in the very oldest part of Paris. The nicest part of the Latin quarter. Just back of the Pantheon and the Ecole Polytechique. It has a tennis court right across the street and a bus line ends in the square around the corner so that you can get anywhere in the city. We were having an awfully good time in Paris, [b]ut the weather was so rotten that we were glad to come down here.
Love,
Ernie and Hadley

[Hadley adds:]

P.S. Dear Family:-
Here we are filling our lungs with the cold dry air of the Swiss Alps and hiking and bobbing all day long-at night we are so weary we tumble into our beds, pull up the immaculate white feather beds-and drop off into the deepest sleep that doesn't break till they come in to light the stove and lamp at 8 o'clock in the morning. Breakfast in bed! Then a little reading or talking then on the roads again or shopping in Montreux. We are feeling fitter each day-Hope to hear a little gossip about the family doings soon.
Always devotedly
Hadley

TO SHERWOOD ANDERSON, MARCH 9, 1922

Dear Sherwood-
You sound like a man well beloved of Jesus. Lots of things happen here. Gertrude Stein and me are just like brothers and we see a lot of her.
. . . Joyce has a most god-damned wonderful book. It'll probably reach you in time. Meantime the report is that he and all his family are starving but you can find the whole celtic crew of them every night at Michaud's where Binney and I can only afford to go about once a week.
Gertrude Stein says Joyce reminds her of an old woman out in San Francisco. The woman's son struck it rich as hell in the Klondyke and the old women went around wringing her hands and saying. "Oh my poor Joey! My poor Joey! He's got so much money!" The damned Irish, they have to moan about something or other, but you never heard of an Irishman starving.
I've been teaching Pound to box wit little success. He habitually leads wit his chin and has the general grace of the crayfish or crawfish. He's willing but short winded. Going over there this afternoon for another session but there aint much joy in it as I have to shadow box between rounds to get up a sweat. Pound sweats well, though, I'll say that for him. Besides it's pretty sporting of him to risk his dignity and his critical reputation at something he don't know nothing about. He's really a good guy, Pound, wit a fine bitter tongue onto him. He's written a good review of Ulysses for April Dial . . .

TO JOHN MCCLURE, SEPTEMBER 1922

Dear Mr. McClure:-
Mr. Lewis Galantiere, some months ago, suggested that when I write you I should tell you, for him, that you were a son of a bitch. I did so in jest.
I now send you the same message, not from M. Galantiere but from myself, and this time in earnest. You are a son of a bitch Mr. McClure. I repeat it .

For some time the title- Double Dealer puzzled me. It is no longer a puzzle. Double Dealer means that your practice is to rook, gyp or kike both the subscriber and the contributor.

If you have enough money to buy the back cover of the New Republic why not pay for contributions . . .

Hemingway is responding to a letter from John McClure, managing editor of *The Double Dealer*, turning down a group of Hemingway's poems and encouraging him to send more work. McClure praised Hemingway's "A Divine Gesture" and "Ultimately" (which appeared in the May and June 1922 issues). He added that the magazine owed Hemingway "several dollars on those" and said the check probably would arrive late in September, assuring him that "there is no intention or likelihood of the *Double Dealer*'s defaulting—it is merely in arrears" (JFK Library, August 3 [?], 1922). Hemingway wrote this response, apparently unfinished and unsent, on the verso of handwritten notes documenting his September 1922 interview with Georges Clemenceau.

A full-page advertisement for *The Double Dealer* ran on the back cover of the August 2, 1922, *New Republic*. Whether Hemingway ever received payment for his contributions to *The Double Dealer* is not known.

The Letters of Ernest Hemingway 1907–1922.

THREE STORIES AND TEN POEMS

Hemingway's first book is privately printed and issued in blue-gray wrappers by Robert McAlmon's Contact Publishing Company. Maurice Darantière, who, the previous year, was responsible for printing James Joyce's *Ulysses*, prints three hundred copies, four of which are given to Hemingway. In November 1923 Hemingway inscribes a copy to Edmund Wilson when he petitions the influential critic for a review. Wilson's laudatory essay—published in the October 24 issue of *The Dial*, an American literary magazine that regularly featured work by an array of leading modernist authors—established Hemingway as a major new talent. Wilson praised Hemingway's compressed vignettes and short stories as "a harrowing record of the barbarities of the period in which we live." Hemingway thought Wilson's review "was cool and clear minded and decent and impersonal and sympathetic."
—DK

TO ANSON HEMINGWAY, MARCH 14, 1923

Cortina D' Ampeszo, Italy.
March 14th, 1923
Dear Grandfather,
I cannot tell you how shocked and sad I feel to learn in a letter just received from my father that dear sweet grandmother is gone. Hadley and I wanted to cable you our love and sympathy but feel that since several weeks have passed the cable might simply be disturbing.

There is nothing that we can say or do. It is impossible for me to believe that Grandmother is dead. I will never be able to believe it, because she is not the kind of person that can die. Dear, beautiful, brave, cheerful, sweet, kind, little Grandmother. You must know how we love you and feel for you who miss her as none of us can.
Your loving grandson,
"Ernest."

TO SYLVIA BEACH, NOVEMBER 6, 1923

Dear Seelviah-
. . . If the baby had been a girl we would have named her Sylvia. Being a boy we could not call him Shakespeare. John Hadley Nicanor is the name. Nicanor Villalta the bull fighter.

How is Adrienne? We both send her our love. We have a new song to sing her.

This is no place to make up songs though. The humane society kills 7,853 feather cats a year. All the human society does is kill animals.

Women call up the humane society to kill woodpeckers that knock on their roofs.

Canadians are all tapettes at heart underneath all the big free open spaces. There are no gigolos because no old women have money. Otherwise they would all be. It is a dreadful country.

O'Brien has taken the story MuyOld Man for The Best and Worst Short Stories of 1923.

He also asked to dedicate the book to me. Don't say anything about it or he may change his mind . . .

SHAKESPEARE AND COMPANY

In those days there was no money to buy books. Books you borrowed from the rental library of Shakespeare and Company, which was the library and bookstore of Sylvia Beach at 12 rue de l'Oden. . . . No one that I ever knew was nicer to me.

I was very shy when I first went into the bookshop and I did not have enough money on me to join the rental library. She told me I could pay the deposit any time I had the money and made me out a card and said I could take as many books as I wished.

There was no reason for her to trust me. She did not know me and the address I had given her, 74 rue Cardinal Lemoine, could not have been a poorer one. But she was delightful and charming and welcoming and behind her, as high as the wall and stretching out into the back room which gave onto the inner court of the building, were the shelves and shelves of the richness of the library.

I started with Turgenev and took the two volumes of A Sportsman's Sketches and an early book of D. H. Lawrence, I think it was Sons and Lovers, and Sylvia told me to take more books if I wanted. I chose the Constance Garnett edition of War and Peace, and The Gambler and Other Stories by Dostoyevsky.

"You won't be back very soon if you read all that," Sylvia said.

"I'll be by to pay," I said. "I have some money in the flat."

"I didn't mean that," she said. "You pay whenever it's convenient."

Ernest Hemingway
A Moveable Feast

PLEASE RETURN :

Americana 1926 (although it is not overdue)

TO :

SHAKESPEARE AND COMPANY
12, RUE DE L'ODÉON - PARIS - VI•

TO EDMUND WILSON, NOVEMBER 11, 1923

Dear Mr. Wilson:

In Burton Rascoe's Social and Literary notes I saw you had drawn his attention to some writing of mine in the Little Review.

I am sending you Three Stories and Ten Poems. As far as I know it has not yet been reviewed in the States. Gertrude Stein writes me she has done a review but I don't know whether she has gotten it published yet.

Yours sincerely,
Ernest Hemingway
1599 Bathurst Street
Toronto, Canada

 P.S.
 This is an awful country

TO EZRA POUND, DECEMBER 9, 1923

Esteemed General Pound-

. . . Christ how I want to get drunk with some one that knows what the hell I am talking about. You were right. It is all right to have done once-but even better not to do. For Christ sake never come back.

Don't let Strater kid you or Heep and Co. Heep and Co. don't live in any country. Those people live in Homosexualia which is international. They tote it with them and set it up wherever they go.

But for a man who likes to drink and fuck and eat and talk and read the papers and write something and keep clear of the shits, literary shits, artistic shits, photographic shits, journalistic shits, high minded shits, low minded healthy shits, sickly shits, money making shits, poor shits, book shop shits, book review shits ignorant shits, Dull Dial shits, bright Vanity Fair shits, eager shits, tired shits, virgins, cock suckers, lawyers, land lords, city editors, Pullman porters, masturbators, Ministers, Gilbert Seldes, all his friends, Everybody in New York, The Governor General, Lady Byng, Mr. Atkinson, Charlie Goode, The Arts and Letters club, D. H. Lawrence, Mickey Walker, Yeats the Senator, Norman Douglas, Norman Angell, Norman Hapgood, Norman Blood, the Labor Party, Protection, Free Trade, Mr. Coolidge, Strater's Old Man, Strater's Conscience, Scofield Thayer, Buggary, Sodomy, ass licking, cunt lapping, (except among friends) cancers, The Nobel Prize, Theosophy, Christian Science, Carpentier, Dechamps, Millerand, -

Shit on them all
Love to Dorothy-
Hem.

Have just realized that this would probably bore a guy who wrote Blast.
What t' hell.- Write me.

"Heep and Co." is a reference to Jane Heap and her longtime partner, Margaret Anderson, editors of *The Little Review*, which Anderson had founded in Chicago in 1914.

Blast: Review of the Great English Vortex was a polemical avant-garde modernist magazine founded by the British writer and painter Wyndham Lewis (1882–1957) with the assistance of Pound. It ran for two issues in 1914 and 1915.

The Letters of Ernest Hemingway 1923–1925, ed. Sandra Spanier, Albert J. Defazio III and Robert W. Trogdon (Cambridge University Press, 2013).

TO GERTRUDE STEIN AND ALICE B. TOKLAS, NOVEMBER 9, 1923

Dear Friends:
. . . I am going to chuck journalism I think. You ruined me as a journalist last winter. Have been no good since. Like a bull, or a novillo rather, well stuck but taking a long while to go down. . . . I'm quitting on January 1[.] I have some good stories to write-will try not to be turgid—.

TO JOHN BONE, LATE DECEMBER 1923

Mr. Bone:
I regret very much the necessity of tendering my resignation from the local staff of the Star. This resignation to take effect January 1st, 1924 if convenient to you.
Please believe there is no rudeness implied through the brevity of this memorandum.
Ernest

TO EZRA POUND, FEBRUARY 10, 1924

Dear Prometheus-
We have trouved an apt. at 113 Rue Notre Dame Des Champs semi furnished over a saw mill. . . .

TO DONALD OGDEN STEWART, EARLY JULY 1924

Dear Don-
. . . You leave the Gare D'Orsay at 7:10 pm arriving San Sebastien about 9:15 a.m. You can play around there and go swimming very stylishly at noon and catch the train leaving San Sebastien at 4 pm for Pamplona . . .

In 1924 George Gershwin composes *Rhapsody in Blue*, E. M. Forster's *A Passage to India* is published and for the first time photographs are transmitted across the Atlantic Ocean. Ernest Hemingway begins work on what will become *The Sun Also Rises*.

TO EDWARD J. O'BRIEN, SEPTEMBER 12, 1924

Dear O'Brien-
. . . I have written 14 stories and have a book ready to publish. It is to be called In Our Time and one of the chapters of In Our Time I sent you comes in between each story. . . . All the stories have a certain unity-the first five are in Michigan starting with Up In Michigan-which you know and in between each one comes bang! The In Our Time-It should be awfully good I think. . . . Dos Passos and Don Stewart and a bunch of us were down in Spain and I got gored in an amateur bull fight at Pamplona. Was in the ring 5 different days. Gotten to know a lot about it. It is what a man needs. Don Stewart was very fine. The men went on and walked across the Spanish face of the Pyrenees to Andorra—460 kilometers in 14 days-

FRONT COVER OF *IN OUR TIME*. HEMINGWAY COLLECTION, JOHN F. KENNEDY PRESIDENTIAL LIBRARY AND MUSEUM, BOSTON.

Making lists of potential titles for his short stories and novels was a regular part of Hemingway's creative process throughout his career. This is Hemingway's list of working titles for *In Our Time* (1924). The first six titles, most of which are visibly inferior, suggest that Hemingway struggled to find the right title for his second book. The title he finally chose was taken from the *Book of Common Prayer*. "Give us peace in our time, O Lord." Given that many of the book's vignettes and stories describe or imply violence, Hemingway's choice of title was deliberately ironic. The subtitle, "I Am Not Interested in Artists," was never used. —DK

Hemingway's *In Our Time* was published by Boni & Liveright on October 5, 1925. Other notable works that were published that year included F. Scott Fitzgerald's *The Great Gatsby*, John Dos Passos's *Manhattan Transfer*, Franz Kafka's *The Trial*, Gertrude Stein's *The Making of Americans*, Virginia Woolf's *Mrs. Dalloway*, Sherwood Anderson's *Dark Laughter* and T. S. Eliot's *Poems 1905–1925*.

TO HOWELL G. JENKINS, NOVEMBER 9, 1924

113 Rue Notre Dame des Champs,
Paris, France.
November 9, 1924

Dear Old Carpative-
. . . We are going to Spain again. Get a Ford for 1,000 francs a month with Insurance and drive down from here. You are going to drive.
There is swell fishing. The wildest damn country in the Spanish Pyrenees in from Roncevaux. . . . We'll camp in at the headwaters of the Irati for a week and then go back to Burguete, get in the car and drive through the pass down to Pamplona for the big Feria and the bull fights. Six bull fights on six successive days and every morning an amateur fight in which will take part the noted Espadas Howell Griffiths Jenkins and Ernest de la Mancha Hemingway representing the Stock Yards of Chicago.
The godamdest wild time and fun you ever saw. Everybody in the town lit for a week. . . . Honest to Gawd Carper there never is anything like it anywhere in the world. Bull Fighting is the best damn stuff in the world . . .

TO WILLIAM B. SMITH, JR., MARCH 4, 1925

Smyth-

. . . playing with Paul Nelson, Ezra Pound and Loeb—Loeb could give you a game. He is the guy that started Broom. A hell of a good guy. . . . Loeb is a male you can wrestle wit. He aint been throwed since he learned in Princeton-only weighs 150 about. Heavy weights cant throw him. He's never wrestled pros or of course he's have got throwed. Still he aint been throwed. I tried to throw him and he throwed me in no time . . .

THE WRITER'S DECLARATION OF INDEPENDENCE

In a March 20, 1925, letter, Ernest Hemingway, after detecting disapproval from his parents concerning the stories in *In Our Time*, attempts to explain to his father what he is trying to achieve in his writing. Other criticism by Gertrude Stein, that stories like "Up in Michigan" were pornographic and unpublishable, was met with uncharacteristic silence by the young Hemingway. This time, however, his parents' criticism is met with the young writer's declaration of artistic independence. Hemingway is venturing into new territory and he knows it. He is seeking his own voice and he is uncompromising and sure about his direction. He is part of a churning year that also sees the publication of Adolf Hitler's *Mein Kampf* and the prosecution of the Scopes Monkey Trial in Tennessee.

TO CLARENCE HEMINGWAY, MARCH 20, 1925

Dear Dad,

. . . The reason I have not sent you any of my work is because you or Mother sent back the In Our Time books. That looked as though you did not want to see any.

You see I'm trying in all my stories to get the feeling of the actual life across-not to just depict life-or criticize it-but to actually make it alive. So that when you have read something by me you actually experience the thing. You cant do this without putting in the bad and the ugly as well as what is beautiful. Because if it is all beautiful you cant believe in it. Things arent that way.

It is only by showing both sides-3 dimensions and if possible 4 that you can write the way I want to.

So when you see anything of mine that you dont like remember that I'm sincere in doing it and that I'm working toward something. If I write an ugly story that might be hateful to you or to Mother the next one might be one that you would like exceedingly. . . .

With love and good luck,

Ernie

TO HORACE LIVERIGHT, MARCH 31, 1925

113 Rue Notre Dame des Champs,
Paris, France.
March 31, 1925

Dear Mr. Liveright:
Enclosed is the signed contract and a new story to replace the one you are eliminating as censorable.
As the contract only mentions excisions it is understood of course that no alterations of words shall be made without my approval. This protects you as much as it does me as the stories are written so tight and so hard that the alteration of a word can throw an entire story out of key. I am sure you and Mr. T. R. Smith understand this.
There is nothing in the book that has not a definite place in its organization and if I at any time seem to repeat myself I have a good reason for doing so.
As for obscenities you and Mr. Smith being on the spot know what is and what is not unpublishably obscene much better than I do. I understand that it is no longer necessary to eliminate the fine old word son of a bitch. This is indeed good news. . . .

FIRST CONTACT AND A TWIST OF FATE

In October 1924 F. Scott Fitzgerald contacts his editor at Charles Scribner's Sons to recommend Hemingway's writing. On February 21, 1925, Scribner's editor Maxwell Perkins solicits Hemingway for the first time. Perkins writes, "I had heard you were doing very remarkable writing and was most anxious to see it and after a great deal of effort and correspondence, I finally did manage to get this book which seems not to be in circulation in this country." Perkins expresses interest in Hemingway's work and then goes on "to ask whether you might have anything that you would allow us to consider as publishers." Receiving no reply, Perkins sends another letter dated February 26, 1925, and encloses the first letter. The correspondence is received by Sylvia Beach and passed on to Hemingway. In the second letter Perkins solicits Hemingway for any future work. Perkins writes, "We should certainly read it with promptness and sympathetic interest if you gave us the opportunity." On February 25, 1925, Hemingway receives cables from Harold Loeb and Don Stewart informing him that Boni & Liveright wish to publish *In Our Time*. Hemingway sends a cable to Liveright on March 6 accepting their offer. Hemingway's April 15 response to Perkins states that he had just signed an agreement with Boni & Liveright. For the foreseeable future, it seems to end the matter, but events would shift as a result of some of Hemingway's contractual and literary cleverness. Within a short time Perkins and Hemingway would come across each other again and together would forge what was to become a lasting and legendary relationship.

EXPOSITION
JOAN MIRO

A LA GALERIE PIERRE
13, Rue Bonaparte (VIe)

Du Vendredi 12 au Samedi 27 Juin 1925
de 10 h. à 12 h. et de 2 h. à 6 h. 1/2. Dimanches exceptés.

GALERIE PIERRE

TABLEAUX

13, RUE BONAPARTE _ PARIS

TÉLÉPH: FLEURUS 39-87._ R.C. SEINE 292.859

Reçu de Monsieur Hemingway la somme
de 1000 francs (mille francs) en acompte sur
le paiement d'un tableau par Miro: La Ferme.
Reste due la somme de 2000 francs (deux mille
francs)

Paris le 22 Juillet 1925

TO MAXWELL PERKINS, APRIL 15, 1925

113 Rue Notre Dame des Champs,
Paris VI, France
April 15, 1925

Maxwell E. Perkins Esq.
Charles Scribner's Sons,
Publishers
New York City

Dear Mr. Perkins:
 On returning from Austria I received your letter of February 26 inclosing a copy of a previous letter which unfortunately never reached me. About ten days before your letter came I had a cabled offer from Boni and Liveright to bring out a book of my short stories in the fall. They asked me to reply by cable and I accepted.
 So that is how the matters stand. I cannot tell you how pleased I was by your letter and you must know how gladly I would have sent Charles Scribner's Sons the manuscript of the book that is to come out this fall. It makes it seem almost worth while to get into Who's Who in order to have a known address.
 I hope some day to have a sort of Daughty's Arabia Deserta of the Bull Ring, a very big book with some wonderful pictures. But one has to save all winter to be able to bum in Spain in the summer and writing classics, I've always heard, takes some time. Somehow I don't care about writing a novel and I like to write short stories and I like to work at the bull fight book so I guess I'm a bad prospect for a publisher anyway. Somehow the novel seems to me to be an awfully artificial and worked out form but as some of the short stories now are stretching out to 8,000 to 12,000 words maybe I'll get there yet.
 The In Our Time is out of print and I've been trying to buy one to have myself now I hear it is valuable; so that probably explains your difficulty in getting it. I'm awfully glad you liked it and thank you again for writing me about a book.
Very Sincerely,
Ernest Hemingway

TO EZRA POUND, APRIL 22, 1925

Dear Ezra:
Have greeted Miro. Claimed he was writing you. Feels he owes all to you . . . I have bought The Farm. That may bring you back to Paris sometime to look at it.

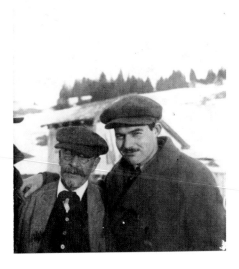

SCOTT FITZGERALD

. . . When I had finished the book I knew that no matter what Scott did, nor how preposterously he behaved, I must know it was like a sickness and be of any help I could to him and try to be a good friend. He had many good, good friends, more than anyone I knew. But I enlisted as one more, whether I could be of any use to him or not. If he could write a book as fine as The Great Gatsby I was sure that he could write an even better one. I did not know Zelda yet, and so I did not know the terrible odds that were against him. But we were to find them out soon enough.
Ernest Hemingway
A Moveable Feast

TO ZELDA FITZGERALD, MID-MAY 1925 CABLE

MADAME FITZGERALD 14 RUE DE TILSITT PARIS SCOTT MISSED TRAIN PLEASE WIRE HIM CARE GARAGE I WILL BE AT HOTEL BRISTOL LYON WIRE ME ADDRESS OF GARAGE THERE
HEMINGWAY

Hemingway and F. Scott Fitzgerald first met at the Dingo Bar sometime in late April 1925. Hemingway drafted this cable to Zelda Fitzgerald during his journey with Scott to retrieve the automobile that the couple had abandoned in Lyon while en route from Italy to Paris in late April 1925. According to Hemingway's memorable account of the trip in the "Scott Fitzgerald" chapter of *A Moveable Feast*, he had not yet met Zelda, nor had he yet read Fitzgerald's new novel, *The Great Gatsby*. The Fitzgeralds moved into their Paris apartment at 14 rue de Tilsitt on May 12, 1925, which places the date of this cable on or after that date (Fitzgerald to Max Perkins, May 1, [1925], in *F. Scott Fitzgerald: A Life in Letters*, ed. Matthew J. Bruccoli, with the assistance of Judith S. Baughman [New York: Scribner's, 1994], 107–9). This cable drafted by Hemingway survives only as a blind impression left on a rear blank page of a book owned by Fitzgerald. The book, *Portraits: Real and Imaginary* (New York: Doran, 1924) by Ernest Boyd (1887–1946), survives at the University of South Carolina Libraries.

The Letters of Ernest Hemingway 1923–1925.

TO EZRA POUND, JUNE 8-10, 1925

Dear Ezrah-
. . . Scott Fitzgerald in town and on a perpetual drunk. I went down to Lyon to drive his car up.
Didn't miss one vintage from Montrachet to Chambertin. Elaborate trip. Old ford has new teeth.
Don't fit so well. . . .

1925, A MOMENTOUS YEAR

1925 proves to be a critical year in the life of Ernest Hemingway in regard to his relationships and his work. *In Our Time* is published by Boni & Liveright in New York and the magazine publishing of Hemingway's short stories picks up steam. In February, his poem "The Age Demanded" is published, as are "Mr. and Mrs. Elliot," "Homage to Ezra," "Big Two-Hearted River" and "The Undefeated." He will make his last payment on Miró's painting *The Farm*.

In mid-March Hemingway meets Pauline Pfeiffer for the first time. Hemingway plans to go to the Festival of San Fermín in Pamplona, Spain. Following that sexually explosive and alcohol-fueled festival he begins work on what will become *The Sun Also Rises*, published in 1926. As a result of that book along with *Torrents of Spring*, his satire about Sherwood Anderson's *Dark Laughter* and Gertrude Stein's *The Making of Americans*, Hemingway will strain some of his friendships and destroy others. He will also be heralded as one of the most important new writers of his generation.

TO HAROLD LOEB, JUNE 21, 1925

Dear Harold:

My son of a bitching editor has double X ed me and is arriving tomorrow- I.E. Monday June 22nd –So we cant get off till Wednesday morning or Thursday night.

I'll wire you. Pat and Duff are coming too. Pat has sent off to Scotland for rods and Duff to England for Funds. As far as I know Duff is not bringing any fairies with her. You might arrange to have a band of local fairies meet her at the train carrying a Daisy chain so that the transition from the quarter will not be too sudden . . . Don will be at Pamplona and so will Bob Benchley. Pamplona is going to be damn good. . . . Hadley and I have been very tight and having a swell time . . .

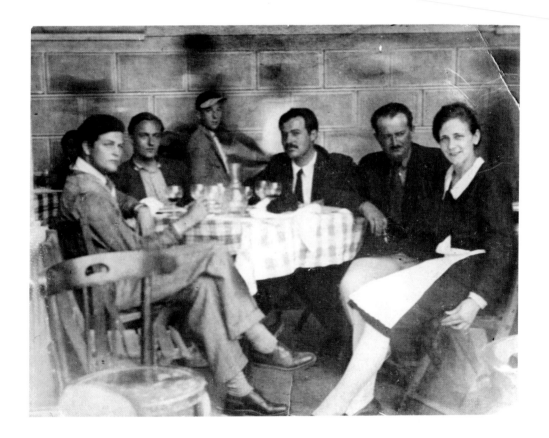

ERNEST HEMINGWAY SITS AT A CAFÉ TABLE WITH FOUR UNIDENTIFIED PEOPLE IN PAMPLONA, SUMMER 1925. ON THE BACK: "TARJETA."
COPYRIGHT UNKNOWN, HEMINGWAY COLLECTION, JOHN F. KENNEDY PRESIDENTIAL LIBRARY AND MUSEUM, BOSTON.

TO F. SCOTT FITZGERALD, JULY 1, 1925

Burguete, Navarra
July 1-

Dear Scott-
We are going to Pamplona Tomorrow. . . . How are you? And how is Zelda?

I am feeling better than I've ever felt—havent drunk any thing but wine since I left Paris. God it has been wonderful country. But you hate country. All right omit description of country. I wonder what your idea of heaven would be— A beautiful vacuum filled with wealthy monogamists, all powerful and members of the best families all drinking themselves to death. And hell would probably [be] an ugly vacuum full of poor polygamists unable to obtain booze or with chronic stomach disorders that they called secret sorrows.

To me heaven would be a big bull ring with me holding two barrera seats and a trout stream outside that no one else was allowed to fish in and two lovely houses in the town; one where I would have my wife and children and be monogamous and love them truly and well and the other where I would have my nine beautiful mistresses on 9 different floors . . . Then there would be a fine church like in Pamplona where I could go and be confessed on the way from one house to the other and I would get on my horse and ride out with my son to my bull ranch named Hacienda Hadley and toss coins to all my illegitimate children that lined the road. I would write out at the Hacienda and send my son in to lock the chastity belts onto my mistresses because someone had just galloped up with the news that a notorious monogamist named Fitzgerald had been seen riding toward the town at the head of a company of strolling drinkers.

Well anyway were going into town tomorrow early in the morning. Write me at the / Hotel
Quintana
Pamplona
Spain

Or dont you like to write letters. I do because it's such a swell way to keep from working and yet feel you've done something.
So long and love to Zelda from us both-
Yours,
Ernest

A MOMENTARY DISAGREEMENT (WELL, KIND OF)

Hemingway is so taken by the previous year's festival in Pamplona that he writes to friends describing the events as "The godamdest wild time and fun you ever saw." His excitement is infectious and for a number of months he tries to convince his friends to join him and Hadley for the 1925 festival. All goes quite badly and in one unpleasant episode Harold Loeb and Hemingway very nearly get into a fistfight over Duff Twysden, who was Loeb's ex-lover and whom he had spent the previous week with in Saint-Jean-de-Luz, which heightened Hemingway's jealousy. Fueled with alcohol, lots of it, tempers and jealousies flare, casting a pall on the entire festival. Hemingway would take this event and immortalize it in what would become *The Sun Also Rises*. The real-life characters would be transformed and in some cases the characterizations, like that of Harold Loeb, would not only shatter friendships but also scar and haunt those portrayed for the remainder of their lives. Duff Twysden and her friend Pat Guthrie would become Brett Ashley and Michael Campbell, and Harold Loeb would become Robert Cohn. Hemingway was Jake Barnes.

The day after the two men nearly came to blows Hemingway writes Loeb a heartfelt apology.

TO HAROLD LOEB, JULY 12, 1925

Dear Harold-
I was terribly tight and nasty to you last night and [I hope you can -crossed out] don't want you to go away with that nasty insulting lousiness as the last thing of the fiestas. I wish I could wipe out all the mean-ness and I suppose I cant but this is to let you know that I'm thoroly ashamed of the way I acted and the stinking, unjust uncalled for things I said.
So long and good luck to you and I hope we'll see you soon and well.
Yours Ernest.

TO GRACE HALL HEMINGWAY, SEPTEMBER 11, 1925

Dear Mother-
. . . It should be a very fine novel. So Far it is called Fiesta but I may change the title. Have been offered a $1000 advance on it by another publisher if I would leave Liveright but of course will stick to my contract.
. . . Bumby is strong and healthy and brown and a great french talker. He talks English with a french accent. Says "I luff Poppa like mad!"
Love to you and to Dad. Love to all the Kids and salutations to distinguished relatives.
Always yours,
Ernie

Hadley is better looking and huskier than ever. She's had her hair cut like a boys as all the chic people now and has several people in love with her including a very nice bull fighter named Nino de la Palma who dedicates bulls to her and gives her the ears. These are carefully saved in my handkerchiefs.

TO HAROLD LOEB, EARLY NOVEMBER 1925

Dear Harold:
. . . Finished the novel . . . So far am calling it The Sun Also Rises. May change the title.

. . . We've been seeing a lot of Pauline Pfeiffer.

THE BEGINNING OF THE END OF A FRIENDSHIP

In his November 8, 1925, letter to Ezra Pound, Hemingway expresses his frustration and anger at Gertrude Stein's reluctance to write a review of *In Our Time*, preferring, as Hemingway reports, to wait until he has his novel. This is one of the first cracks in Stein and Hemingway's friendship. Hemingway is increasingly uncomfortable with the roles of master and student that have initially defined their relationship.

TO EZRA POUND, NOVEMBER 8, 1925

Dear Duce-
. . . Le Grand Gertrude Stein warned me when I presented her with a copy not to expect a review as she thought it would be wiser to wait for my novel. What a lot of safe playing kikes. Why not write a review of one book at a time? She is afraid that I might fall on my nose in a novel and if so how terrible it would have been to have said anything about this book no matter how good it may be. These things help one very much. It is like the litmus paper test for acid mouth.
* . . . Eliot [T. S. Eliot] dosen't know whether I am any good or not. He came over and asked Gertrude if I were serious and worth publishing and Gertrude said it were best to wait and see- that I was just starting and there wasn't any way of knowing yet.*

TO HORACE LIVERIGHT, DECEMBER 7, 1925

Paris, December 7, 1925
Dear Mr. Liveright:-
 I am sending you, with this letter, on the Mauretania tomorrow the Mss. of my new book The
Torrents of Spring. Scott Fitzgerald has read the manuscript and was very excited about it and said he
was going to write you about it.
 . . . The only reason I can conceive that you might not want to publish it would be for fear of
offending Sherwood. I do not think that anybody with any stuff can be hurt by satire. In any event it
should be to your interest to differentiate between Sherwood and myself in the eyes of the public and you
might as well have us both under the same roof and get it coming and going. If you take the book I want
an advance of $500. As that is the smallest guarantee I can have that the book-will be pushed at all.

TO F. SCOTT FITZGERALD, DECEMBER 15, 1925

Dear Scott-
I hope you and Zelda are well again. Did Pauline bring the books? . . . You write about the Murphy's.
They're grand people. Nice people are so damned nice.
 . . . And don't for Christ sake feel bad about missing the war because I didnt see or get anything
worth a damn out as a whole show, not just as touching myself, which is the cheap, romantic view point,
because I was too young. Dos, fortunately, went to the war twice and grew up in between. His first book
was lousy.

TO ARCHIBALD MACLEISH, DECEMBER 20, 1925

Dear Archie-
. . . My mother sent me your review of Dark Laughter from the Atlantic Monthly. Monthly is correct. It
is a damned good review. My mother always sends me everything that shows up Sherwood or when he
gets a divorce or anything because she has read that I am much the same thing only not so good and
she naturally wants me to know how the Master is getting along.

TO F. SCOTT FITZGERALD, DECEMBER 24, 1925

Dear Scott-
. . . God I hope Zelda gets all right at the bains place. Pain's such an awful thing. It's such a rotten shame
for her to be sick. I do think she'll get better down South and you will both be a damned sight better off
on the Riviera than in Paris. You both looked so damned well when you came up last fall and Paris is
poisonous for you.
 . . . Pauline Pfeiffer gets here tomorrow to stay for Xmas and New Years.

On December 12, 1925, while on vacation with Hadley and Bumby in Austria, Ernest Hemingway continues to work on *The Sun Also Rises*. Pauline Pfeiffer will arrive for Christmas and stay until the middle of January.

1925 and 1926 will be critical years for Hemingway both personally and professionally. Some old friends and mentors will be left behind or drift away from the increasingly confident young writer. There will be success and fame, betrayal and regrets.

On December 30 Hemingway's publisher Boni & Liveright rejects *The Torrents of Spring*, which terminates his agreement with them. On January 25 Hemingway leaves Austria for Paris and on February 3 he boards the *Mauretania* in Cherbourg for New York City. From the 9th to the 20th of February, Hemingway goes to the publishing houses of Scribner's, Boni & Liveright and Harcourt. After meeting with Maxwell Perkins at Scribner's he signs a contract for both the *Torrents of Spring* and *The Sun Also Rises*. In a very jubilant mood he travels back to France aboard the *President Roosevelt*. Two of his fellow travelers are Robert Benchley and Dorothy Parker. Back in Paris, Hemingway and Pauline begin their love affair. In late April, early May, while traveling in France with Pauline and her sister Virginia, Hadley finds out about Pauline and Ernest's affair.

The Torrents of Spring is published by Scribner's on May 28, 1926. In June Hemingway revises *The Sun Also Rises* as F. Scott Fitzgerald had advised. He edits out the original opening. Returning to Paris, Hadley and Ernest separate, with Hadley demanding that Ernest and Pauline have a three-month separation before considering a divorce.

On October 22, 1926, *The Sun Also Rises* is published by Scribner's.

Hadley will not hold the lovers to the three-month condition and on November 16 says the divorce can go forward. On December 8 Hadley files for divorce in Paris.

Hemingway writes to Hadley informing her that he is signing over all royalties for *The Sun Also Rises* to her.

TO F. SCOTT FITZGERALD, JANUARY 1, 1926

Dear Scott-
Have just received following cable from Liveright-Rejecting Torrents of Spring Patiently Awaiting Manuscript Sun Also Rises Writing Fully-
* . . . As you know I promised Maxwell Perkins that I would give him the first chance at anything if by any chance I should be released from Liveright.*

TO WILLIAM B. SMITH, JR., AND HAROLD LOEB, FEBRUARY 18, 1926

Gents-

. . . Scribner's advance me $1500 on The Torrents of Spring (satire) and The Sun Also Rises (novel) They will pay 15% royalties on everything. No cut on the movies or dramatics. Have an option on only these two books/Say that they pleasing me is all the option they want. God but they are white people.

TO ERNEST WALSH, APRIL 7, 1926

113 Rue N.D. des Champs
Paris VI
Dear Ernest-

. . . We saw Pauline Pfeiffer the other day-She'd visited with you and said you were well. I wrote her at your address to pay her some money I borrowed going through Paris. She bought me some night gowns for Hadley . . .

TO SHERWOOD ANDERSON, JULY 1, 1926

Dear Sherwood Anderson:

Your letter was fine (this is not the Master talking to his pupil) and what a horse's ass I must become as soon as I sit in front of a typewriter if those are the snooty kind of letters I've written you. But anyhow if I did write that way I won't write that way anymore . . .

Responding to Hemingway's letter of May 21, 1926 (and to his other letters of the "last two or three years"), Anderson had expressed his surprise at Hemingway's "patronizing," saying "You always do speak to me like a master to a pupil. It must be Paris—the literary life. You didn't seem like that when I knew you" (June 1926, JFK Library).

The Letters of Ernest Hemingway 1926–1929, ed. Rena Sanderson, Sandra Spanier and Robert W. Trogdon (Cambridge University Press, 2015).

TO PAULINE PFEIFFER, JULY 24, 1926

PAULINE PFEIFFER
8 RUE PICOT
PARIS

TODAYS STILL PFEIFFER DAY IN VALENCIA
LOVE HADLEY AND ERNEST

TO F. SCOTT FITZGERALD, AFTER SEPTEMBER 8, 1926

69 Rue Froidevaux
Paris 14
Dear Old Fitz-
. . . Hadley and I are still living apart. . . . Our life is all gone to hell which seems to be the one thing you can count on a good life to do. Needless to say Hadley has been grand and everything has been completely my fault in every way. That's the truth, not a polite gesture.

. . . I haven't been drinking, haven't been in a bar, haven't been at the Dingo, Dome or Select. Haven't seen anybody. Not going to see anybody. Trying unusual experiment of a writer writing. . . .

"I am very prejudiced against suicide . . ."

TO ISIDOR SCHNEIDER, SEPTEMBER 30, 1926

Dear Isidor-
. . . The world is so tough and can do so many things to us and break us in so many ways that it seems as though it were cheating when it uses accident or disease . . .

Hadley and I have been having some hell too-but all you can do about hell is last through it. If you can last through it. And you have to. Or at least I always will I guess because I am very prejudiced against suicide because somehow I would not like to even run a chance of having to spend the rest of the time with a lot of the sort of people who commit suicide. Altho of course that doesn't hold true because there are some swell ones. The real reason for not committing suicide is because you always know how swell life gets again after the hell is over. So you have to resolve in advance to last out the time when you don't believe that.

TO T. S. ELIOT, AFTER OCTOBER 16, 1926

Dear Mr. Eliot:-
It is much too late but I would like to apologize to you for an insulting statement I made about you in an article in the Transatlantic Review for September 1924. I was looking at the Bound Volumes of the Transatlantic today and saw the article and it made me feel remorse for being more violent and ignorant than usual even.

TO PAULINE PFEIFFER, NOVEMBER 12, 1926

Dear Pfife-
. . . I know that you did the extra three months because you thought that was what Hadley wanted-and also because at the time you were in such a state that sacrifice seemed like the thing to do. And of course all that Hadley wanted was to delay the divorce-anything to delay the divorce- she didn't want

to just smash us both up-she won't admit it but she knows we're that same person-sometimes she has admitted it-but instead of giving her the delay that is practically the only thing left in the world that she wants we rail-road her toward divorce and smash ourselves both up at the same time . . . As long as I had you I could stand anything and get through anything— and now I haven't got you and you've taken yourself deliberately away and I know you are sick and ill in the head and miserable Pfife and I can't stand it.

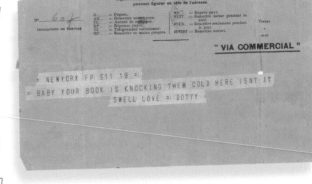

" VIA COMMERCIAL "

= NEWYORK FP 511 19 =
= BABY YOUR BOOK IS KNOCKING THEM COLD HERE ISNT IT
SWELL LOVE = DOTTY =

Last fall I said perfectly calmly and not bluffingly [a]nd during one of the good times that if this wasn't cleared up by Christmas I [w]ould kill myself- because that would mean it wasn't going to clear up- and I've learned about blowing up from you Pfife and I can't stand it- and evidently all I can do is to remove the sin out of your life and avoid Hadley the necessity of divorce . . .

. . . And all I want is you Pfife and oh dear god I want you so. And I'm ashamed of this letter and I hate it. But I had to get the poison out and I've just been stewed in it . . .

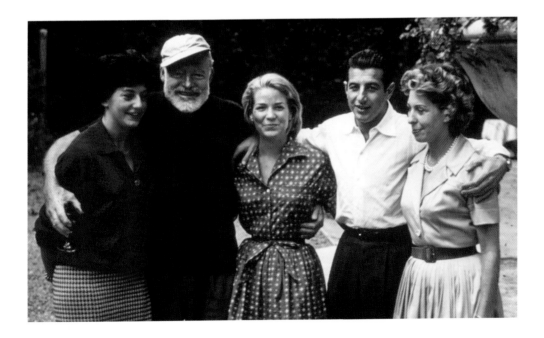

1. TELEGRAM FROM DOROTHY PARKER. COPYRIGHT JFK LIBRARY. 2. FLORENCE MALRAUX, ERNEST HEMINGWAY, CARMEN ORDÓÑEZ, ANTONIO ORDÓÑEZ, NICOLE PARDO. COPYRIGHT JFK LIBRARY.

TO HADLEY RICHARDSON HEMINGWAY, NOVEMBER 18, 1926

My dearest Hadley-

. . . I think your letter like everything that you have ever done is very brave and altogether unselfish and generous.

During the past week I found out, and the horror of it was very great. How Pauline and I without me[a]ning to had constantly exerted a pressure on you to divorce me- a pressure that came from a sort of hurried panic fear that we should lose one another-that naturally you were suspicious of and re-acted against as a basis for two people to marry on. Your reactions have always been right and I have always trusted them and believed in them as well as in your head.

I think that perhaps when Pauline and I realized how cruel we had been to you in that way and that we could not expect to found any basis of happiness on such a continued cruelty-and re-realized that we could go on any length of time that would suit you without each other rather than have you consent to a divorce that you did not feel was inevitable, or desireable,- I think that when you felt that, and I hope you believe it was sincere, it maybe have helped to remove your natural and right re-action against setting two people free to marry each other who did not seem to deserve each other or anything else.-

Now, if you wish to divorce me, I will start at once finding out the details and about lawyers. I will start that at any rate-as you ask in your letter- and write you when I learn. . . . If it is an inevitable step I think we will all feel better and things can start to clear once it is started. That is, please dear Hadley, not me trying to influence you- or speed up my own affairs. It is only that we seem like two boxers who are groggy and floating and staggering around and yet will not put over a knock-out punch: which would terminate the combat and let the process of healing and recovering start.

. . . In any event, no matter what you do, I am writing to Scribners that all royalties from The Sun Also Rises should be paid to you. These will not commence until after 3000 copies have been sold-we spent the advance on that sale together-but from then on will mount rapidly at 30 cents a copy on each book. And from the way Max Perkins writes about the future printings etc. and the way they are advertising it might, if it should go, be a very good sum.

. . . I want you please not to make any objection to this-it is onlt thing that I who have done so many things to hurt you can do to help you-and you must let me do it

There is no question of my suffering from any lack of money as I know that I could borrow money from Scott [Fitzgerald], Archie [MacLeish], or the Murphies-all of whom are wealthy people- or that I could accept money from Pauline whose Uncle Gus seems always wanting to give it to her. I need in the mantime the financial pressure of starting clean-and the income from those books belongs to you by every right- you supported me while they were being written and helped me write them- I would never have written any of them In Our Time, Torrents or The Sun if I had not married you and had your loyal and self-sacrificing and always stimulating and loving-and actual cash support backing.

I would include In Our Time, and Torrents but I believe the one is on the deficit side still and the other not likely to m[a]ke money.

But I am making a will and writing to my agents and my publishers that in case of my death the income from all my books, past and future, is to go to Bumby where you can hold it in trust for him.

. . . With that to count on – it cannot be less than several hundred dollars- you can make the American trip and not worry about money. During your absence I would give Bumby the benefit of whatever benefit a papa is. I would also be on my honor that Pauline would not see Bumby in case she should be here any of that time- so you would not have to worry about that. If it would be a thing you would worry about. Our conversation confused certain phases of your letter. You say the three months absence thing is officially terminated. If it would make any difference to you I am sure Pauline and I would be glad, I am sure, to complete the three months apart from each other. If it makes no difference I imagine she might come back in January or when she wished. Please let me know about this and if you want me to communicate the facts of our letters to Pauline.

I am sorry this is so long and there are doubtless many things I have left out. I'll see a lot of Bumby-and I think the luckiest thing Bumby will ever have is to have you for a mother. And I won't tell you how I admire your straight thinking, your head, your heart and your very lovely hands and I pray God always that he will make up to you the very great hurt that I have done you-who are the best and truest and loveliest person that I have ever known.

Ernest

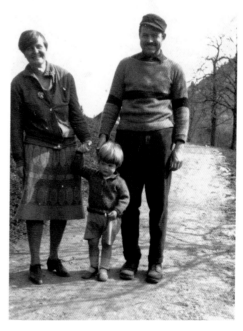

1. ERNEST HEMINGWAY AND HADLEY HEMINGWAY IN SCHRUNS, AUSTRIA. COPYRIGHT UNKNOWN, HEMINGWAY COLLECTION, JOHN F. KENNEDY PRESIDENTIAL LIBRARY AND MUSEUM, BOSTON. 2. HADLEY HEMINGWAY, JOHN "BUMBY" HEMINGWAY AND ERNEST HEMINGWAY IN SCHRUNS, AUSTRIA, 1926. HEMINGWAY COLLECTION, JOHN F. KENNEDY PRESIDENTIAL LIBRARY AND MUSEUM, BOSTON.

TO MAXWELL PERKINS, DECEMBER 21, 1926

Dear Mr. Perkins:

. . . When the royalty check comes due you may send it to Hadley R. Hemingway-Guaranty Trust Co. of N.Y. One Rue des Italiens. Paris.

In 1927, Charles Lindbergh is the first man to fly solo across the Atlantic, Nicola Sacco and Bartolomeo Vanzetti are executed, and Hemingway's *Men Without Women* is published to critical acclaim. Ernest and Hadley divorce.

ON MAY 10, 1927, ERNEST HEMINGWAY MARRIES PAULINE MARIE PFEIFFER.

They will have two sons, Patrick and Gregory. Years after Hemingway's divorces from Pauline and Martha Gellhorn, he will romanticize his first marriage to Hadley in *A Moveable Feast*, blaming, in large part, Pauline for his own infidelity.

. . . It sounds very silly. But to really love two women at the same time, truly love them, is the most destructive and terrible thing that can happen to a man when the unmarried one decides to marry. The wife does not know about it and trusts the husband. They have been through really difficult times and share those times and have loved each other she finally trusts the husband truly and completely. The new one says you cannot really love her if you love your wife too. She does not say that at the start. That comes later when the murder's done. That comes when you lie to everyone all around and all you know is that you truly love two women.

. . . The new and strange girl that now owned half of you, once she had decided to marry, you could not say decided to break up the marriage because that was only a necessary step, a regrettable step, not an end, probably passed over or avoided in thinking, made only one grave mistake. She undervalued the power of remorse. . . . When I saw my wife again standing by the tracks as the train came in by the piled logs at the station, I wished I had died before I ever loved anyone but her.

On November 4, 1940, Ernest and Pauline Hemingway divorce. Four years previously, in December 1936, Hemingway met Martha Gellhorn in Key West at Sloppy Joe's bar. On November 21, 1940, Hemingway and Gellhorn are married.

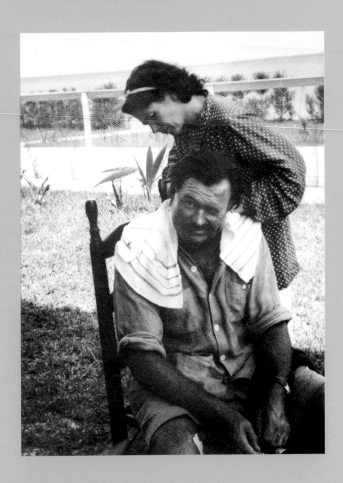

PAULINE HEMINGWAY CUTTING ERNEST HEMINGWAY'S HAIR, KEY WEST, FLORIDA. COPYRIGHT UNKNOWN, HEMINGWAY COLLECTION, JOHN F. KENNEDY PRESIDENTIAL LIBRARY AND MUSEUM, BOSTON.

FINCA VIGIA, SAN FRANCISCO DE PAULA, CUBA

"You can't get away from yourself by moving from one place to another."
—Ernest Hemingway, *The Sun Also Rises*

BUREAU COMMUN
DES Cᵐ DE CHEMINS DE FER
4 - JUIL 1927

BUREAU COMMUN
DES Cᵐ DE CHEMINS DE FER
1 ₄ MARS 1928
ESPAGNOLS
PARIS

CONDICIÓN 9. — Este billete matriz no tendrá validez alguna sin que previamente se haya establecido el canje de cupones por uno o más billetes complementarios en la estación de salida.

Artes Gráficas, S. A.' Sucesores de Henrich y Cª—Barcelona

BILLETE NÚMERO

Valedero para viajar por las líneas de la

Norte
Madrid a Zaragoza y a Alicante
Andaluces
Madrid a Cáceres y Portugal y del
Oeste de España
Sur de España
Caminos de Hierro de Granada
(Baza a Guadix)
Medina del Campo a Zamora y de
Orense a Vigo
Pontevedra a Santiago

1.ª cla

Serie 5

Nombres de las personas

D. Ernest hil

Dª Pauline

Prix Franc 3467

Precio total, comprendid
y confección.............
INCLUIDO EL AUMENTO DE
R. D. de 26 de Diciembr

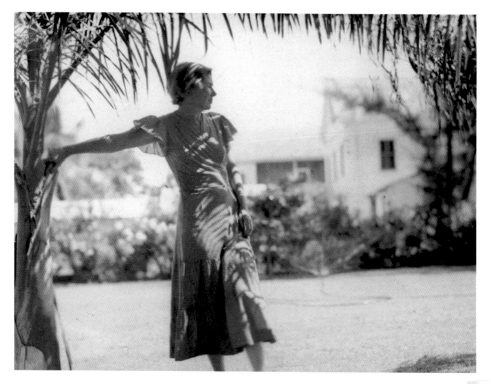

1928

1928 is a year of great promise, with America's future looking bright. Herbert Hoover is elected president. Thirteen million radios are in U.S. homes and twenty-six million cars in use. George Gershwin composes *An American in Paris* and D. H. Lawrence's *Lady Chatterley's Lover* is published. Amelia Earhart flies across the Atlantic as the first female passenger and newlyweds Mr. and Mrs. Ernest Hemingway return to the United States, making their home in Key West, Florida. *The Sun Also Rises* continues to sell well and Hemingway's reputation as a writer of consequence continues to grow. He begins work on *A Farewell to Arms*. Hemingway's second son, Patrick, is born.

1928 is also a year that brings tragedy to the Hemingway family. Hemingway's father, Dr. Clarence Hemingway, suffers from a severe case of diabetes and struggles with bouts of depression. Those conditions, plus his concerns over the family's financial future, finally become too much. On December 6, 1928, Clarence Hemingway commits suicide using his father's Civil War pistol. For years after, Ernest Hemingway blames his mother, Grace, for driving his father to suicide.

TO MAXWELL PERKINS, DECEMBER 6, 1928

NA610 19=PRR DEPOT TRENTON NJ 6 453P
MAXWELL E PERKINS=
CHARLES SCRIBNERS SONS 5 AVE AND 48 ST=
PLEASE WIRE $100 IMMEDIATELY WESTERNUNION NORTH
PHILADELPHIA STATION MY FATHER DEAD MUST GET FIRST
TRAIN CHICAGO:
 =ERNEST HEMINGWAY
PUL, Cable, Western Union destination receipt stamp: 1928 Dec 6 PM 5 19

TO MAXWELL PERKINS, DECEMBER 6, 1928

NB64 6=GO PHILADELPHIA PENN 6 808P
PERKINS, CHAS SCRIBNERS=
5 AVE AND 48 ST=
DISREGARD WIRE GOT MONEY FROM SCOTT=
HEMINGWAY

TO PAULINE PFEIFFER HEMINGWAY, CIRCA MARCH 28, 1928

Dear Miss Pfeiffer or should may I call you "Mrs. Hemingway?"—
We are five or ten days out on our trip or tripe to Cuba which promises to extend indefinitely into the future. I have often wondered what I should do with the rest of my life and now I know-- I shall try and reach Cuba . . .
Anyway I love you and if you forgive this bad letter I will write a good one sometime. Only lets hurry and get to Havana and to Key West and then settle down and not get on Royal Male Steam Packets any more.
The end is weak but so is Papa.

TO MADELAINE HEMINGWAY, DECEMBER 7, 1928

MADELAINE HEMINGWAY
1100 South Street
Key West
Florida
Mother Says Disregard First Letter CHEERFUL ONE SENT TONIGHT EVERYONE FINE REALLY ALL SEND LOVE Duke too FUNERAL TOMORROW planning LEAVE Saturday night LOVE ERNIE

TO MAXWELL PERKINS, DECEMBER 9, 1928

Corinth Miss
Sunday
Dear Mr. Perkins-
. . . What makes me feel the worst is my father is the one I cared about-. . .

TO F. SCOTT FITZGERALD, DECEMBER 9, 1928

Dear Scott- You were damned good and also bloody effective to get me
That money-
 I had like a fool only 35-40 bucks with me after Xmas shopping . . .
 My Father shot himself as I suppose you may have read in the papers.
 Will send you the $100 as soon as I reach Key West- or have Max Perkins send it.
 Thanks again like hell for your werry admirable performance as we say in the automotive game.
 I was fond as hell of my father and feel too punk-also sick etc.-to write
A letter but wanted to thank you-
 Best to Zelda and Scotty-
yrs always
Ernest

TO MARY PFEIFFER, DECEMBER 13, 1928

Dear Mother Pfeiffer-
What you want to hear about no doubt is Pat- who is very fine and happy and seems to have a lot of
color this morning . . . The truth is that I can't write a letter-I was planning to write you and Mr. Pfeiffer
on the way back from N.Y. but instead had the trip to Chicago etc/. I was awfully fond of my father –and
still feel badly about it all and not able to get it out of my mind and my book into my mind) . . .

TO GRACE HALL HEMINGWAY, LEICESTER HEMINGWAY AND CAROL HEMINGWAY, DECEMBER 19, 1928

Dear Mother Les and Deef)-
Merry Christmas from the old Steen and all his family. We are thinking of you and hope you are all in
splendid shape and going well.
 If Marce and Sterling [Sanford] are there wish them Merry Christmas from us too. I haven't
sent them any presents because there is nothing here to send and I don't want to insult them with a
check but know you won't mind because I never was a shopper anyway. Have had the grippe and a
filthy throat since leaving Chicago but worked every day and by the time you get this will doubtless be
healthy. Sun [Sunny] is O.K. now too. Pat, Bumby and Pauline flourishing.
 Best love and again wish you as merry a Christmas as I know Dad would have wanted you and us
all to have.
Best love to everybody,
Ernie

1929

On October 24, Wall Street crashes. The year will see the start of a world depression and, in stark contrast, the creation of the Foundation of the Museum of Modern Art in New York. William Faulkner's *The Sound and the Fury* is released along with Thomas Wolfe's *Look Homeward, Angel*, Erich Remarque's *All Quiet on the Western Front* and Ernest Hemingway's *A Farewell to Arms*. The Rev. Martin Luther King, Jr., is born.

TO JOHN DOS PASSOS, JANUARY 4, 1929

Drama Hell you poor bastard!
. . . We are much poorer than when you were here before [b]ut have an entire house and are living exclusively on fish and game. It is the crawfish, stone crab and fresh shrimp season also snipe. Shot 12 yesterday! 20 day before yesterday and fifteen two days before that. Every other day we shoot snipe for the day after. My old man shot himself on the other hand (not in the other hand. In the head) as you may have read in the paper. I have my bloody book all gone over in pencil and one third typed. Should be finished by the end of Jan . . .

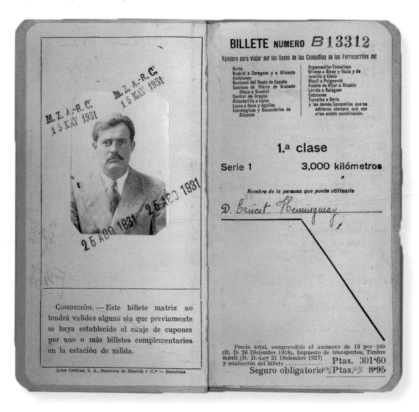

Dear Mr. Perkins-
Have 20 chapters done and typed [EH insertion: must be around 30,000 words]- have been over the
whole thing once in pencil and re-read it all. Going good but have been working 6-10 hours every day
and will be glad to lay off and take a trip when you come down- . . .

1930

In spite of the world being in the grips of a depression, construction begins on the Empire State Building in New York City on March 17. The Jacob Schick company patents its first electric razor. A world away, Mahatma Gandhi begins his civil disobedience campaign against the British in India and France begins construction of the Maginot Line. Dashiell Hammett's *The Maltese Falcon* is published by Alfred A. Knopf. John Dos Passos's *The 42nd Parallel* is published, as is Sigmund Freud's *Civilization and Its Discontents*. Because of wide-scale unemployment, the U.S. State Department restricts the entry of foreign laborers to the United States. Ernest Hemingway travels to Spain and begins work on *Death in the Afternoon.*

1931

Britain and Japan leave the Gold Standard. President Herbert Hoover signs legislation that makes "The Star-Spangled Banner" the national anthem and Adolf Hitler meets President Paul von Hindenburg for the first time. Al Capone is convicted of tax evasion and sentenced to eleven years in prison. Ernest Hemingway finishes *Death in the Afternoon,* and on December 28, a new law in Italy requires that professors and teachers must take an oath of allegiance to Mussolini and his fascist state.

1932

Preproduction begins on what will be Fred Astaire and Ginger Rogers's first film together, *Flying Down to Rio.* Franklin D. Roosevelt is elected president, Charles Lindbergh's son is kidnapped and there is revolution in Spain. On March 7, in Dearborn, Michigan, police open fire on unemployed autoworkers as they march in protest outside the Ford factory, killing four.

Veterans peacefully protesting for the bonuses they were promised from World War I are camped near the capital in Washington, D.C. The attorney general of the United States orders police to evacuate the protesters. The veterans do not comply and the police open fire. Two people are killed. The Kingdom of Hejaz and Nejd becomes the Kingdom of Saudi Arabia. Adolf Hitler obtains German citizenship through naturalization and in the German Reichstag the Nazis are the largest party. Ernest Hemingway's *Death in the Afternoon* is published, his

third son, Gregory, is born and he begins to be criticized by leftist writers for avoiding major political themes in his writing.

1933

Hindenburg appoints Adolf Hitler Chancellor of Germany on January 30, FDR's "New Deal" is begun and the 20th Amendment to the Constitution passes, establishing that in the event of the president not being able to carry out his duties the vice president would assume the presidency. On March 22, Dachau becomes the first concentration camp in Germany and on March 25 Hitler seizes power. The Falange Española is founded in Spain, and Japan and Germany leave the League of Nations.

Jews and non-Aryans are forbidden from working in civil service jobs and from practicing law in Germany.

Ernest Hemingway visits Africa for the first time thanks to Pauline Pfeiffer's uncle Gus, who pays for the couple's travel and safari. Hemingway's *Winner Take Nothing* is published and the 21st Amendment to the Constitution is ratified, ending Prohibition.

TO JOSEPHINE MERCK, JUNE 17, 1933, FROM HOTEL AMBOS MUNDOS, HAVANA

Dearest Josie:--

It's really lovely, Josie. Cool and fine--when they were having all that heat wave it was wonderful cool weather here. We go out in the boat and there are lots of these Marlin swordfish-- Jump better than Old Faithful. I've caught 44-- Caught 7 in one day (world's record)

Then there is the finest beach you ever saw to swim--sand that wrinkles on the bottom--and a beach miles long without a house or a person-- (You can swim at a new beach every day--we troll right along by the coast--)

We go in in the boat and anchor and swim ashore-- Troll down there and back-- You would like that kind of fishing-- It is as exciting as war nearly when they strike--

. . . We'd have a fine time. We love you very much and hate to go a summer without seeing you. Pauline is fine and looks beautiful.

I've been working hard lately-- Have 2 new long stories and a fine title for the book.

You can come on a Ward Line boat "Moro castle" or "Oriente" or on one of those new Grace Liners--plenty of boats--good trip and not long--good weather now--

We get a room at this pub which is very clean and fresh and on the water front near where we have the boat-- This is really a fine town-- We take trips in the boat along the coast-- Have swell fun-- Damned strange places--wild alligators and all sorts of birds and fish you've ever seen--

Damn it would be fine to see you-- Pauline usually comes over for 10 days and then stays in KW a week-- She is finishing building a workhouse for me--

You can write us at this address-- This is really a nice hotel-- Can get a swell room for 2.00

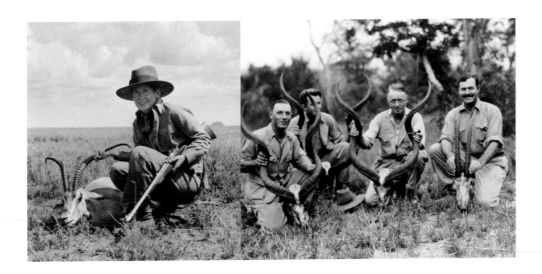

1934

Thousands of Americans gather in Queens, New York, for a pro-Nazi rally on April 8, 1934. F. Scott Fitzgerald's *Tender Is the Night* is released, as are Henry Miller's *Tropic of Cancer* and Evelyn Waugh's *A Handful of Dust*. The U.S. Congress passes the Gold Reserve Act, allowing the president to regulate the U.S. dollar. President Roosevelt nationalizes silver and establishes the Securities Exchange Commission, with Joseph Kennedy becoming its first chairman. Henry Ford brings in the $5.00 minimum wage for his workers, and the states of Oklahoma, Texas, Kansas, Colorado and Arkansas persevere while dust storms blow away their topsoil. The Dust Bowl has begun. One of the first organized strikes in U.S. history begins in San Francisco on July 16 with over eleven thousand members of the International Longshoreman's Association. Ernest Hemingway buys a large fishing boat from Wheeler Shipyard in Brooklyn, New York, which he will use for deep-sea fishing. He names it *Pilar*, his nickname for his wife, Pauline. Alcatraz prison opens in San Francisco.

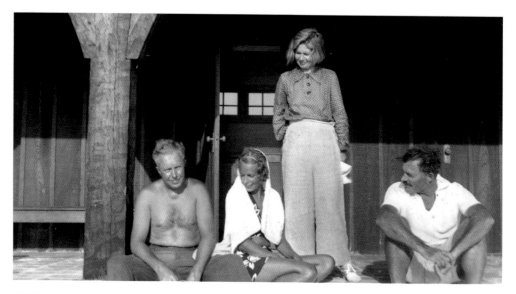

1935

The legendary Babe Ruth retires from baseball with a career batting average of .342, 714 home runs and 5,793 total bases. Claudette Colbert and Clark Gable win the Academy Awards for best actress and actor for their performances in Frank Capra's *It Happened One Night*. Italy invades Abyssinia and Will Rogers and aviator Wiley Post are killed when Post's plane crashes near Point Barrow, Alaska. Ernest Hemingway's *Green Hills of Africa* is published.

1936

Margaret Mitchell's book *Gone With the Wind* is published and Bing Crosby's song "Pennies from Heaven" is a hit. Eugene O'Neill wins the Nobel Prize for Literature and General Franco, with the support of Germany and Italy, leads a revolt of the Falange against the elected government of Spain. The Spanish Civil War has begun. Hemingway donates thousands of dollars to Republicans in Spain and Britain's King Edward VIII abdicates. Ernest Hemingway meets Martha Gellhorn.

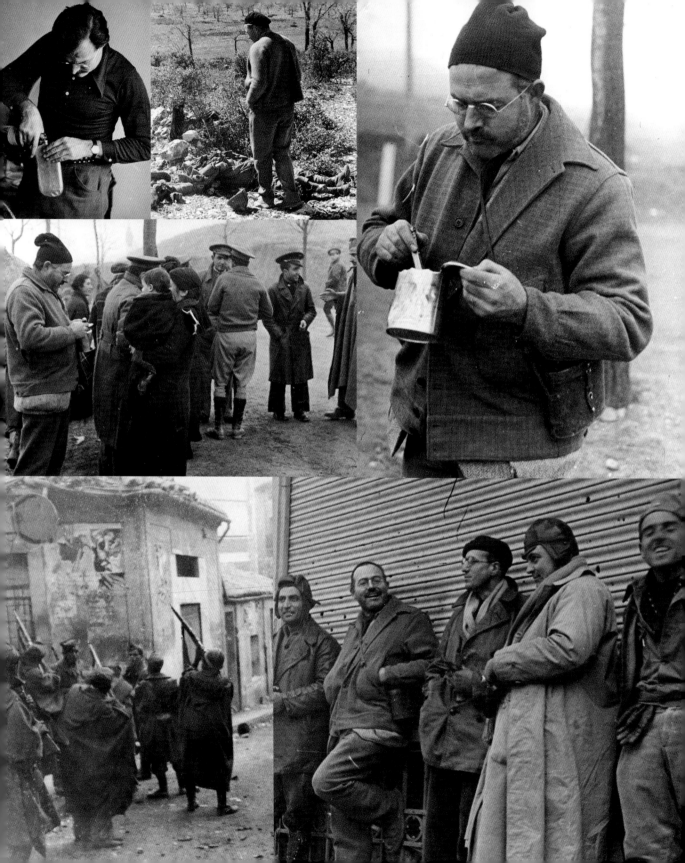

In the following letter, Ernest Hemingway writes to John Dos Passos from Montana while working on *To Have and Have Not* (1937), expressing his interest in the political situation there and his knowledge of Spanish history.

TO JOHN DOS PASSOS, SEPTEMBER 22, [1936]

Dear Dos:

you can imagine how hated to miss the Spanish thing— But think it will go on for a long time— We were on way west when it started and looked like a military revolt that would be over before you could get over there— Am going over to see who and what's left as soon as finish this. There are so many people arrived that the fascists cant hold it even if they take Madrid. I think it will be something like the Carlist War with Navarre definitely split away from the rest of Spain—

. . . Well we've missed the best thing for our lousy trade there ever was and the thing best equipped to handle. The Spaniards certainly fight in Spain—not to mention the Moors— I hope to Christ they save the pictures though— To hell with the architecture--anything looks better after shelled. That's just what the Escorial needs—

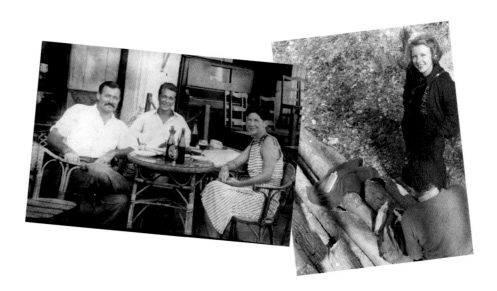

1937

Ernest Hemingway, hoping to lessen his leftist critics, publishes *To Have and Have Not*. The book's reviews are mixed. He travels to Spain as a correspondent and works on the pro-Republican film *The Spanish Earth*. Martha Gellhorn is with him posting her own stories of the conflict. Because of her friendship with Franklin and Eleanor Roosevelt, the film premieres at the White House. Japan invades China, Joe Louis is crowned heavyweight boxing champion of the world and Amelia Earhart and her navigator, Fred Noonan, are lost on their Pacific flight. John Steinbeck's *Of Mice and Men* is released.

1938

Clark Gable and Spencer Tracy star in *The Test Pilot* and Ernest Hemingway begins an affair with Martha Gellhorn. His play *The Fifth Column* is a commercial failure and he returns to Key West and his wife, Pauline. The reunion between man and wife does not go well and shortly after he returns to Spain. After Spain, Hemingway goes to Cuba. He begins work on what will become *For Whom the Bell Tolls*.

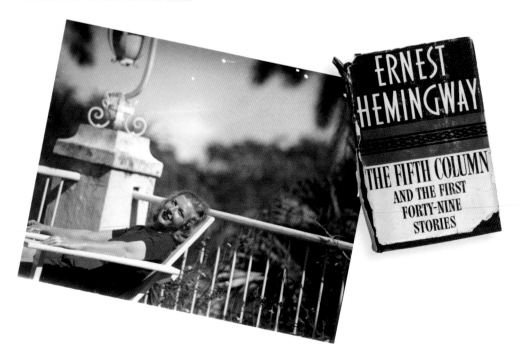

1. MARTHA GELLHORN RECLINES IN A LOUNGE CHAIR AT THE FINCA VIGÍA, CUBA, MARCH 1940. HEMINGWAY COLLECTION, JOHN F. KENNEDY PRESIDENTIAL LIBRARY AND MUSEUM, BOSTON. 2. FRONT COVER OF ERNEST HEMINGWAY'S *THE FIFTH COLUMN AND THE FIRST FORTY-NINE STORIES*. REPRINTED WITH PERMISSION OF SCRIBNER, A DIVISION OF SIMON & SCHUSTER, INC. COPYRIGHT © SCRIBNER. ALL RIGHTS RESERVED. HEMINGWAY COLLECTION, JOHN F. KENNEDY PRESIDENTIAL LIBRARY AND MUSEUM, BOSTON.

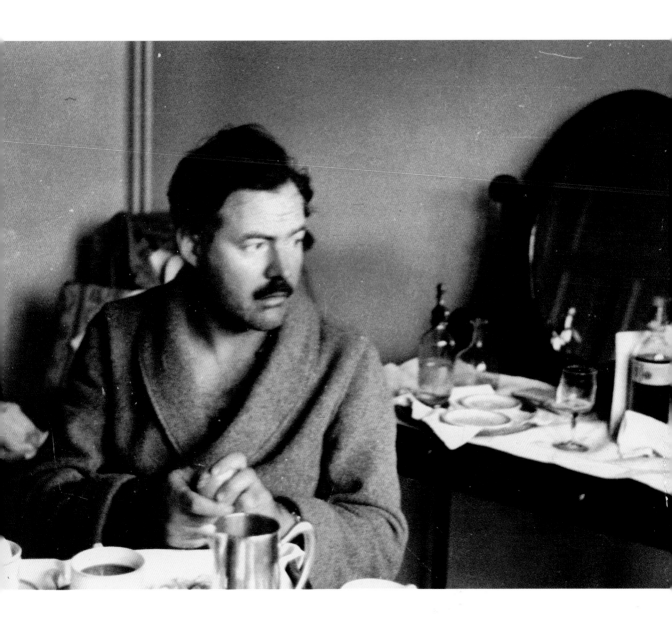

ERNEST HEMINGWAY WEARING A ROBE IN A HOTEL ROOM DURING THE SPANISH CIVIL WAR. COPYRIGHT JFK LIBRARY.

Dear Wilson;

You were the first critic to take any interest in my writing and I have always been very grateful and have always looked forward to reading anything you write about what I publish.

I respect your judgement of my work although I cannot, of course, always agree with it. But I certainly would not argue about it.

After all it is for me to write and you to criticize and not for me to write, you to criticize and then me to defend.

But just to keep the record straight I think you should know that the selected news dispatches published by Fact were published without my consent or approval; that they were taken from cable dispatches to a newspaper syndicate and that I had no opportunity to even put them into the form in which they were originally written. I was paid to write what are called "eye witness" accounts of fighting in a civil war (it turned into a foreign invasion) and what it called, or was asked for as "colour stuff." Most of such stuff is faked. Mine was not. It was straight reporting and the personal angle was what had been asked for by the editors.

If you are being paid to be shot at and write about it you are supposed to mention the shooting. I refused to allow my dispatches to be reprinted but Fact did it behind my back and without my knowledge. I am not ashamed of the dispatches. All are true. But I do not go in for re-printing journalism.

The odd thing, and what I thought might interest you, was that the story of the old man at the pontoon bridge at Amposta was written and sent out by cable the same night we lost the Amposta bridge-head. The differences was that it was for a magazine so I could write a story about that old man and not a news dispatch.

I know that all of you who took no part in the defence of the Spanish republic must discredit those who did take a part and I understand human beings enough to appreciate your attitude and the necessity for it. The suppression of the P.O.U.M., the poor old Poum, was a god-send to all the cowards as a pretext for takeing no part in the fight against Fascism in Spain and I hope to live long enough to see John Dos Passos, James Farrell, Max Eastman, and yourself rightly acclaimed as the true heroes of the Spanish war and Lister, el Campesino, Modesto, Duran and all our dead put properly in their places as stooges of Stalin. And I will tell my children I knew all those great revolutionists well and when they say, "Papa did you really know Edmund Wilson?"

. . . "What did he do Papa?"

"He stayed in New York and attacked everybody who went to Spain as a tool of Stalin."

"Wasn't he smart," said the children admiringly.

1939

The first commercial transatlantic flights begin and Poland is invaded by Germany. After Barcelona is captured by the Nationalists and Madrid surrenders to Franco's forces the Spanish Civil War ends. War is declared on Germany by Britain and France. Clark Gable and Vivien Leigh star in the film adaptation of *Gone With the Wind* and John Steinbeck's *The Grapes of Wrath* is published.

TO IVAN KASHKIN, MARCH 23, 1939

Dear Kashkeen:

[. . .]

We know war is bad. Yet sometimes it is necessary to fight. But still war is bad and any man who says it is not is a liar. But it is very complicated and difficult to write about truly. For instance to take it on a simply personal basis—in the war in Italy when I was a boy I had much fear. In Spain I had no fear after a couple of weeks and was very happy. Yet for me to not understand fear in others or deny its existence would be bad writing. It is just that now I understand the whole thing better. The only thing about a war, once it has started, is to win it—and that is what we did not do. The hell with war for a while. I want to write.

That piece you translated about the American dead was very hard for me to write because I had to find something I could honestly say about the dead. There is not much to say about the dead except that they are dead. I would like to be able to write understandingly about both deserters and heroes, cowards and brave men, traitors and men who are not capable of being traitors. We learned a lot about all such people.

Well it is all over now but the people like these did nothing about defending the Spanish Republic now feel a great need to attack us who tried to do something in order to make us look foolish and justify themselves in their selfishness and cowardice. And we having fought as well as possible, and without selfishness, and lost, they now say how stupid it was ever to have fought at all.

1. FRONT COVER OF ERNEST HEMINGWAY'S *FOR WHOM THE BELL TOLLS*. REPRINTED WITH PERMISSION OF SCRIBNER, A DIVISION OF SIMON & SCHUSTER, INC. COPYRIGHT © SCRIBNER. ALL RIGHTS RESERVED. HEMINGWAY COLLECTION, JOHN F. KENNEDY PRESIDENTIAL LIBRARY AND MUSEUM, BOSTON . 2. FRONT COVER OF ERNEST HEMINGWAY'S *THE SPANISH EARTH* (J. B. SAVAGE COMPANY, CLEVELAND, 1938. LIMITED FIRST EDITION, WITH ERNEST HEMINGWAY'S PENCILED CORRECTIONS). HEMINGWAY COLLECTION, JOHN F. KENNEDY PRESIDENTIAL LIBRARY AND MUSEUM, BOSTON.

1940

Two weeks after his divorce from Pauline, Ernest Hemingway marries Martha Gellhorn. Penicillin first starts being used to treat patients and the Battle of Britain has begun. Leon Trotsky is assassinated in Mexico and Hemingway's *For Whom the Bell Tolls* is released to excellent reviews that once again herald him as the writer of his generation. In the following letter is Ernest Hemingway's reaction to Martha Gellhorn's hesitancy about marriage. At the time, he is finishing reviewing proofs for *For Whom the Bell Tolls*.

TO MARTHA GELLHORN, LATE AUGUST 1940

Dear Marty;
There is only one imprtant thing you have to know
aside from the fact that I love you truly, love you
always and never love and never will love anyone else
and look forward to haveing as fine and gay and useful
a life with you as anyone can have once this battle I
have been in is over (and it is over the day I get them
the final proofs)

 . . . There's only one thing I would like to ask
you. If you have decided that you don't want to marry
me (and I would be the first one to congratulate you
on such a decision even though I think I could make
you a good sound husband and also happy and also
show you strange countries and help you truly) will
you please tell me now before I start out across that
gulf stream where too much time to think, also K.W.
with too much time to think alone under un-jolly
circumstance and 3,000 miles of driving.

Mrs. George Gellhorn
has the honour of
announcing the marriage of her daughter
Martha
to
Mr. Ernest Hemingway
Thursday, the twenty-first of November
One thousand, nine hundred and forty
Cheyenne, Wyoming

 Because if you are going to decide at the last minute that you do not want to marry me I would
like to halt the divorce and make Pauline, who says she wants no divorce but a settlement, accept a
decent settlement instead of giveing her all of the world with a fence around it which I am cockeyed
delighted to do if it is to marry you. And I mean cockeyed delighted. And I mean I would fence the moon
and thrw it in too.

1941

Charles Lindbergh appears before Congress. He urges the United States to sign a neutrality pact with Adolf Hitler. The Empire of Japan attacks the U.S. Fleet at Pearl Harbor. Hitler invades Russia and on December 11 the United States declares war on Japan. F. Scott Fitzgerald's book *The Last Tycoon* is released and Irving Berlin's song "White Christmas" is first sung by Bing Crosby.

Hemingway, at Martha Gellhorn's insistence, travels east to cover the Sino-Japanese War. Hemingway begins refitting work on his boat *Pilar* for the purpose of hunting German submarines off the coast of Cuba.

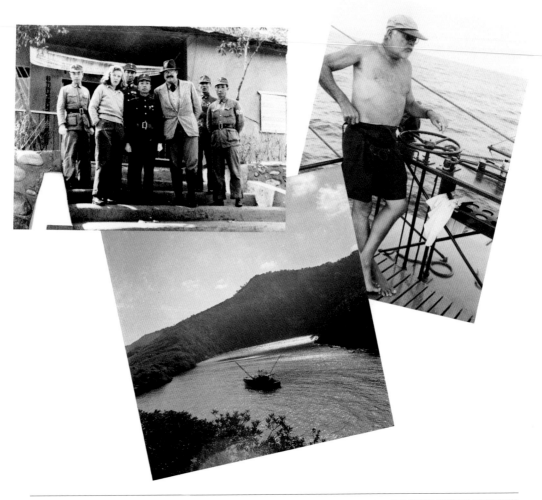

1. MARTHA GELLHORN AND ERNEST HEMINGWAY POSED WITH SEVERAL UNIDENTIFIED PUBLIC INFORMATION OFFICERS DURING THE SINO-JAPANESE WAR. COPYRIGHT UNKNOWN, HEMINGWAY COLLECTION, JOHN F. KENNEDY PRESIDENTIAL LIBRARY AND MUSEUM, BOSTON. 2. ERNEST HEMINGWAY ABOARD THE *PILAR*. HEMINGWAY COLLECTION, JOHN F. KENNEDY PRESIDENTIAL LIBRARY AND MUSEUM, BOSTON. 3. ERNEST HEMINGWAY'S BOAT, THE *PILAR*, UNDER WAY IN CUBA. HEMINGWAY COLLECTION, JOHN F. KENNEDY PRESIDENTIAL LIBRARY AND MUSEUM, BOSTON.

1944

Franklin Roosevelt is elected for an unprecedented fourth term as president of the United States. Already gravely ill, he will not live out his term. The Allies land in Normandy and the Germans retreat. Hemingway travels to Europe as a war reporter. He is with General Buck Lanham at the Battle of Hürtgen Forest. While in Paris he meets Simone de Beauvoir, George Orwell, Pablo Picasso and Jean-Paul Sartre. He also meets Mary Welsh, an American journalist, whom he falls in love with. Hemingway is reported dead by the international press after a car crash in London. This will be one of two times in the author's lifetime that his death will be prematurely reported.

TO PATRICK HEMINGWAY, SEPTEMBER 15, 1944

Dearest Mousie:

It has been about 2 months once Papa came back to France after landing on D Day on Omaha beach. Suppose you saw that piece in Colliers. After that flew with R.A.F. as I wrote you and then came over to France and have been with an Infantry Division ever since except for the time that commanded a French Maquis outfit (while temporarily detached from being a correspondent) that was the best time of all but cant write you about it but will have to tell you. Was under same service Bumby is in now. It is lovely story and we need never have any long dull winter evenings until you all get sick of hearing it. We entered Paris with outfit liberated The Travellers Club, The Ritz etc. and had wonderful time. I had to write a couple of pieces and try to get them passed and then rejoined Division. We went way to the North and then East and the Division has done wonderful job and have been very happy to be with them. We have had some tough times and some wonderful times.

Havent heard from Marty since letter dated in June. Saw all her friends in Paris and she could just as well have been there and through all that wonderful advance and fight if she had not been such a Prima-Donna that she would not wait one week. As it is she may have made the Southern Landing in which event she will have OK story. But I am sick of her Prima-Donna-ism. When head was all smashed and terrible headaches etc. she would not do anything for a man that we would do for a dog. I made a very great mistake on her--or else she changed very much--I think probably both--But mostly the latter. I hate to lose anyone who can look so lovely and who we taught to shoot and write so well. But have torn up my tickets on her and would be glad to never see her again.

[. . .]

When I was in such bloody awful shape in London--have to sleep flat on back with tins on each side because head would go if it turned sideways--Capa's girl Pinkie was awfully good to me and so was another fine girl named Mary Welsh. I saw her again in Paris and we had fine time. Think you would like. Have nicknamed Papa's Pocket Rubens. If gets any thinner will promote to Pocket Tintoretto. You will have to go to Metropolitan Museum to get the references. Very fine girl. Looked after me in worst time ever had.

Mouse, my boy, if we last through next 2 weeks we will have a wonderful life.

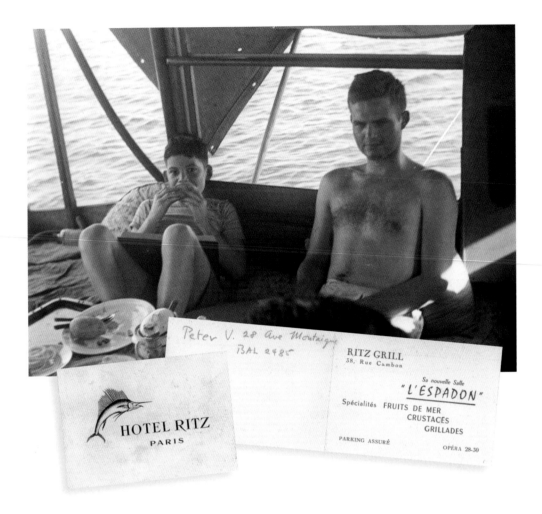

1945

On April 12, Franklin Roosevelt dies. Harry Truman becomes president. Adolf Hitler commits suicide, the United States drops the atomic bomb on Hiroshima and Franco's fascist Spain is refused admission to the newly formed United Nations. George Orwell's *Animal Farm* is published and Hemingway divorces Martha Gellhorn and returns to the home they shared in Cuba. Mary Welsh will join him there.

1. GREGORY "GIGI" HEMINGWAY, EATING, AND JACK "BUMBY" HEMINGWAY SITTING ON THE *PILAR* NEAR PARAISO (CAYO MEDANO DE CASIGUAS, CUBA). COPYRIGHT UNKNOWN, JFK LIBRARY. 2. COPYRIGHT UNKNOWN, JFK LIBRARY.

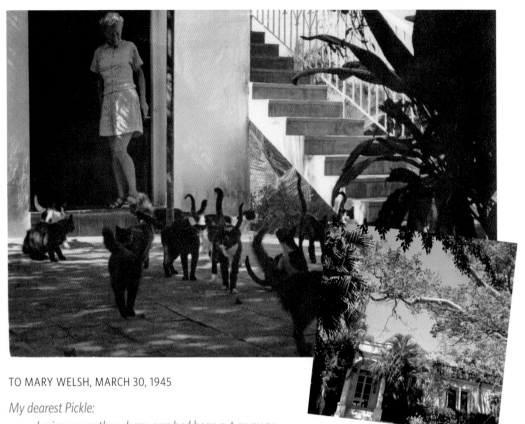

TO MARY WELSH, MARCH 30, 1945

My dearest Pickle:

I miss you as though my arm had been cut away or my heart had been taken out. For a while it was bearable because I knew you were comeing and I had two lovely letters - one just after I had left and a wonderful one when you were back from the front. I know will get more and will try not to waste the time and will get in good shape. But Pickle living without you is like trying to hold your breath under water. It will be so wonderful to see you again. Hope it doesnt hit you as badly as it does me.

[. . .]

You have to be terribly careful about the sun. I burned badly in just an hour at the pool. Will take very good care of you about that. Now am getting brown and thin and hard.

On the practical side have re-wired all of house etc. where hurricane damaged it. Repaired Capeheart so it plays beautifully. Bought a vast lot of new records that think you will like. Am converting boat to make it comfortable (hope) to live on (instead of like mosque cockpit). Have had vet in to try to salvage poor starved and deficiency diseased cotsies. (That's a sad chapter)

[. . .]

1. MARY WITH CATS AT THE FINCA VIGÍA, ERNEST HEMINGWAY'S HOUSE IN CUBA. A. E. HOTCHNER, "PAPA HEMINGWAY." COPYRIGHT JFK LIBRARY.
2. ENTRANCE DOOR TO THE FINCA VIGÍA. HEMINGWAY COLLECTION, JOHN F. KENNEDY PRESIDENTIAL LIBRARY AND MUSEUM, BOSTON.

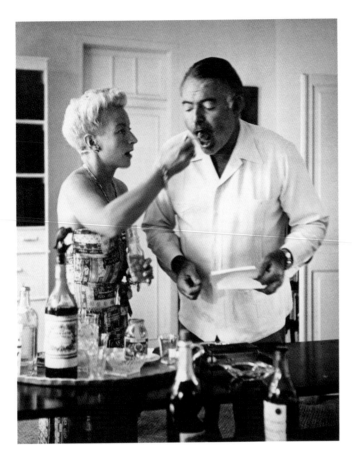

Started to study JAI-ALAI (Basque ball game) form. Been twice, won twice. $60 and $30 - bet. (actually only netted $48 and $27 as gave odds. But we havent lost a nickle gambling this year. Jai Alai (pelota) is as really beautiful and exciting as ever. You will love it. Practically only thing I've come back to that has lost nothing of its kick. A certain something has been removed from the ocean - But it is still a lovely place. Will be completely so when you are here.

[. . .]

Today is Good Friday and Paxche wanted to give a return home banquet for Mousie and Gigi and me at the shooting club but on acct. of the day lots of people were shocked and afraid. So Paxche and all the non-good fearing element are giving a lunch today at the restaurant that over-hangs the sea at Cojimar. The weather is so beautiful you cannot believe it. I wish you were going to be there. In a Spanish country people wont even go to the café on Good Friday. So you see what a step forward out of darkness this lunch is.

[. . .]

Pickle. Must stop. But I love you as always. Always will love you and love you a little more today than ever before.

Mountai

1946

A new year and a new wife. Ernest Hemingway marries Mary Welsh.

1947

On June 17, 1947, Maxwell Perkins dies from pneumonia in Stamford, Connecticut. The news of Perkins's death greatly upsets Hemingway. Perkins, who was told about the young writer by F. Scott Fitzgerald, was instrumental in publishing Hemingway's early work when many at Scribner's Sons were opposed because of what were seen as off-color words and subjects. Through perseverance Perkins won over the objections. *The Sun Also Rises* became a success and even today is one of Hemingway's bestselling titles. Perkins's loss is felt keenly by Hemingway because he knows how pivotal his role had been. Rumors begin to circulate that maybe Hemingway's best work has already been written.

TO CHARLES SCRIBNER, NEW YORK

LA FINCA VIGÍA, CUBA, JUNE 28, 1947

Dear Charlie:

Don't worry about me kid. You have troubles enough without that. I didn't write you after I cabled because what the hell can you say. We don't need to talk wet about Max to each other. The bad was for him to die. I hadn't figured on him dying; I'd just thought he might get so completely damn deaf we'd lose him that way. Anyway for a long time I had been trying to be less of a nuisance to him and have all the fun with him possible. We had a hell of a good time this last time in New York and wasn't it lucky it was that way instead of a lot of problems and arguments. Anyway he doesn't have to worry about Tom Wolfe's chickenshit estate anymore, or handle Louise's business, nor keep those women writers from buildings nests in his hat. Max had a lot of fun, anyway I know we had a lot of fun together, but useing up all his resistance that way by not takeing some lay offs to build up is a good lesson to us and don't you get to overworking now, at least until young Charlie gets to know the business for quite a long time because I want to be able to see your alcohol ravaged face when I come in the office for at least the next twenty two years to help me feel someone in N.Y. has a worse hangover than I have. . . . If it would do any good you might let it be known that while Max was my best and oldest friend at Scribners and a great, great editor he never cut a paragraph of my stuff nor asked me to change one. One of my best and most loyal friends and wisest councillors in life as well as in writing is dead. But Charles Scribners Sons are my publishers and I intend to publish with them for the rest of my life.

. . . So long Charlie. Take care of yourself.

Best always

Ernest

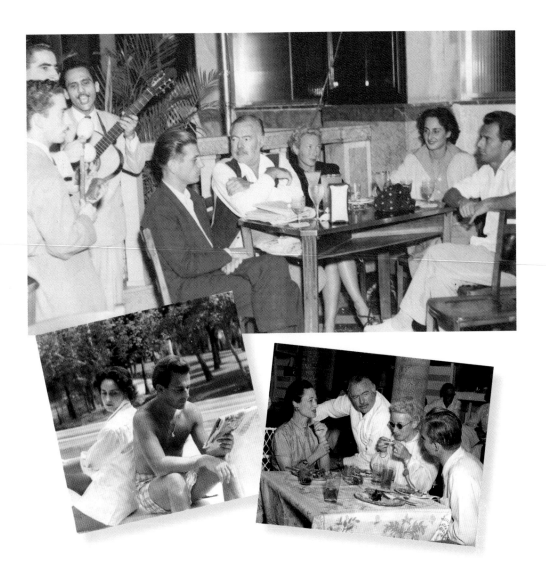

Have you heard anything from Martha? I haven't heard from her since Christmas. Have a new house-maid named Martha and certainly is a pleasure to give her orders. Marty was a lovely girl though. I wish she hadn't been quite so ambitious and war crazy. Think it must be sort of lonesome for her without a war.

1. (LEFT TO RIGHT) UNIDENTIFIED MAN, ERNEST HEMINGWAY, MARY HEMINGWAY, ADRIANA IVANCICH AND GIANFRANCO IVANCICH SITTING AT A TABLE. A BAND PLAYS NEARBY. LA FLORIDITA, HAVANA, CUBA. COPYRIGHT UNKNOWN, JFK LIBRARY. 2. ADRIANA IVANCICH AND GIANFRANCO IVANCICH POOLSIDE AT THE FINCA VIGÍA, CUBA. COPYRIGHT MANZANA DE GOMEZ-TEL.A-6309.

1948 AND 1949

Increasingly Ernest Hemingway wants to enjoy his life after the horrors of war, his marital breakup and, in spite of being married, his continued pining for Martha Gellhorn. The world is shifting and changing in dramatic ways. Lines are being drawn and actions by the Soviet Union and the United States begin to expose the troubles to come. In 1948 Ernest and Mary Hemingway are touring Italy. It is on that trip that he first meets Adriana Ivancich. From their first meeting Hemingway is attracted to the young woman who is thirty years younger. He will put his sexual desires into words and immortalize her as the nineteen-year-old countess Renata in *Across the River and into the Trees*. The Soviet blockade

of West Berlin begins. In 1949 the North Atlantic Treaty is signed and George Orwell's *1984* is published, as is Simone de Beauvoir's *The Second Sex*.

The Berlin Blockade is lifted and in the People's Republic of China, Mao Tse-tung is chosen as the leader of the Chinese Communist Party. Arthur Miller's play *Death of a Salesman* is performed.

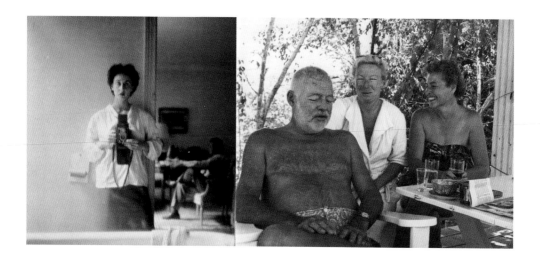

1. ADRIANA IVANCICH HOLDING A CAMERA. COPYRIGHT UNKNOWN, HEMINGWAY COLLECTION, JOHN F. KENNEDY PRESIDENTIAL LIBRARY AND MUSEUM, BOSTON.
2. ERNEST AND MARY HEMINGWAY WITH URSULA (HEMINGWAY) JEPSON AT THE FINCA VIGÍA IN CUBA, EARLY 1950S. PHOTOGRAPHER UNKNOWN, JOHN F. KENNEDY PRESIDENTIAL LIBRARY AND MUSEUM, BOSTON.

My dearest Marlene,
 . . . How are you, daughter? And how is everything going?
I am very jealous at you being a grand-mother and me not being a legal
grandfather. But have told Bumby to throw in his armour and try to
remedy this situation. . . . My health is about as well as can be expected;
that of a re-built jeep.

A NEW BOOK AND DARK CLOUDS

Ernest Hemingway's *Across the River and into the Trees* is released to poor reviews in 1950. In Washington, the Committee on Un-American Activities begins its work. It is a dark time in America where just a mention by the committee of anyone knowing or having been a member of the Communist Party could mean financial ruin and possible prosecution. It is a time of settling scores and of political theater and for the grabbing of power. People are made to name names, betray old friendships and speak untruths for no other reason than personal survival. It is not America's finest hour. Much cowardice is on display but so too defiance and courage. To criticize the committee is to incur their wrath and risk being subpoenaed. This is no small matter because the committee rarely, if ever, works from evidence or facts. It is a bully pulpit driven by fear, rumor and innuendo and few broadcasting companies or media organizations dare to cross this line.

At the time, Ernest Hemingway is looked upon with suspicion, by powerful people like J. Edgar Hoover. This is because of his activities concerning the Spanish Civil War and his sympathies and financial support for the Republican cause. One would think, because he surely understood the threat, that Hemingway would keep a low profile in Cuba and say nothing. But in a remarkable show of indignation and courage, he writes to Senator McCarthy. The letter is signed twice but it is unclear if it was sent. If it was, it was a very risky thing to do, because the FBI has been compiling a file on Hemingway's activities. It is unclear if Hemingway knows that at the time he writes the letter.

Honorable Senator Joe McCarthy:

My dear Senator:

Quite a number of people are beginning to get tired of you and you have possibilities of becoming a complete stranger. If you lost limbs or your head in the action in the Pacific everyone would naturally sympathize with you. But many people are merely bored since they have seen good fighters who had it in their time. Some of us have even seen the deads and counted them and counted the numbers of McCarthys.

There were quite a lot but you were not one and I have never had the opportunity to count the number of your wounds and get any sort of reading on the comparison with how your mouth, repeat moth, get it straight mouth, goes off.

I know you were in a fine force and you must have been wounded really badly but Senator you certainly bore the bejeesus out of some tax-payers and this is an invitation to get it all out of your system. You can come down here and fight for free, without any publicity, with an old character like me who is fifty years old and weighs 209 and thinks you are a shit, Senator, and would knock you on your ass the best day you ever lived. It might be healthy for you and it would certainly be instructive.

So you are always welcome, kid, and in case you have dog blood, which I suspect, don't report to sopoeanas [misspelled] but come ondown all expenses paid and if you are a small Marine you can fight any of my kids and get a reputation. I have them that weigh 152 to 186. You can fight any one. But afterwards me.

Good luck with the good part of your investigations and, if we can take off the part of the uniform you take when you go outside, and fornicate yourself. You would have a nice fight without witnesses and then you could tell it to all.

Yours always

 Ernest Hemingway

Actually I don't think you have the guts to fight a rabbit; much less a man. Am old but would certainly love to take you quick. Or to see the kids take you slow and careful.

Yours always, and with great respect for your office

Ernest Hemingway

1951

1951 brings the publication of J. D. Salinger's *The Catcher in the Rye*, James Jones's *From Here to Eternity* and, on Broadway, Rodgers and Hammerstein's *The King and I*, starring Yul Brynner and Gertrude Lawrence, opens at the St. James Theatre. Greta Garbo gets U.S. citizenship. Mickey Mantle hits his first home run as a New York Yankee and a mob attempts to keep a black family from living in Cicero, Illinois. General Douglas MacArthur addresses a joint session of Congress after being fired by President Harry Truman and on Monday, October 1, at 4:00 a.m., Pauline Hemingway dies in Los Angeles. The following day, Ernest Hemingway writes to Charles Scribner.

Dear Charlie:

. . . The wave of remembering has finally risen so that it has broken over the jetty that I built to protect the open roadstead of my heart and I have the full sorrow of Pauline's death with all the harbor scum of what caused it. I loved her very much for many years and the hell with her faults.
Best always
Ernest

1952

General Dwight Eisenhower defeats Adlai Stevenson, becoming president of the United States. Princess Elizabeth of York becomes Queen of England and in Kenya, the Kikuyu, unhappy with their poverty and unemployment, begin the Mau Mau Rebellion. The British declare martial law there. The Cuban government is overthrown, with Fulgencio Batista y Zaldívar taking power. Gary Cooper stars in *High Noon* and John Steinbeck's *East of Eden* is published, as is Beckett's *Waiting for Godot*. In Argentina, Eva Perón dies and Gregory Pincus tests progesterone

in rats. He makes the acquaintance of John Rock, who has been testing contraception in women. Their work, along with that of others, will lead to FDA approval of the pill in 1957.

The Catholic Church publicly condemns the late Nobel Prize–winning André Gide's writings. Ernest Hemingway's *The Old Man and the Sea* is released to universal praise. It will be made into a film starring Spencer Tracy. *The Old Man and the Sea* will become one of Hemingway's most enduring books and continue to be one of his biggest-selling ones for decades to come.

ELICIO ARGUELLES AND ERNEST HEMINGWAY DURING THE FILMING OF *THE OLD MAN AND THE SEA*, 1955. PHOTOGRAPH BY WARNER BROS., HEMINGWAY COLLECTION, JOHN F. KENNEDY PRESIDENTIAL LIBRARY AND MUSEUM, BOSTON.

ERNEST HEMINGWAY AND MARY HEMINGWAY'S FEET. FINCA VIGÍA, SAN FRANCISCO DE PAULA, CUBA. COPYRIGHT UNKNOWN, HEMINGWAY COLLECTION, JOHN F. KENNEDY PRESIDENTIAL LIBRARY AND MUSEUM, BOSTON.

ESSAY BY SANDRA SPANIER

I can trace my passion for Hemingway to a sweltering July afternoon in Key West in the 1970s. My husband and I were there with a couple of friends who were eloping. We were the sole witnesses to the wedding, conducted in the office of the justice of the peace, who, upon learning the purpose of our visit, walked over to a hook on the back of his door, removed the necktie hanging there and put it on over his golf shirt. After the ceremony we had lunch at a fish shack, and as I was already too sunburned to think about the beach, we headed for the Hemingway House.

I don't recall seeing any other visitors. In the living room the high French doors were open to the veranda, and a cat was napping on the sofa. In the kitchen another cat had draped itself across the top of the stove. The guide invited us to take a cat home if we wanted to—they were special six-toed "Hemingway cats," he said, but it didn't seem practical. (We know now, thanks to the recollections of the author's son Patrick Hemingway, who grew up in that house in the 1930s, that despite the present-day hype, the family did not have cats on the property, but kept peacocks instead.) We walked through the rooms, up the center staircase, around the house on the outside balcony, and across a catwalk to the room on the second floor of the coach house, where Hemingway retreated to write.

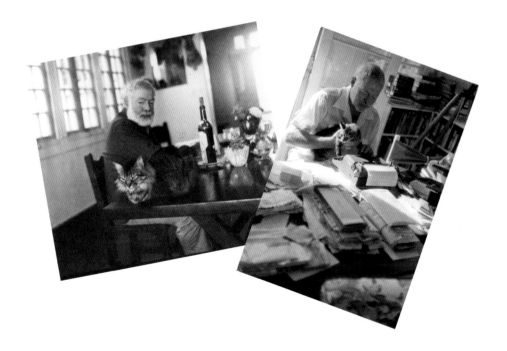

1. ERNEST HEMINGWAY SITS AT THE TABLE WITH HIS CAT, CRISTOBAL COLON. COPYRIGHT JFK LIBRARY. 2. ERNEST HEMINGWAY AT HIS DESK, TYPING, FINCA VIGÍA, WITH CRISTOBAL. EARL THEISEN © ROXANN LIVINGSTON, COURTESY JFK LIBRARY 2018.

As a fellow midwesterner (a native of Des Moines, Iowa, a few hundred miles due west of Hemingway's hometown of Oak Park, Illinois), I felt the lure of the exotic: the turquoise waters of the Gulf, faded old wood houses with gingerbread trim, turtle soup and conch chowder, the sign saying "Southernmost Point of the United States—90 miles to Cuba." My interest in Hemingway was piqued, and I began reading everything he had written.

If I had to identify one thing that most strongly attracted me to Hemingway—and attracts me still—it probably would be his art of evoking a sense of place. Henry James—not one of Hemingway's favorite writers—advised those who aspired to write fiction, "Try to be one of the people on whom nothing is lost." As a writer who started out as a journalist, Hemingway had a sharp eye and keen ear. His letters capture his own immediate impressions and excitement of discovery as his world widened out from the American heartland.

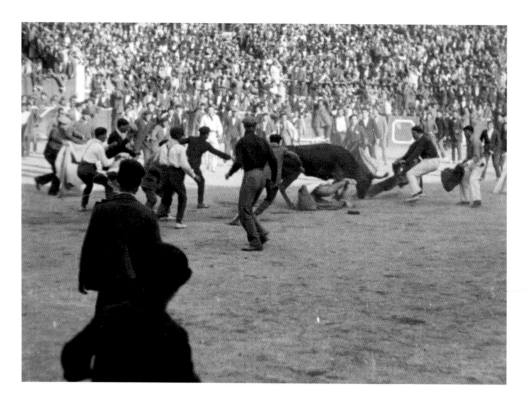

In May 1923, encouraged by Gertrude Stein, Hemingway traveled to Spain to witness his first bullfights. He was immediately enthralled. Just weeks after returning home to Paris in mid-June, he headed back to Spain with his wife, Hadley. On July 18, 1923, he wrote to

ERNEST HEMINGWAY (IN THE WHITE PANTS?) IN "THE AMATEURS" AT PAMPLONA, SPAIN. HEMINGWAY COLLECTION, JOHN F. KENNEDY PRESIDENTIAL LIBRARY AND MUSEUM, BOSTON.

The Sun Also Rises

A Novel

By Ernest Hemingway

*You are all a lost generation —
Gertrude Stein in Conversation.*

Vanity of vanities, saith the Preacher,
vanity of vanities; all is vanity
One generation passeth away, and another
generation cometh; but the earth abideth
for ever The sun also ariseth, and
the sun goeth down, and hasteth to the
place where he arose ... The wind
goeth toward the south, and turneth about
unto the north; it whirleth about
continually, and the wind returneth again
according to his circuits ... All the
rivers run into the sea; yet the sea
is not full; unto the place from whence
the rivers come, thither they return again.

Ecclesiastes.

his ambulance corps comrade Bill Horne, "Have just got back from the best week I ever had since the Section—the big Feria at Pamplona—5 days of bull fighting dancing all day and all night—wonderful music—drums, reed pipes, fifes—Faces of Velasquez's drinkers, Goya and Greco faces, all the men in blue shirts and red handkerchiefs—circling, lifting floating dance. We the only foreigners at the damn fair." He described the morning running of the bulls through the streets, from the corrals on the edge of town into the bullring, "with all of the young bucks of Pamplona running ahead of them!" Of the bullfight itself, he wrote, "It's a great tragedy—and the most beautiful thing I've ever seen and takes more guts and skill and guts again than anything possibly could. It's just like having a ringside seat at the war with nothing going to happen to you."

Hemingway returned to Spain the next two summers for the Festival of San Fermín, and immediately after the 1925 Festival ended, he began a novel, writing in French school notebooks and completing a draft in ten weeks. Because of that novel, *The Sun Also Rises*, published in 1926, "foreigners" by the tens of thousands throng to Pamplona every summer, drawn by the force of Hemingway's imagination. Outside the bullring, a stone bust of the author presides over the Paseo de E. Hemingway, the street named in his honor.

Hemingway had a knack for putting places on the map. His presence is still palpable in Key West, a remote tropical outpost when he and his second wife, Pauline, arrived in 1928. Another bust of Hemingway—reputedly forged from melted-down boat propellers donated by local fishermen—keeps watch over the harbor in Cojímar, the fishing village east of Havana where he kept his beloved boat, *Pilar*, and set his 1952 novel *The Old Man and the Sea*. The Finca Vigía, his longtime Cuban home, where he lived with Martha Gellhorn from 1939 to 1944 and later with Mary Welsh, is now a national museum.

A year after my first visit to Key West, we moved to State College, Pennsylvania, where I began work on my master's degree at Penn State, taking whatever courses were offered in the evenings and summers while teaching junior high English in the public schools. More than anything, I wanted to study with Philip Young, "Our Hemingway Man," as he was known in the Penn State English Department—who had written one of the first books about Hemingway, published in 1952 (despite Hemingway's resistance to being "dissected alive" by a literary critic). Unfortunately, Professor Young did not teach evenings or summers, so I arranged to do an independent-study course with him, assisting in research for his book *Revolutionary Ladies*, about Loyalist women during the American Revolution. I spent a summer in the base-

ment of the library, poring over the spidery handwriting of eighteenth-century letters on microfilm and getting my first taste of the excitement of watching history unfold through running eyewitness accounts.

A few years later, as a doctoral student, I finally had my chance to take Philip Young's Hemingway seminar, and I asked if he would direct my dissertation. Fine, he said, but not on Hemingway. Hemingway had been done to death. There was nothing new to say about him.

I was disappointed at the time, but in retrospect I am grateful for his advice. As a result I encountered the work of one of Hemingway's contemporaries in Paris in the twenties, Kay Boyle—a writer I had never heard of, and I had the remarkable privilege of getting to know her over the last thirteen years of her life. What began as my dissertation evolved into the first book about her, in 1986, and shortly before she died in 1992 at the age of ninety, she asked if I would compile and edit a volume of her selected letters. Although she had always resisted what she considered prurient public interest in writers' private lives, she wanted the story of her life to be on the record in her own words as an antidote to whatever distortions a future biographer might perpetrate. I jumped at the chance, of course. Little did I know that she had written more than twenty-five thousand letters (copies of some seven thousand of them now fill my file cabinets), or that it would be twenty-four years before the volume, *Kay Boyle: A Twentieth-Century Life in Letters*, was finally published in 2015.

In the meantime, my interest in Hemingway never flagged, and his places always beckoned. Like countless other aficionados, a copy of *The Sun Also Rises* in hand, I have followed Jake Barnes's walk through Paris from the Île Saint-Louis across the bridge to the Left Bank of the Seine, up the rue du Cardinal Lemoine, past the Place de la Contrescarpe, down the rue du Pot du Fer, and on to the cafés of Montparnasse. From Paris I have followed Jake's trail to Bayonne, San Sebastián, Burguete, Pamplona, and Madrid, ending with dinner at the Restaurante Botín. Always there is the shock of recognition. Hemingway always got it absolutely, perfectly right. Braids of garlic are sold in street stalls during the fiesta in Pamplona, hence the wreaths of white garlic the revelers wear around their necks as they dance around Brett Ashley. I have slept in the northeast corner room of the Hotel Ambos Mundos in Havana, one floor below Hemingway's favorite room (now a small museum). Except for a few modern architectural intrusions, the view is just as he described it to readers of the first-ever issue of *Esquire* magazine (Autumn 1933) in "Marlin off the Morro: A Cuban Letter." There really are black squirrels in the woods around Windemere, the family cottage on the shore of Walloon Lake, Michigan, where the young Hemingway spent every summer of his youth—the country he made us all see in his Nick Adams stories.

My professor Philip Young would probably be surprised—and, I know, pleased—to see

March 20 – 1925

Dear Dad –

Thanks for your fine letter enclosing the K.C. Star review. I'm so glad you liked the Doctor story. I put in Dick Boulton and Billy Tabeshaw as real people with their real names because it was pretty sure they would never read the Transatlantic Review. I've written a number of stories about the Michigan country – the country is always true – what happens in the stories is fiction.

This Quarter – a new quarterly review is publishing a long fishing story of mine in 2 parts called Big Two Hearted River. It should be out the first of April. I'll try and get it for you. The river in it is really the Fox above Seney. It is a story I think you will like.

The reason I have not sent you any of my work is because you or Mother sent back the In Our Time books. That looked as though you did not want to see any.

48

the vigorous health of Hemingway studies today, along with the intense, seemingly insatiable widespread public interest in Hemingway and his work.

One of the most exciting ongoing projects focuses on Hemingway's letters. Some six thousand of them survive, and with the blessing and encouragement of Patrick Hemingway, an effort is under way to publish Hemingway's complete collected letters in an edition projected to run to at least seventeen volumes. It is an honor for me to serve as general editor of the Hemingway Letters Project, directing an international team of scholars to produce *The Letters of Ernest Hemingway*, being published by Cambridge University Press.

Hemingway's published work is painstakingly crafted, but his letters are unguarded and unpolished. They chart the course of his friendships, his marriages, his family relationships, his literary associations, and his business dealings. The letters are striking for their sense of immediacy. When he grumbles about a balky typewriter, doubts whether he has spelled a word correctly, reports the mileage on his car's odometer or the measurements of a fish he caught, tallies the page count of a book in progress or complains of a sore throat, we are reminded that the great writer and Nobel laureate was also a human being.

Hemingway wrote in another piece for *Esquire* magazine, "Old Newsman Writes: A Letter from Cuba" (December 1934): "All good books are alike in that they are truer than if they had really happened and after you are finished reading one you will feel that all that happened to you and afterwards it all belongs to you; the good and the bad, the ecstasy, the remorse and sorrow, the people and the places and how the weather was. If you can get so you can give that to people, then you are a writer."

Hemingway did not regularly keep a journal, but his letters are a vivid and spontaneous real-time record of his life and times. Hemingway's letters capture in the freshness of the moment the people and the places and how the weather was. Taken together, they constitute the raw footage of an epic life story and a chronicle of the twentieth century.

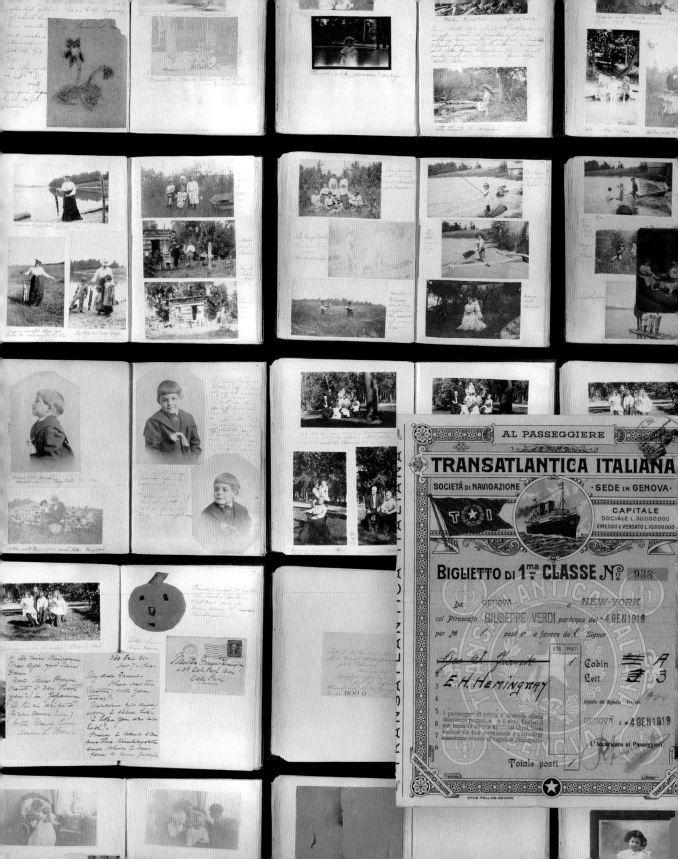

Artifacts from a Life

In order to write about life first you must live it. —Ernest Hemingway

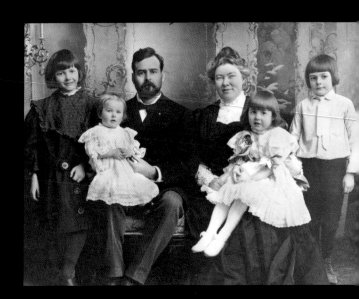

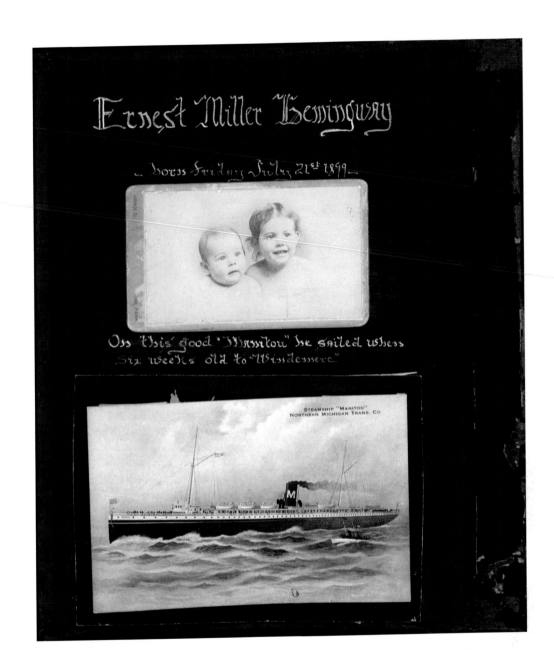

Ernest Miller Hemingway

born Friday July 21st 1899

On this good "Manitou" he sailed when Six weeks old to "Windemere"

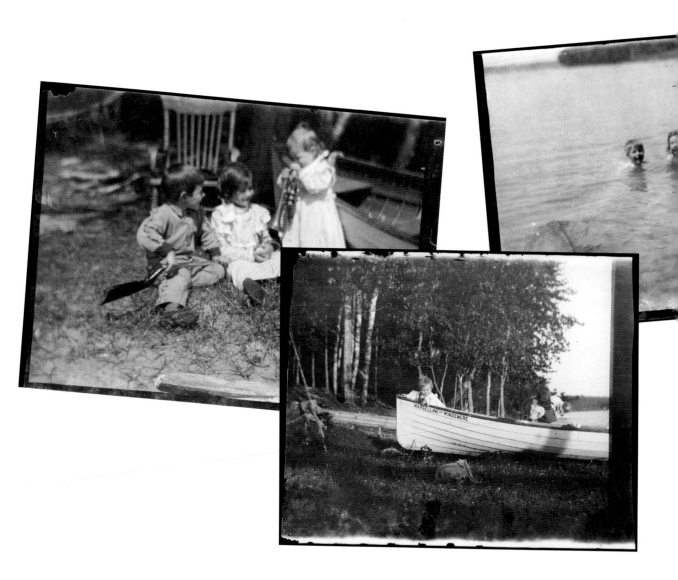

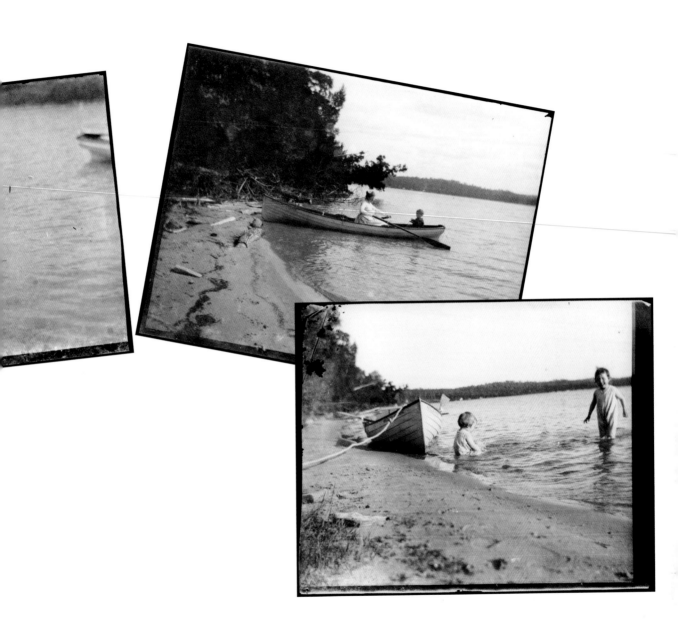

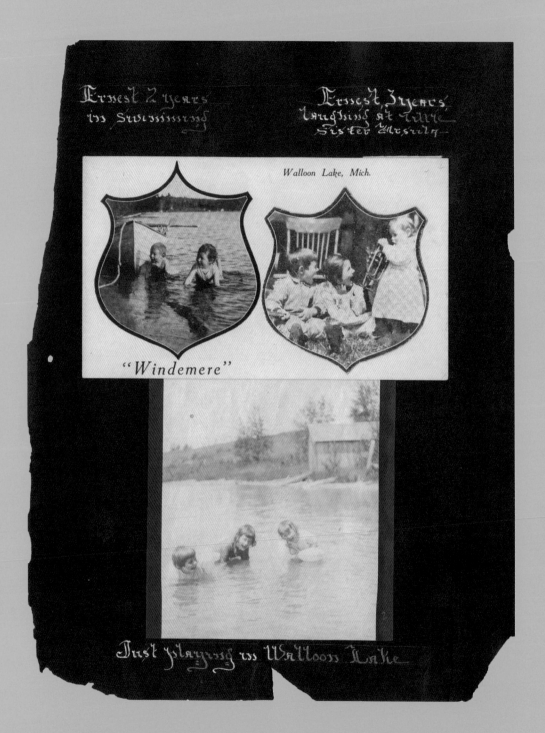

Ernest 2 years in Swimming

Ernest 3years laughing at little sister Ursula

Walloon Lake, Mich.

"Windemere"

Just playing in Walloon Lake

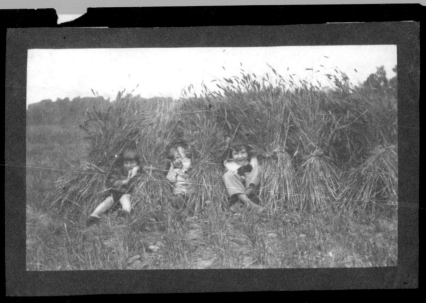

Marcelline, Ernest and Ursula
Just playing in shocks of Wheat
"Cream of Wheat"

"Windemere"

Ernest 4 years old — playing soldier

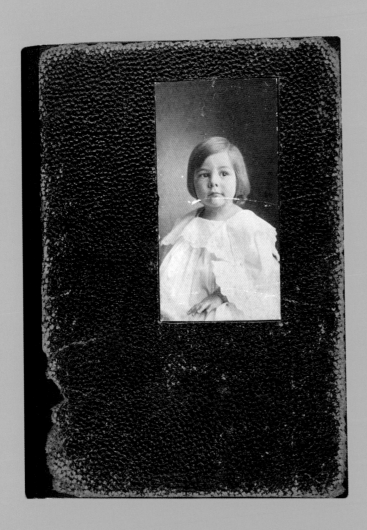

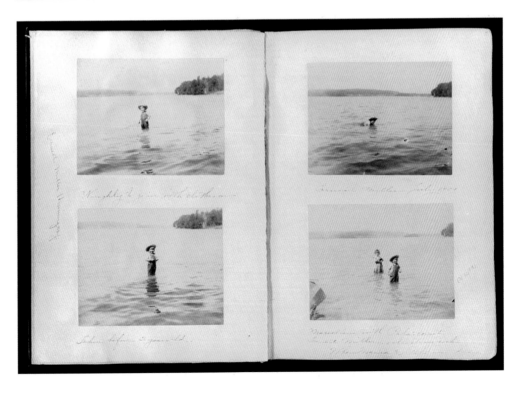

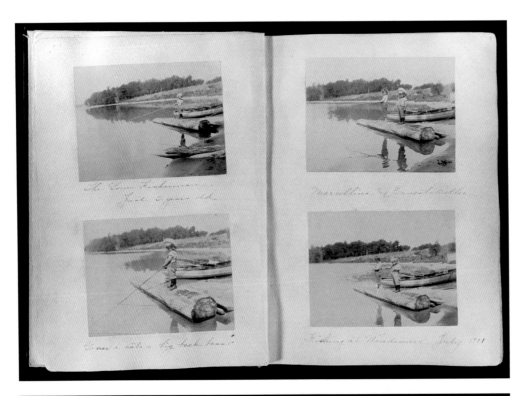

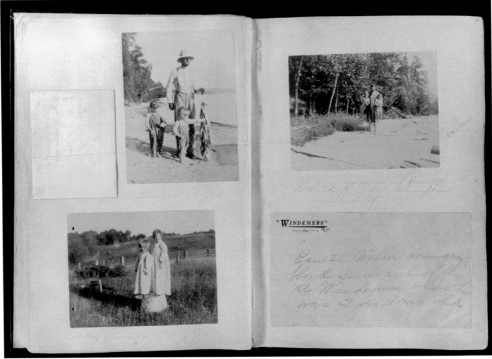

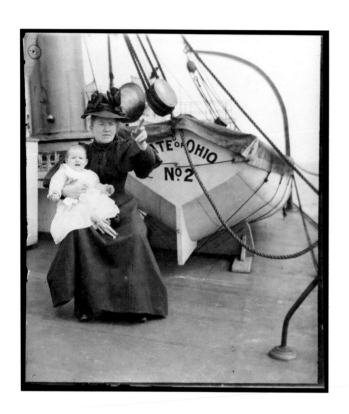
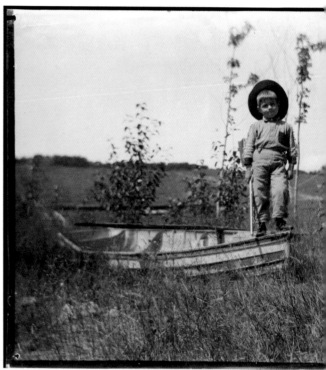

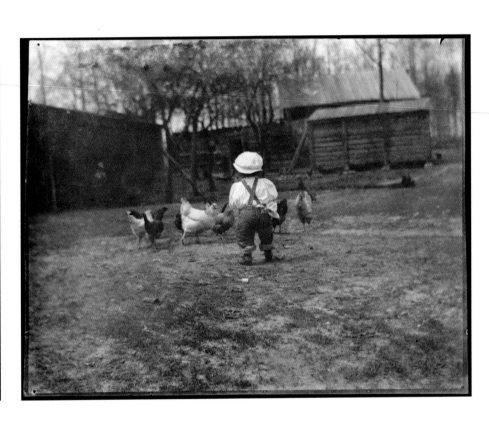

July 15th 1915.
Walloon Lake Ernest
over the Top.

Family of C.E.H.

In the hayfield
Ernest on the ground
farmer on the Wagon
Miles in front.

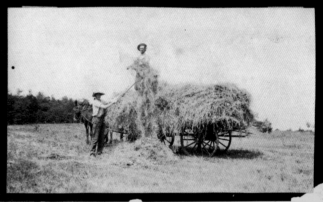

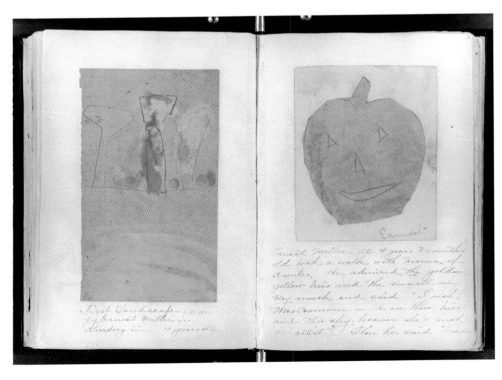

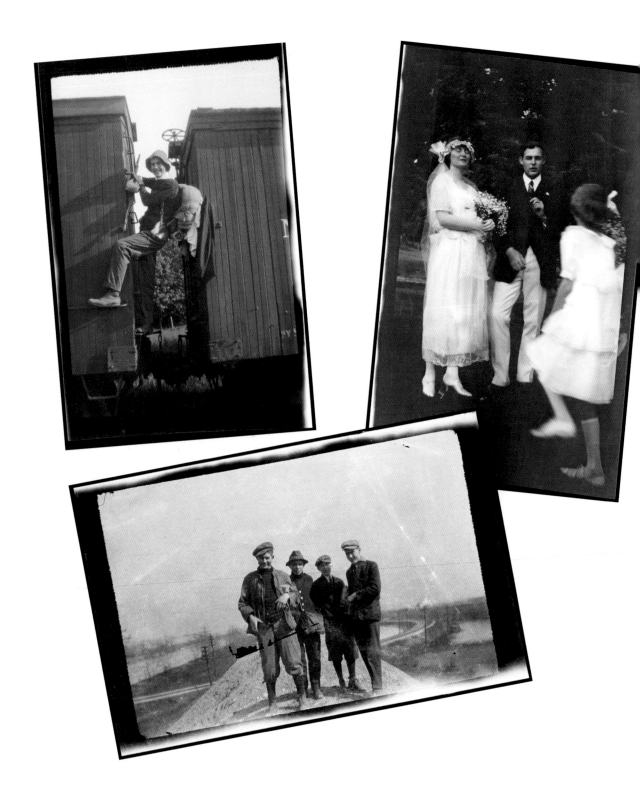

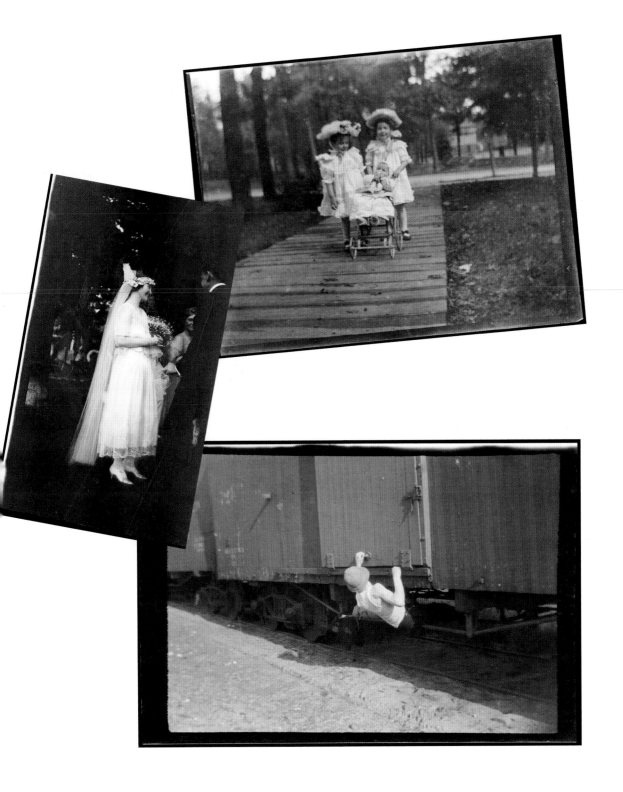

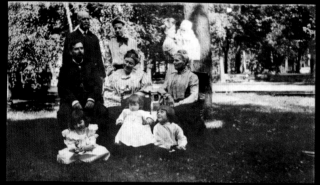

Dr & Mrs Hemingway - Ursula, Ernest, & Marcelline

Autumn of 1904 - Oak Park
Grandfather & Grandmother
Hemingway - Mother & Father
of Ernest- sisters' Marcelline
and Ursula- Aunt Arabell and
baby Frank Hines (born March 14th
1904- Ernest on Grass at
Grandmothers' feet - 5 years

Dr & Mrs C.E. Hemingway-
Mrs' George Hemingway
and two daughters'
Ernest (3 years old) and Mass.

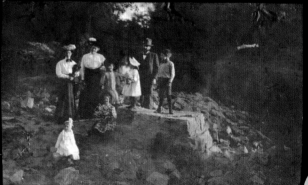

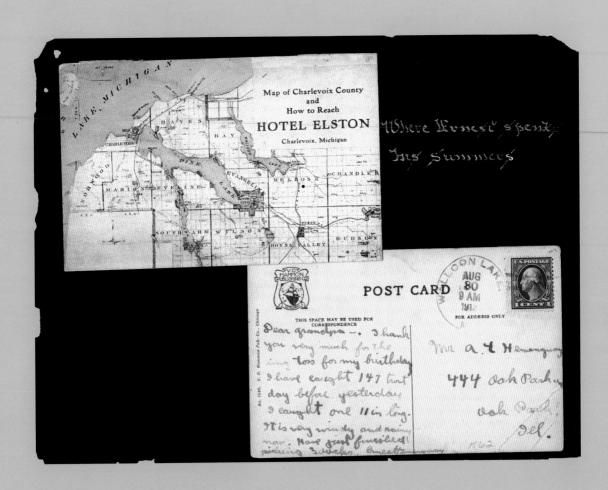

LITERARY

Sepi Jingan

By ERNEST HEMINGWAY, '17

 "'VELVET'S' like red hot pepper; 'P. A.' like cornsilk. Give me a package of 'Peerless'."

Billy Tabeshaw, long, lean, copper-colored, hamfaced and Ojibway, spun a Canadian quarter onto the counter of the little north-woods country store and stood waiting for the clerk to get his change from the till under the notion counter.

"Hey, you robber!" yelled the clerk. "Come back here!"

We all had a glimpse of a big, wolfish-looking, husky dog vanishing through the door with a string of frankfurter sausages bobbing, snake-like, behind him.

"Darn that blasted cur! Them sausages are on you, Bill."

"Don't cuss the dog. I'll stand for the meat. What's it set me back?"

"Just twenty-nine cents, Bill. There was three pounds of 'em at ten cents, but I et one of 'em myself."

"Here's thirty cents. Go buy yourself a picture post-card."

Bill's dusky face cracked across in a white-toothed grin. He put his package of tobacco under his arm and slouched out of the store. At the door he crooked a finger at me and I followed him out into the cool twilight of the summer evening.

At the far end of the wide porch three pipes glowed in the dusk.

"Ish," said Bill, "they're smoking 'Stag!' It smells like dried apricots. Me for 'Peerless.'"

Bill is not the redskin of the popular magazine. He never says "ugh." I have yet to hear him grunt or speak of the Great White Father at Washington. His chief interests are the various brands of tobacco and his big dog, "Sepi Jingan."

We strolled off down the road. A little way ahead, through the gathering darkness, we could see a blurred figure. A whiff of smoke reached Bill's nostrils. "Gol, that guy is smoking 'Giant'! No, it's 'Honest Scrap'! Just like burnt rubber hose. Me for 'Peerless.'"

The edge of the full moon showed above the hill to the east. To our right was a grassy bank. "Let's sit down," Bill said. "Did I ever tell you about Sepi Jingan?"

"Like to hear it," I replied.

"You remember Paul Black Bird?"

"The new fellow who got drunk last fourth of July and went to sleep on the Pere Marquette tracks?"

"Yes. He was a bad Indian. Up on the upper peninsula he couldn't get drunk. He used to drink all day—everything. But he couldn't get drunk. Then he would go crazy; but he wasn't drunk. He was crazy because he couldn't get drunk.

"Paul was Jack-fishing [spearing fish illegally] over on Witch Lake up on the upper, and John Brandar, who was game warden, went over to pinch him. John always did a job like that alone; so next day, when he didn't show up, his wife sent me over to look for him. I found him, all right. He was lying at the end of the portage, all spread out, face down and a pike-pole stuck through his back.

"They raised a big fuss and the sheriff hunted all over for Paul; but there never was a white man yet could catch an Indian in the Indian's own country.

"But with me, it was quite different. You see, John Brandar was my cousin.

"I took Sepi, who was just a pup then, and we trailed him (that was two years ago). We trailed him to the Soo, lost the trail, picked it up at Garden River, in Ontario; followed him along the

north shore to Michipicoten; and then he went up to Missainabie and 'way up to Moose Factory. We were always just behind him, but we never could catch up. He doubled back by the Abittibi and finally thought he'd ditched us. He came down to this country from Mackinaw.

"We trailed him, though, but lost the scent and just happened to hit this place. We didn't know he was here, but he had us spotted.

"Last fourth of July I was walking by the P. M. tracks with Sepi when something hit me alongside the head and everything went black.

"When I came to, there was Paul Black Bird standing over me with a pike-pole and grinning at me!

"'Well,' he smiled, 'you have caught up with me; ain't you glad to see me?'

"There was where he made a mistake. He should have killed me then and everything would have been all right for him. He would have, if he had been either drunk or sober, but he had been drinking and was crazy. That was what saved me.

"He kept prodding me with the pike-pole and kidding me. 'Where's your dog, dog man? You and he have followed me. I will kill you both and then slide you onto the rails.'

"All the time I kept wondering where Sepi was. Finally I saw him. He was crawling with his belly on the earth, toward Black Bird. Nearer and nearer he crawled and I prayed that Paul wouldn't see him.

"Paul sat there, cussing and pricking me with the long pike-pole. Sepi crawled closer and closer. I watched him out of the tail of my eye while I looked at Paul.

"Suddenly Sepi sprang like a shaggy thunderbolt. With a side snap of his head, his long, wolf jaws caught the throat.

"It was really a very neat job, considering. The Pere Marquette Resort Limited removed all the traces. So, you see, when you said that Paul Black Bird was drunk and lay down on the Pere Marquette tracks you weren't quite right. That Indian couldn't get drunk. He only got crazy on drink.

"That's why you and me are sittin' here, lookin' at the moon, and my debts are paid and I let Sepi steal sausages at Hauley's store.

"Funny, ain't it?

"You take my advice and stay off that 'Tuxedo'—'Peerless' is the only tobacco.

"Come on, Sepi."

When a Woman Will

By ZELMA OWEN, '17

FOR a half hour I had sat looking into space and enjoying my idleness, when Hugh Canston obstructed my view and made his appearance still better known by saying hurriedly, "You have just enough time to go to 5061 E. Shively Street and find out about the wedding there last night." I had been in New York only five months but had already grown tired of its artificiality and continued grinding, but knowing the duties of a reporter I donned my coat and hat uncomplainingly and went out into the rainy street to get wedding news that thousands would read thoughtlessly, even if they read it at all.

I found 5061 E. Shively to be an old brick building with one entrance. The first and third stories were vacant so, knowing that the second must be my destination, I looked at the windows. A light was shining in the front room and showed but dimly through the dark red draperies. I entered and rang the bell, and on being asked to go upstairs I mounted the steps that would have been much cleaner had there been fewer cigarette stubs lying around. No one had come to the door when I reached the top, so I knocked. Someone from within unconcernedly invited me to enter, and I opened the door.

The room into which I stepped was filled with easels and brushes and other artists' materials. It was surprisingly dusty and disorderly. It looked almost like a wreck. In the middle of the debris, and in front of a glowing wood fire, sat a woman contemplating the toe of a dirty pink satin slipper. She matched the room in the respect that both were rather faded. She was a blonde, and had pale grey eyes and faded lips. I found later that they were quite literally faded, for the cigarette which she had been smoking when I came in, and which she held between her second and third finger of her right hand during our conversation, was quite

Milan, Italy
July 14th 1918.

Dear Mr. Hemingway,

I have just come from seeing Ernest at the American Red Cross Hospital here. He is fast on the road to recovery and will be out a whole man once again, so the doctor says, in a couple of weeks. Although some two hundred pieces of shell were lodged in him none of them are above the hip joint. Only a few of these pieces was large enough to cut deep; the most serious of these being two in the knee and two in the right foot. The doctor says there will be no trouble about these wounds healing and that Ernest will regain entire use of both legs.

Now that I have told you about his condition I suppose you would like to know all the circumstances of the case. Let me say right here that you can be very proud of your son's actions. He is going to receive a silver medal of valor which is a very high medal indeed and corresponds to the Medaille Militaire or Legion of Honor of France.

At the time he was wounded Ernest was not in the regular ambulance service but in charge of a Red Cross canteen at the front. Ernest, among several others in our section which was in the mountains where there was not very much action, volunteered to go down on the Piave and help out with the canteen work. This was at the time when the Italians were engaged in pushing the Austrians back over the river so he got to see all the action he wanted.

Ernest was not satisfied with the regular canteen service behind the lines. He thought he could do more good and be of more service by going straight up to the trenches. He told the Italian command about his desire. A bicycle was given him which he used to ride to the trenches every day laden down with chocolate,cigars,cigarettes, and post cards. The Italians got to know his smiling face and were always asking for their " giovane Americano !

Well things went along fine for six days. But about midnight on the seventh day an enormous trench mortar lit within a few feet of Ernest while he was giving out chocolate. The concussion of the explosion knocked him unconscious and buried him with earth. There was an Italian between Ernest and the shell. He was instantly killed while another, standing a few feet away, had both his legs blown off. A third Italian was badly wounded and this one Ernest, after he had regained consciousness, picked up on his back and carried to the first aid dug-out. He says he does not remember how he got there nor that he had carried a man until the next day when an Italian officer told him all about it and said that it had been voted upon to give him a valor medal for the act.

Naturally, being an American, Ernest received the best of medical attention. He had only to remain a day or so at a hospitalat the front when he was sent to Milan to the Red Cross hospital. Here he is being showered with attention by American nurses as he is one of the first patients in the hospital. I have seen a cleaner,neater, and prettier place than that hospital. You can rest easy in your mind that he is receiving the best care in Europe. And you need have no fear for the future for Ernest tells me that he intends now to stick to regular ambulance work which, to use his own words," is almost as safe as being at home."

Since writing the last time I have seen Ernest again. He told me the doctor had just seen him and made another careful examination. The result showed that no bones were broken and the joints were unharmed, all the splinters making merely flesh wounds.

By the time this letter will reach you he will be back in the section. He has not written himself because one or two of the splinters lodged in his fingers. We have made a collection of shell fragments and bullets that were taken out of Ernie's leg which will be made up into rings.

Ernie says he will write very soon. He dictate love to "ye old Ivory", Ura, Nun-bones", "Nubbins," " ye young Brute".

Please include my love also although I haven't had the pleasure of meeting the foregoing. Tell Mrs. Hemingwayhow sorry I was that I didn't get to see her while in Chicago.

Sincerely,

Theodore B. Brumback.

- 2 -

P. S.

 Dear Folks -
 I am all O. K. and include much love to ye parents. I'm not
near so much of a hell roarer as Brummy makes me out.
 Lots of love,

 Ernie.

 Sh ----------- Dont worry Pop.

Dear George —
 I had Lewis Clanahan
make a few copies of this
fine letter which brings us first
news from Ernest direct ——
 Read and then let
me have same to go around the
loop of friends. — All hot here
100° today, 104° in shade yesterday. —
 Much love.
 Clarence —

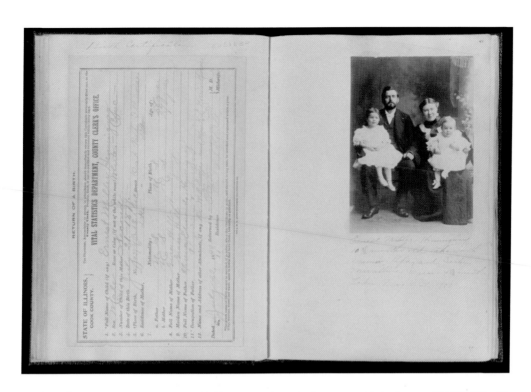

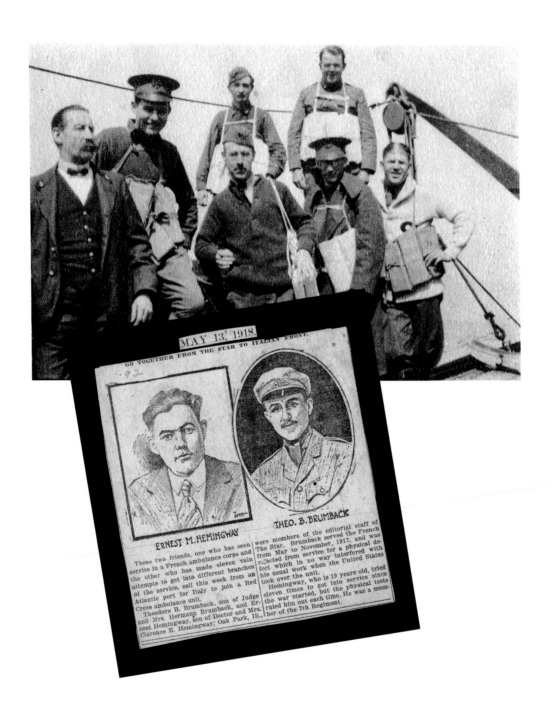

MAY 13, 1918.

GO TOGETHER FROM THE STAR TO ITALIAN FRONT.

ERNEST M. HEMINGWAY

THEO. B. BRUMBACK

These two friends, one who has seen service in a French ambulance corps and the other who has made eleven vain attempts to get into different branches of the service, sail this week from an Atlantic port for Italy to join a Red Cross ambulance unit.

Theodore B. Brumback, son of Judge and Mrs. Hermann Brumback, and Ernest Hemingway, son of Doctor and Mrs. Clarence E. Hemingway, Oak Park, Ill.,

were members of the editorial staff of The Star. Brumback served the French from May to November, 1917, and was rejected from service for a physical defect which in no way interfered with his usual work when the United States took over the unit.

Hemingway, who is 19 years old, tried eleven times to get into service since the war started, but the physical tests ruled him out each time. He was a member of the 7th Regiment.

AMERICAN RED CROSS
L'A CROCE ROSSA AMERICANA

TELEFONO 49-64

VIA MANZONI, 10

MILANO 12 Dic. 1918.

OSPEDALE MILITARE SUCCURSALE
 DI RISERVA.
OSPEDALE MAGGIORE
 (SEZIONE MALATTIE NERVOSE).

OGGETTO:

 This is to certify that Mr. E. Hemmingway has been
attended by me from July 8-1918 to the present date.

 He has been totally disabled up till now owing to the
stiffness of right knee and pain preventing its use.

 At present he has acquired the right to bend the knee
almost to a right angle, and I believe that through simple
exercising, the function of the joint will be completely
restored: it is impossible to foretell the length of the
period of partial disability.

 Captain A. S. Jardini M.D.

 Via Lovania 4

 Milano.

CROCE ROSSA AMERICANA
(UFFICIO DI MILANO)

Certificato di Viaggio

rilasciato al *Ten. E. M. Hemingway*

il quale deve partire il *15/12/18*

da *Milano*

per recarsi a *Florence, Roma Napoli* e ritorno, per

ragione di servizio *Croce Rossa Americana*

per *I* Classe

Il Capitano Croce

M. D. R.

Il presente certificato non è valido dop
dalla data d'emissione.

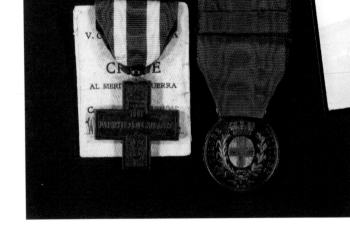

Dear grandfather and grandmother —
We are at Cleveland and
having a great trip × It is
a fine bunch of fellows.
(May 12
1918
With love to all ..
Amer

Dear grandfather, grandmother and aunt grace —
We are stopping at a hotel in
Washington Square and we being
completely equipped and uniformed.
New York is a beautiful ——— etc.
Everything is lovely. I don't know
my overseas address yet.
Ernest

New York May 13 - 1918

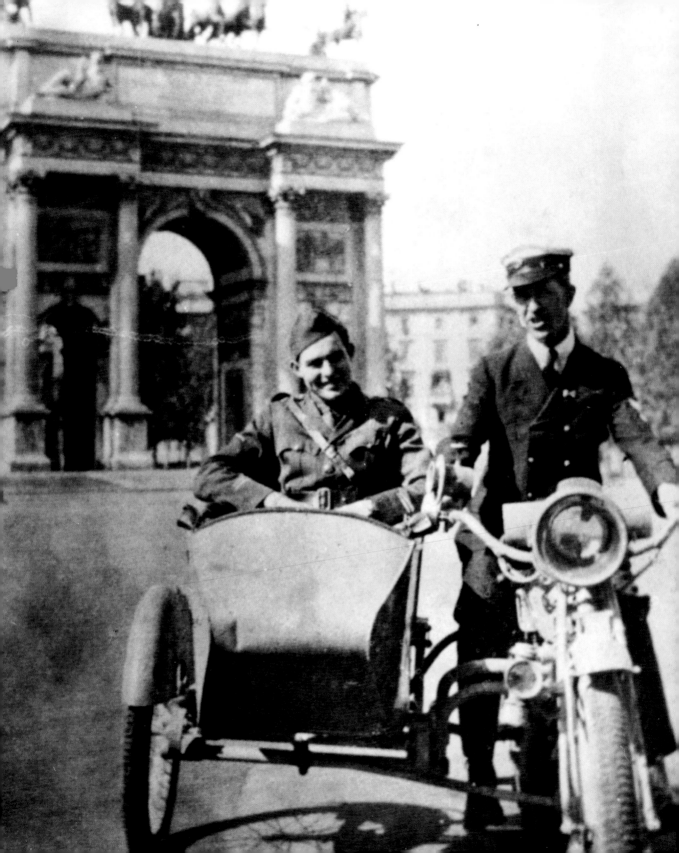

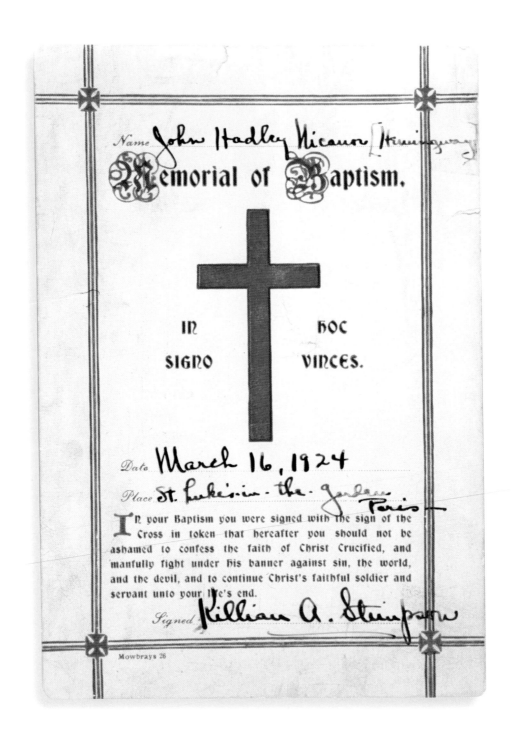

Saturday, September 7, 1918

WITH OUR WOUNDED

Hemingway Is Italian Hero — King Decorates Him — News from Hospitals Shows Hurt Men Happy

Oak Park men wounded in action are finding hospital life agreeable and write happy letters.

One warrior writes that he never found time to think about home and home folks "exactly the way they ought to be thought of" until he was laid up in a base hospital; one thinks that a wound is really rather a necessary sometimes to bring home with a fellow after the war is over; a third has at last found time and interest in which to study French and British history; an Oak Park marine, with shattered ankles and shoulder and arm, writes that it is taking a base hospital cot to find just what the French think about the American devil-dogs; two other wounded men have been cited for bravery, one of them by the King of Italy.

Lieut. Ernest Hemingway, Ambulance Service, is backing enough thrills away into his old kit bag to last any ordinary soldier a lifetime. He has been hailed by the Italian press and people as the first American to be wounded in Italy; moreover, King Victor has personally decorated him with the valor medal in honor of the services he rendered as a rolling canteen bearer in a recent action.

Strapped to a board, his body riddled with wounds where two hundred pieces of shell had found lodging, he was carried out on the piazza of the Red Cross hospital at Milan the other day and given an ovation worthy of an Admiral Dewey or a General Pershing. Italian girls pelted him with flowers and high Italian officers stood at salute, while crowds acclaimed him as the "American hero of the Piave."

Lieutenant Hemingway, a member of the American Ambulance Corps, and wounded nearly two months ago, cabled his parents last week that the last operation had been performed on him, and the last bullet removed. It was found that he had been wounded more seriously than had been thought at first, and it is probable that it will be another month before he is able to use his legs again. In the meanwhile, he writes cheerily of the excellent care he is receiving, and of the wonderful records made by the Italian troops in recent advances. "Genuine Americans" is the affectionate title he won in the six days he dispensed chocolates and cigarettes and post cards among the Italian troops. Hemingway made good with the warlike, but sentimental soldiers by carrying an unconscious Italian, when he himself was badly wounded by the explosion of an enormous trench mortar battery, back to the first aid dugout.

Young Hemingway had left letter to his mother dated on June 16, and he was going to the front on June 15, and he was then happily well up in the foothills in the Italian comprehensive along the

TWO ARE KILLED, FOUR WOUNDED, THREE MISSING

Ambulance Driver Victim of Hun Air Raiders on Italian Front.

'BROTHER AGAINST BROTHER'

CITY CASUALTY LISTS.

Killed in action	42
Died of wounds	33
Died of other causes	12
Severely wounded	119
Slightly wounded	54
Missing or prisoners	17

Total	219

Nine Chicagoans, one of them an ambulance driver on an errand of mercy, are named in today's casualty lists from abroad as victims of the Huns. Another of the nine enlisted in the American army at the declaration of war, altho he had two brothers in the German army.

Of those named, two were killed in action, four wounded severely and three are missing in action.

KILLED IN ACTION.

PRIVATE HENRY BEMBERG, 2046 Howe street, marine.

PRIVATE ERNEST D. BUCHHEISTER, 910 Fullerton parkway, marine.

WOUNDED SEVERELY.

CORPORAL ODIN A. THOMASEN, 7195 Summerdale avenue, marine.

ERNEST MILLER HEMINGWAY, 600 North Kenilworth avenue, Oak Park. Wounded while driving an ambulance on the Italian front.

PRIVATE GEORGE W. BARKER, 2003 Warren avenue, marine.

PRIVATE HARRY R. SCOTT, 1902 Aberdeen street, marine.

MISSING IN ACTION.

PRIVATE CONWAY SKILLICORN, 1416 North Central Park avenue, army.

PRIVATE JAMES T. COTTER, 1522 Ethon avenue, marine.

PRIVATE BENJAMIN E. HENDERSON, 6490 Parnell avenue, marine.

Medal for Valor.

"Ernest is wounded, not seriously; he will be able to walk within ten days. He receives medal for valor."

This was the substance of a brief cablegram delivered this morning to Dr. C. E. Hemingway, 600 North Kenilworth avenue, Oak Park. It was further explained that Ernest Miller Hemingway, 19-year-old son of Dr. Hemingway, was wounded in the leg by a trench mortar while on duty with the Italian ambulance service of the American Red Cross. Hemingway's injuries are slight, as shown by the news that he will be walking about within ten days.

He is a graduate of the Oak Park and River Township High School, class of 1917. For a short period after graduating he was employed on the Kansas City Star.

Whether the valor medal is to be awarded by the Italian or American government is not known, but that it is to be awarded is sufficient cheer for the Hemingway family.

Ernest M. Hemingway, Oak Park, Ill.—Italian War Medal for valor.

OAK PARK BOY 'SHOT TO PIECES' JOKES ABOUT IT

Ernest Hemingway Suffers 227 Wounds While in Red Cross Service.

Thoroly typical of the American spirit and the humor that will carry the men over all obstacles is the letter recently received by Dr. C. E. Hemingway of Oak Park from his 19-year-old son, Ernest, who is convalescing in an Italian hospital from 227 wounds. The letter was published in Oak Leaves.

Young Hemingway was working in the editorial department of the Kansas City Star when he volunteered for ambulance driving in the Red Cross. His work was in the mountainous regions of northern Italy, and late in the summer, when he was working in a front-line trench a shell exploded hurling his comrades under a trench mortar and inflicting the wounds from which Hemingway is now recovering. The letter follows:

"Dear Folks—Gee, family, but there never have been a great hullado about my getting shot up. Oak Leaves and the opposition came today and I have begun to think, family, that maybe you didn't appreciate me when I used to reside in the bosom. It's the next best thing to getting killed and reading your own obituary.

"You know they say that isn't anything funny about this war, and there isn't; but it wasn't so bad because she's been a lot more enjoyable than I've ever seen. It has never since been more dangerous or exciting with the opportunity giving you more to live for..."

WEDNESDAY, OCTOBER 23, 1918.

M's Light of Wounds.

"Oh, ah...I.' Italian, two captain: it is nothing. In Amen...they all do it. It is thought well not to allow the enemy to perceive that they have captured our guns. The great speech recognized some masterful lingual ability, but I see it across and then went to sleep for a couple of minutes.

"After I came to they carried me on a stretcher three kilometers back to a dressing station. The stretcher bearers had to go over lots, as the road was having the entrails shelled out of it. Whenever a big one would come, which we were whoossshh—boom, they would zig me down and get flat.

"My wounds were now hurting like the little devils driving tacks into the raw. The dressing station had been evacuated during the attack, so I lay for two hours in a stable with the roof shot off, waiting for an ambulance. When it came I ordered it down the road to see the soldiers that had been wounded first. It came back with a load and then they lifted me in.

"There was still pretty thick and our batteries were going off all the time 'way back of us and the big Minnie and 250s going overhead for Austria with a noise like a railway train. Then you'd hear the burst back of the lines. Then shrink would come to fire Austrian shell and then the crash of the burst. But we were giving them more and bigger stuff than they sent.

"Then a battery of field guns would go off just back of the shed—boom—boom—boom! and the 75s and then the machine—Boom—boom! and the 75s and then the machine gun bullet which would whispering over to the Austrian lines. And the star shells going up all the time and the machine guns going like riveters—tat-a-tat-tat.

Shot 'Advancing to the Rear.'

"Now, out of all that mess to only get struck by a trench mortar and a machine-gun bullet while advancing to ward the rear, as the Irish say, was fairly lucky. What Family?

"The 227 wounds I got from the trench mortar didn't hurt a bit at the time, only my feet felt like I had an rubber boots full of water that warm, and my knee was acting queer. The machine gun bullet just felt like a sharp smack on the leg with an icy snow ball. However, it spilled me. But I got up again and got my wounded into the dugout. I kind of collapsed at the dugout.

"The Italian I had with me had bled all over me, and my coat and pants looked like some one had made curtain jelly in them and then poured holes to let the pulp out. Well, my captain, who was a great pal of mine (it was his dugout) said—'Poor Hem, he'll be H. J. F. soon. Keat to pieces, that is.'

"You see, they thought I was shot thru the chest, because my bloody coat. But I made them take my coat and shirt off (I wasn't wearing any under shirt), and the old torso was intact. Then I said that I would probably live. That cheered me up any amount.

"I told them in Italian that I wanted to see my legs tho I was afraid to look at them. So they took off my trousers and the old limbs were still there but gee, they were a mess. They couldn't figure out how I had walked a hundred and fifty yards with such a load, with both knees shot thru and my right knee concerned in the big plaster; also over 200 flesh wounds.

Left Among 'Pals.'

"After a ride of a couple of kilometers to an Italian ambulance they unloaded me at a dressing station, where I had a lot of pals among the medical officers. They gave me a shot of morphine and anti-tetanus serum and shaved my legs and took twenty-eight shell fragments varying in size from razors to direct classics to size out my system.

"Then they did a fine job of bandaging and all shook hands with me and would have kissed me, but I kidded them along. Then I zssssd five days at a field hospital and was evacuated to the base hospital here.

"I sent you that cable so you wouldn't worry. I have been in the hospital a month and twelve days and hope to be out in another month. The Italian surgeons did a peach of an operating on my right knee joint and my right foot; took twenty-eight stitches, and assures me that I will be able to walk as well after it is all healed up as before. The wounds all healed up clean and there was no infection. He has my right leg in a plaster splint now, so that will be all right.

"I have some snappy souvenirs that he took out at the last operation. I wouldn't really be comfortable now unless I had some pain. The surgeon is going to take the plaster off in a week now and will allow me on crutches in ten days. I will have to learn to walk again.

"This is the longest letter I have ever written to anyone and it says the most. Give my best to everybody and also shoot me and ze Mz Perticelli rayer. Leave us keep the home fires burning."

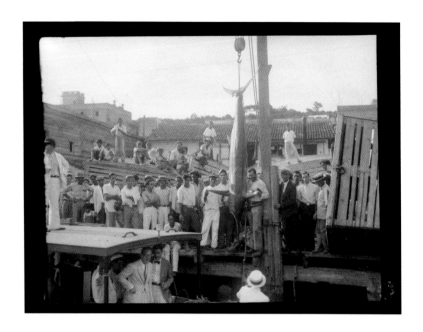

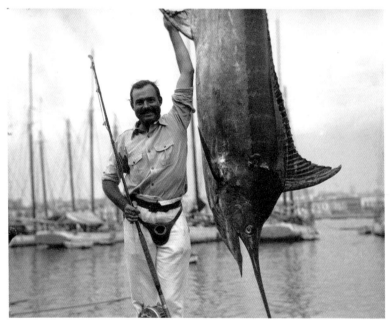

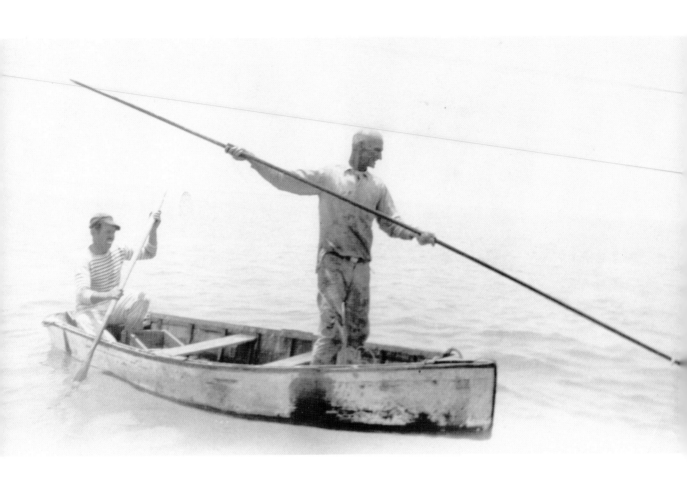

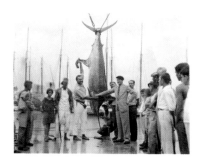

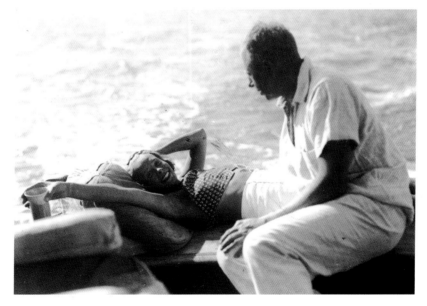

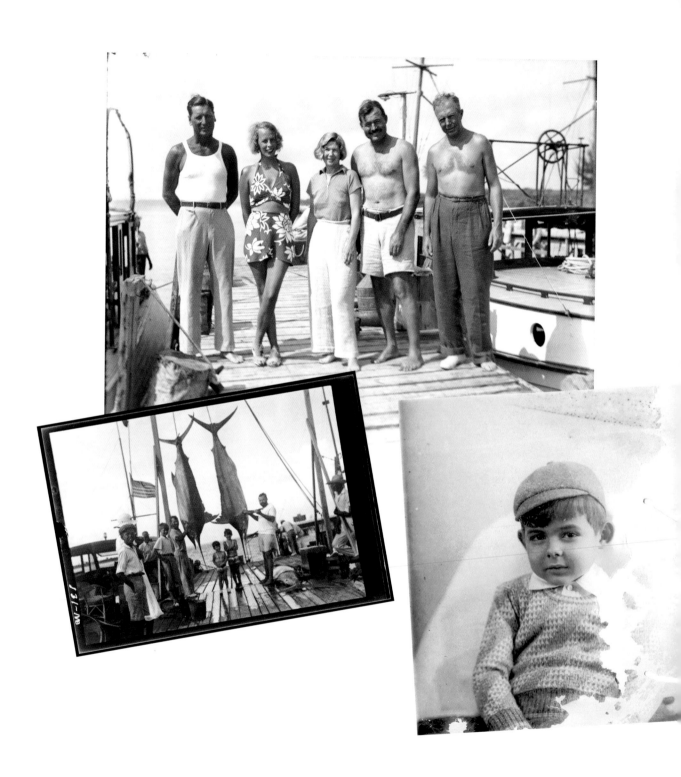

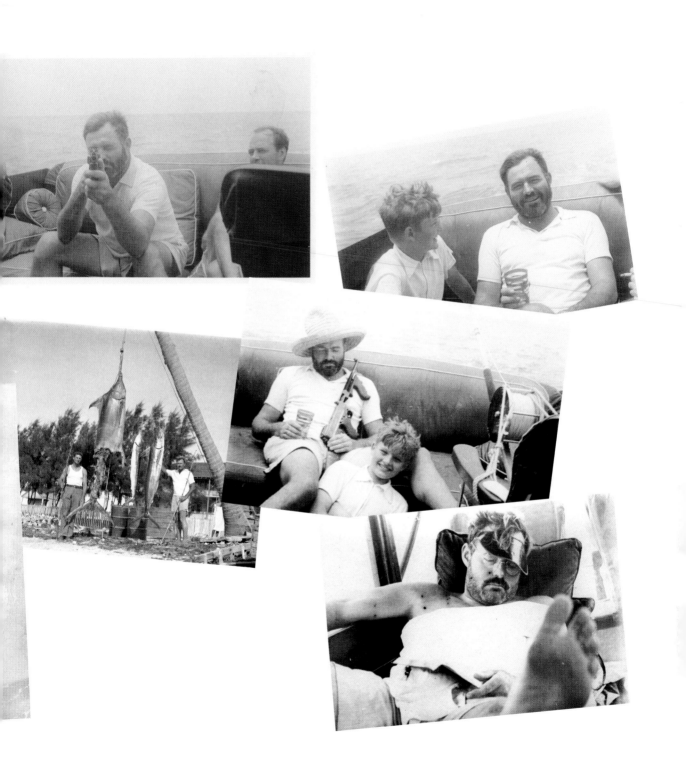

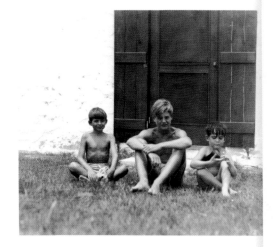

SIDNEY FRANKLIN
MATADOR DE TOROS
1538-East 29th St.,
Brooklyn, N. Y.

Feb. 3, 1937.

Dear Ernest:-

I don't have to tell you just how tickled I was to get your wire, but I had begun to wonder as to the condition the fish would be in when you got it. So then, by the wire I judge you at least were able to taste it. I really hope you and Pauline enjoyed it.

Hot compresses did the trick for the arm. So now that's okay, thank God. I'll get a shot or two more before leaving here which I will be Monday morning at the latest. That will mean that I'll get my passport (a new one) the same Monday afternoon and continue southward that same nite, from Washington. Which all means that I should be in your neighborhood around Thursday if all goes well.

I stopped in to see Roger Chase and got the enclosed list of details. I guess that it will speak for itself. If there's anything you don't like, or can't under-stand, let me know so as to clear it up or to do something about it before I head south. Otherwise I'll go over it with you when I get there. Meanwhile I'll also try to see just what I can do on the outside.

I am also enclosing the folder that the French Line gave me. You will notice that the Paris is the only boat sailing between the dates you gave me. That is, for the French Line . I didn't go into any details about ambulances and such because I imagine you or Roger Chase's crowd will know all about that. Even so, if you have any doubt, we can arrange it all by getting here a few days in advance of the sailing date. Isn't that so?

Incidentally, Chase told me that the $750. he got came from Chicago. When he asked me about it, saying that that amount was the order to go ahead on two ambulances, I told him that I didn't know anything at all. I told him that you were the only one who knew all the details. All I could tell him was that I was tagging along with you and for him to keep that absolutely quiet until you saw fit to let it be known or otherwise. Was that okay?

As for everything else, I still maintain that this is your party and that all you have to do is give the orders for me to carry out. And everything will be as it should be.

Lets know by airmail if there's anything you want me to do before leaving here. And give my best to Pauline, the children, Charles and Lorene, the Sullys, et al, and of course yourself. Until I hear from you and until I see you, don't forget to take care of yourself.

As ever,

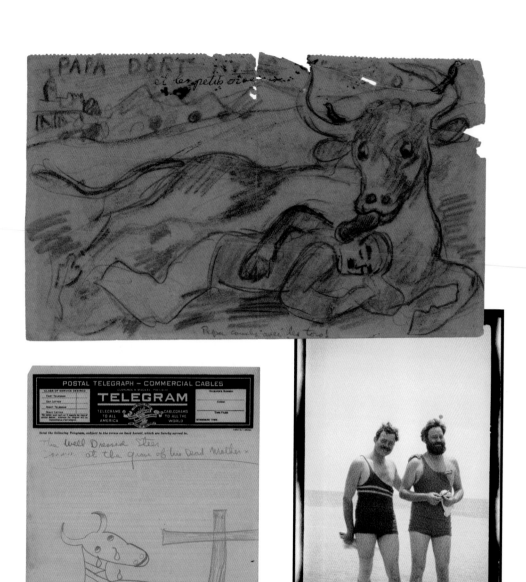

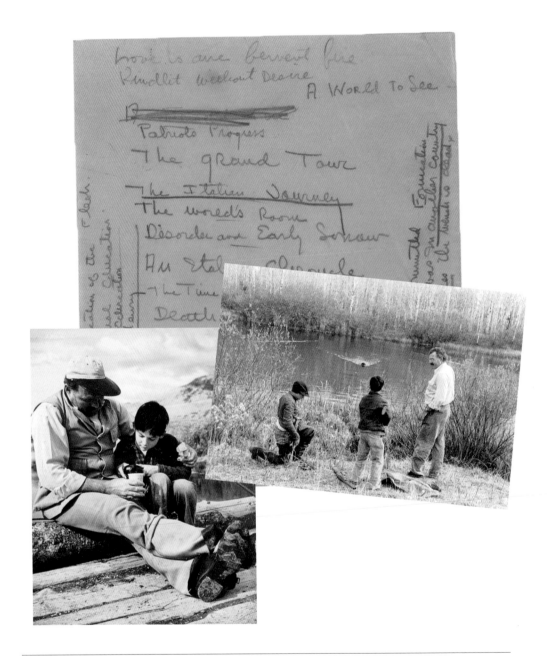

HEMINGWAY WITH HIS ARM AROUND GREGORY. ROBERT CAPA © INTERNATIONAL CENTER OF PHOTOGRAPHY / MAGNUM PHOTOS.

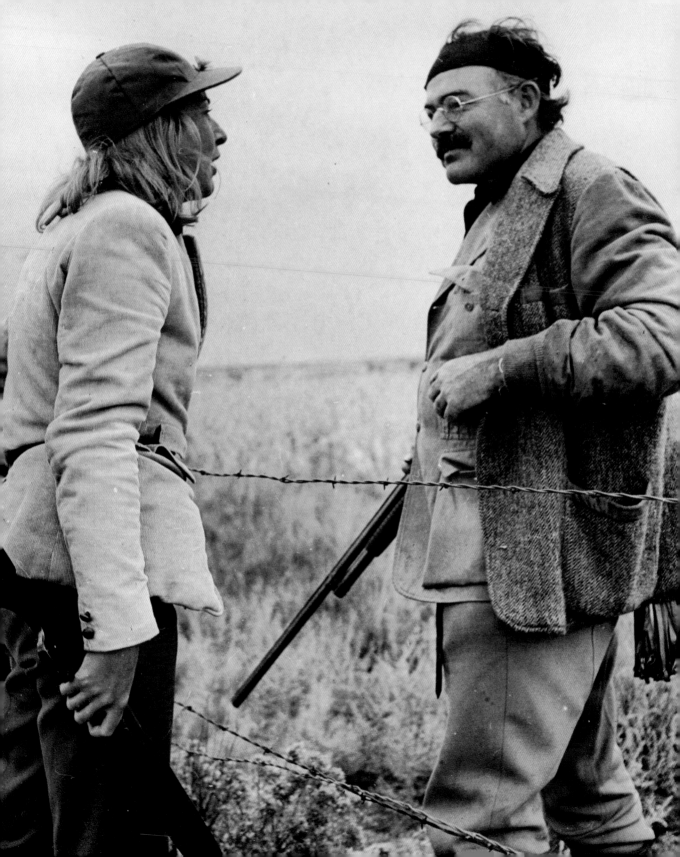

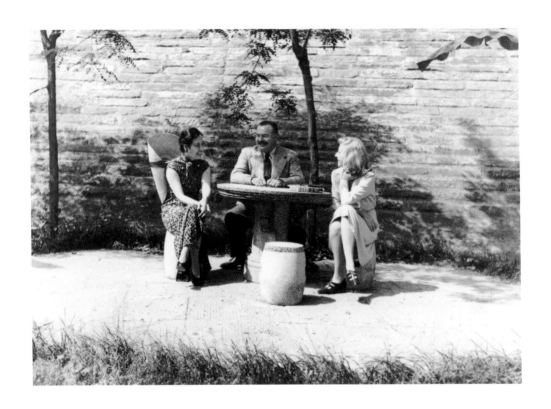

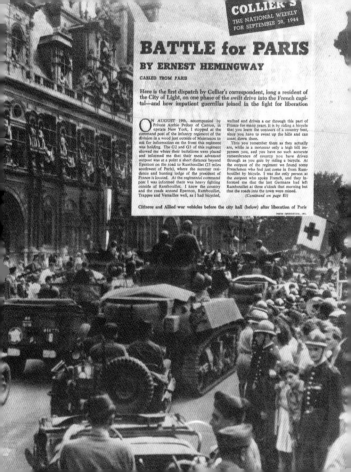

BATTLE for PARIS

BY ERNEST HEMINGWAY

CABLED FROM PARIS

Here is the first dispatch by Collier's correspondent, long a resident of the City of Light, on one phase of the swift drive into the French capital—and how impatient guerrillas joined in the fight for liberation

ON AUGUST 19th, accompanied by Private Archie Pelkey of Canton, in upstate New York, I stopped at the command post of the infantry regiment of the division in a wood just outside of Maintenon to ask for information on the front this regiment was holding. The G2 and G3 of this regiment showed me where their battalions were placed and informed me that their most advanced outpost was at a point a short distance beyond Epernon on the road to Rambouillet (23 miles southwest of Paris), where the summer residence and hunting lodge of the president of France is located. At the regimental command post I was informed there was heavy fighting outside of Rambouillet. I knew the country and the roads around Epernon, Rambouillet, Trappes and Versailles well, as I had bicycled,

walked and driven a car through this part of France for many years. It is by riding a bicycle that you learn the contours of a country best, since you learn to sweat up the hills and can coast down them.

Thus you remember them as they actually are, while in a motorcar only a high hill impresses you, and you have no such accurate remembrance of country you have driven through as you gain by riding a bicycle. At the outpost of the regiment we found some Frenchmen who had just come in from Rambouillet by bicycle. I was the only person at the outpost who spoke French, and they informed me that the last Germans had left Rambouillet at three o'clock that morning but that the roads into the town were mined.

(Continued on page 83)

Citizens and Allied war vehicles before the city hall (below) after liberation of Paris

PRESS ASSOCIATION, INC.

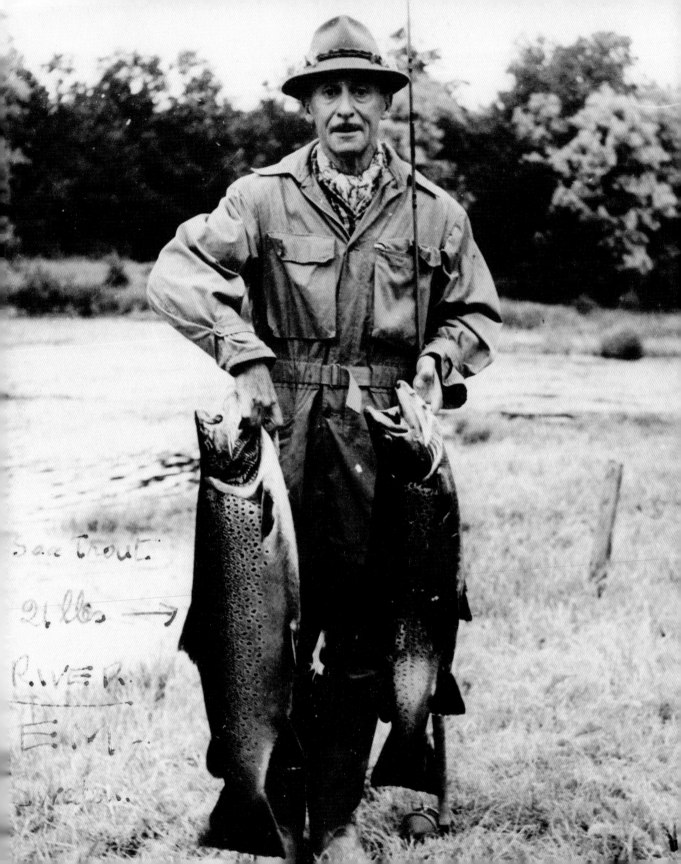

Sea trout.
2 lbs →

RIVER
E.M.
Duston.

HEMINGWAY OUTDOORS WITH FRIENDS. ROBERT CAPA © INTERNATIONAL CENTER OF PHOTOGRAPHY / MAGNUM PHOTOS.

Dear Bug; A notice has come that my clothes are in the customs; Mother will pick them up today. I am very grateful to you for sending them so promptly. I see that the weight is 165 pounds, which must have cost a fortune by air express so please let me know what it was so I can send you a check. And thank you again very much, and I hope it wasn't too much trouble.

I have found out how to ship my things to London. They should be packed and turned over to the Railway Express in Cuba; the Railway Express sends them to the American Express in NYC and thence they are shipped across to London. The way this works is to get a professional packer who will, if possible, put everything ⊖ including barrels of china -- into one big crate (as it costs less and is less likely to get lost in transit, if it is one package). Then this crate should be addressed: Martha Gellhorn, Dorchester Hotel, Park Lane, London, W.1. via American Express, 65 Broadway, NYC, and marked ATTENTION MR. PLUNKETT. Mr. Plunkett is the citizen at Amer Express who is handling all my stuff for shipment to London. It should be insured, overall risk, for $3000.00 plus shipping charges. That means that the insurance also covers the shipping charges; if crate is lost not only the value of the items but also the freight expenses are covered. In making out the customs declaration (the crate goes through NY in bond and only is subject to customs in England) the crate should be declared as containing used household furnishings and personal apparel etc. I know this is scracely a job for a healthy man but I feel sure Joy Kohly would supervise the packing and even round up the items if you give her the enclosed list. The packing should most certainly anyhow be done by a company, who specialize in that stuff, or everything will arrive broken. So just turn it over to her. (how do you like being a housewife,poor darling) and forget it.

You will see by the enclosed list that the things I want

are the possessions or presents of my family, and my clothes, papers,
typewriter. My whole house wouldn't be big enough for my room
furniture; but as I can easily imagine Mary would be much happier in
a room designed by and for her, whenever you get ready to change that
furniture let Mother know, and she will take over. (It will be a
question of having it crated and shipped to a storage company in NY,
but won't bother you with names and addresses now. She will tell you
all that, whenever you get ready to change that room.)

My dear Bug, I may not have been the best wife you ever had, but
at any rate I am surely the least expensive don't you think? That's
some virtue. As for the rest, whatever I had a share in (the ceiba
tree because I found it and even when, at the beginning you said,
"Well if this is where you live, I guess this is where you live", I
did know it was lovely -- do you remember what a stinker that house was,
fresh from the D'Orn's and painted poison green) I give it to you as
a wedding present and hope you are always happy there and that this
marriage is everything you have been looking for and everything you
needed. And I hope you go on writing wonderful books there, and if
you do the finca will one day become a national monument and be
tended by a grateful and admiring government. And meantime it also
makes a fine place for Mousie to paint; I think often of the colors and
the African view over the hills and the palm trees and think he must
be doing lovely things. It is a sorrow not to see Bumbi, not to see
Mousie's work, not to hear Gigi: I really expect I will never see any
of them again. However; I think I have learned all there is to know
about amputations; one has to learn all the time, doesn't one? I never
want to learn again; it seems to me a terribly enduring kind of
knowledge.

Take care of yourself and good luck. Love,

Mook

1) SILVER

I think all the silver, except the Normandie prize cup, and two
Gary Cooper cigarette ~~boxxxx~~ boxes, is stuff from my family: the
table silver (flat silver); silver plates, coffee service, candlesticks,
little cocktail shaker (birthday present from Mother) etc.

2) LINEN

All the monogammed or embroidered sheets and pillowcases, all the
monogramed towels -- hand towels and bathtowels -- mats and washrags
(these are sets), all the damask table linen/and ~~xxbxx~~ embroidered or *and napkins*
monogammed table mats/, all the lace doilies. *and napkins*

 new
There is plenty of ordinary/stuff which I bought in Cuba, sheets,
towels, mats etc., which can stay there. The other is easy to
distinguish because it is mostly old and otherwise has my initials on it.

3) CHINA and GLASS

The white and gold dinner service of my grandmother, the pretty
odd old plates of varying types and colors (not sets of them), the
Chinese stuff (keep half if you want it), the swedish glass wineglasses
and water glasses if any of them are left, the glass carafes -- white
and gold, very thin, the two small hurricane lamps (the big ones came
from Clara Speigel as a wedding present and are yours), the blue
Mexican wine glasses. The champagne glasses you gave me as a present,
so you had better keep them; you're more apt to have champagne anyhow.

There are two modern dinner or rather general use sets which
I bought, one yellow with flowers and one dead white, which can remain
for use until you improve on them.

4) CLOTHES and PAPERS

My typewriter, most important, and all the clothes -- can
give away very readily in England any extras, and all my papers. I
believe there was a tin trunk or a very big suitcase in the

basement under the little house, which was full of papers I had not
kept in my desk; I would like that too please. I think all my clothes
-- even the winter ones -- were packed in my various closets or
xxxx drawers, do not remember anything stored in the little house
basement. It's really impossible to divide books, not knowing what
was mine and what yours, so we'll just have to leave that. Anyhow I
ordered ax second hand Encyclopedia in a burst of enthusiasm so can
read it for the next twenty years, quite happily.

 I do very much want Cuco to have my gun. That's like a xxxxxxx
bequest. It might not even know how to shoot in England, and maybe
I won't shoot there anyhow. I don't know any shooting folks at
present and I have plenty of time anyhow to find another somewhere.
It's got a special kind of sentimental value, which perhaps is not a
sensible kind to carry around with one. The other old things, rounded
up by Mother for me, from many family sources, have not only $-- to me
-- great beauty and a sort of irreplaceability, but a feeling of
continuity. They will make me feel at home, I hope, and someday they
will go to little Martha, Alfred's child. Which is suitable.

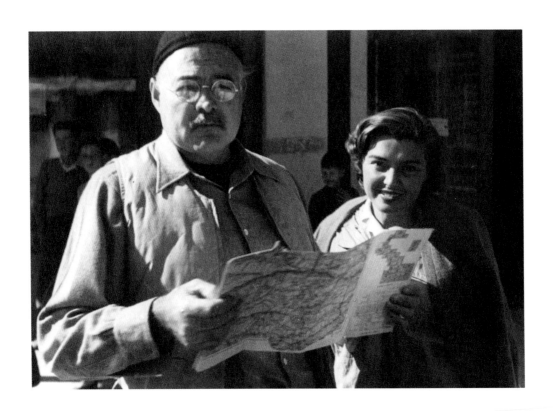

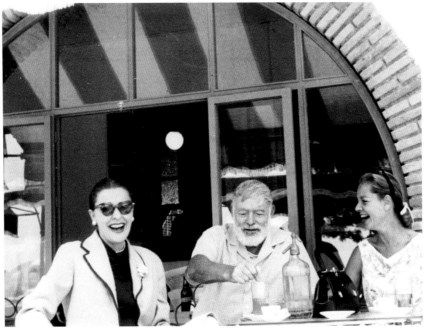

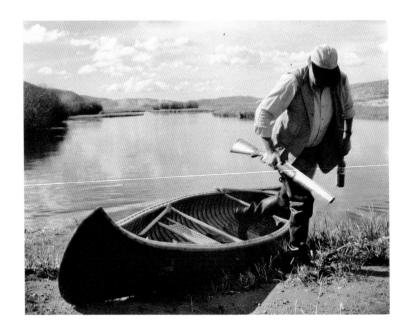

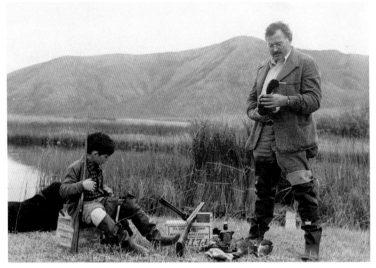

HEMINGWAY STEPPING FROM A CANOE WITH A RIFLE. ROBERT CAPA © INTERNATIONAL CENTER OF PHOTOGRAPHY / MAGNUM PHOTOS.

Yes, the Guy Hickok letters to you, but I'll do the MacLeish
letters - he and Ada were here once - and Mrs. Perkins etc., with

FINCA VIGIA, SAN FRANCISCO DE PAULA, CUBA

somebody to help me with them in N. Y. Mailing things is
such a chore.
Friday, Aug, 11th, 1961

*Dear Hadley*_Do forgive me, for obviously I mislead you

in the business of other people's letters to Ernest. We have had

two weeks of grueling work sorting out E's papers, burning his

own letters to insure that his wishes are carried out, discarding

mountains of papers of no importance and saving his notes, his

mss. and pieces thereof, and the letters of his friends. But I

did not at all intend to say that anyone would receive his

letters soon. With new rules and regulations here which restrain

the sending of anything of any kind out of here, it would be

difficult if not impossible to send packages of letters - too

complicated even to send books Ernest had autographed for people.

So I must first, somehow, get all the stuff, now

packed in wooden boxes, to the U. S. Then there must be a

re-sorting there (if we had tried to do the job completely here,

we should never finish it - and I have what seem to me to be good
reasons for feeling that the place should be put in order now,
while the P. M. is interested in the museum idea.)
It was the chance of noticing a packet of your
letters to Ernest that caused me to send you word of them, and
I intended to say clearly that I would get them to you when I
could. I'm sorry. It may not be for several months. Right now
I'm in the hands of the Cultural council of the Cuban gov't, who
do not appear to be very swift-moving. If the Cubans are going to
have the house, they ought to have some information about the ob-
jects in it, and I am eager to give it and be gone - but gov'ts.
are so slow. Next problem is getting my boxes and Val and me out-
and I am only beginning on that. Please excuse all
The " I " bits — Respects & love to you Mary

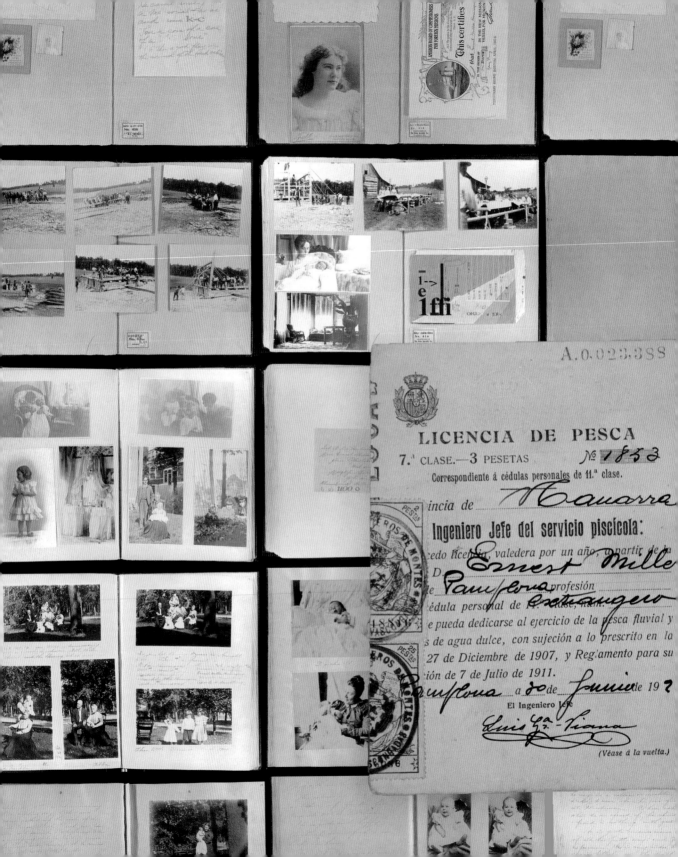

Endings

*. . . In the early morning on the lake sitting in
the stern of the boat with his father rowing,
he felt quite sure that he would never die.*
—*Ernest Hemingway, "Indian Camp"*

Columbia University
in the City of New York
SECRETARY OF THE UNIVERSITY

July 20, 1953

Mr. Ernest Hemingway
San Francisco de Paula
Cuba

Dear Mr. Hemingway:

On behalf of the President and the Trustees of
Columbia University, it is my pleasure to send you herewith
the certificate of the 1953 Pulitzer Prize in Letters
awarded to you.

Sincerely yours,

Richard Herpers

Richard Herpers
Secretary of the University

4

THE TRUSTEES OF COLUMBIA UNIVERSITY
IN THE CITY OF NEW YORK
TO ALL PERSONS TO WHOM THESE PRESENTS MAY COME GREETING
BE IT KNOWN THAT

ERNEST HEMINGWAY

HAS BEEN AWARDED
THE PULITZER PRIZE IN LETTERS FOR "THE OLD MAN AND
THE SEA" FOR DISTINGUISHED FICTION PUBLISHED IN
BOOK FORM DURING THE YEAR BY AN AMERICAN AUTHOR
IN ACCORDANCE WITH THE PROVISIONS OF THE STATUTES OF THE
UNIVERSITY GOVERNING SUCH AWARD
IN WITNESS WHEREOF WE HAVE CAUSED THIS CERTIFICATE TO BE
SIGNED BY THE PRESIDENT OF THE UNIVERSITY AND OUR CORPORATE
SEAL TO BE HERETO AFFIXED IN THE CITY OF NEW YORK ON THE
FOURTH DAY OF MAY IN THE YEAR OF
OUR LORD ONE THOUSAND NINE HUNDRED AND FIFTY-THREE

Grayson Kirk
PRESIDENT

CUP

<h1 style="text-align:center">ENDINGS</h1>

1953 is a year of enormous world change. Dr. Jonas Salk announces that a polio vaccine has been successfully tested. Edmund Hillary and Tenzing Norgay reach the summit of Mount Everest and Joseph Stalin, poet Dylan Thomas and playwright Eugene O'Neill die. Fidel Castro is arrested in Cuba and John F. Kennedy and Jacqueline Bouvier announce their engagement. Pope Pius XII pleads for clemency for convicted spies Julius and Ethel Rosenberg. President Eisenhower rejects the calls and both are executed at Sing Sing prison on June 19. Nikita Khrushchev is elected First Secretary of the Soviet Communist Committee and Hugh Hefner's magazine, *Playboy*, makes its debut with Marilyn Monroe its cover girl and centerfold. In Paris, the first human organ transplant is performed, and in the United States, homosexual employees of the government are dismissed by executive order. Ian Fleming publishes his first James Bond book, *Casino Royale*, and *Nature* magazine's article authored by James Watson and Francis Crick attempts to explain the "double helix" of DNA.

1953 is also a critical year in Hemingway's life. He wins the Pulitzer Prize, but events accelerate the decline of his health, with paranoia and depression becoming more apparent. Patrick Hemingway said that after the last African safari his father was never the same. The end comes in 1961 but 1953–54 is the beginning of the end. The year when Hemingway's legendary luck, while still holding, becomes more fickle. As Hemingway writes in *A Moveable Feast*, regarding his early Paris days, " 'We're always lucky,' I said and like a fool I did not knock on wood."

THE LAST SAFARI

In the autumn of 1952, Ernest Hemingway is in Cuba making plans. He wants to travel to Spain and Africa and contacts his old friend Philip Percival, who twenty years before had guided him and Pauline on their first safari. Ernest's son Patrick has settled in Tanganyika with his wife, "Henny" (Henrietta), and is writing his father reports on the game and his life, all of which whets Hemingway's appetite for adventure. In spite of being well off and the remarkable early success of *The Old Man and the Sea*, Hemingway remains unnecessarily concerned about his finances. He reaches an agreement with *Look* magazine to allow their photographer Earl Theisen to travel with the Hemingways to Africa for a photographic essay. Hemingway would be paid $15,000 for expenses and another $10,000 for a 3,500-word essay. He contacts

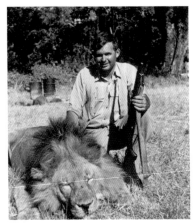

producer Leland Hayward and they agree to terms for the film option to *The Old Man and the Sea.*

ON JULY 11, 1953, ERNEST HEMINGWAY WRITES TO HIS SON PATRICK FROM PAMPLONA, SPAIN

Dear Mouse:

Thanks for your letter with the gen on how to reach your farm. We will arrive at Mombasa on Fernand de Lesseps Aug 27th and proceed to Potha-Machakos. Philip [Percival] is going out with us and he will have another character to do the work. Mayito [Menocal] is coming. He's very excited. We won't hit you until late in Sept. I think. We'll write you when Phillip and I staff it out. Am shipping guns etc, arms etc out to [O.M.] Rees in Nairobi.

Having a fine trip here getting the gen for an appendix to Death In The Afternoon on the evolution and decline of the modern bull fight. One marvelous matador though- Nino de la Palmas boy, Antonio Ordóñez. Better than his father on his father's best day.

Much love to you and Henny. Address c/o Guaranty Trust Co. of N.Y., 4 Place de la Concorde, Paris, France/cable address (GARRITOS). They will forward.

Papa

1. PATRICK "MOUSE" HEMINGWAY, HENRIETTA BROYLES HEMINGWAY, ON PORCH AT HOME IN TANGANYIKA WITH ERNEST HEMINGWAY WRITING INSIDE HOME AT TABLE. HEMINGWAY COLLECTION, JOHN F. KENNEDY PRESIDENTIAL LIBRARY AND MUSEUM, BOSTON. 2. PATRICK "MOUSE" HEMINGWAY POSING WITH LION AND GUN ON SAFARI WHILE IN AFRICA. COPYRIGHT JFK LIBRARY. OPPOSITE (LEFT TO RIGHT) 3. ERNEST HEMINGWAY SEATED AT A DESK WRITING. EARL THEISEN © ROXANN LIVINGSTON, COURTESY JFK LIBRARY 2018. 4. ERNEST HEMINGWAY WRITES AT A SMALL TABLE SET UP OUTSIDE NEXT TO A TENT IN A HUNTING CAMP IN AFRICA. EARL THEISEN © ROXANN LIVINGSTON, COURTESY JFK LIBRARY 2018. 5. ERNEST HEMINGWAY, SHIRTLESS, DRYING HIS ARMS WITH A TOWEL AT CAMPSITE. EARL THEISEN © ROXANN LIVINGSTON, COURTESY JFK LIBRARY 2018. 6. FRONT PAGE OF THE *DAILY MIRROR* CLAIMING THAT ERNEST HEMINGWAY AND MARY HEMINGWAY DIED IN A PLANE CRASH IN AFRICA. HEMINGWAY COLLECTION, JOHN F. KENNEDY PRESIDENTIAL LIBRARY AND MUSEUM, BOSTON. 7. ERNEST HEMINGWAY AND HIS TWO COLLEAGUES SIT AROUND THEIR CAMPFIRE WHILE ON A HUNTING EXPEDITION IN AFRICA. (LEFT TO RIGHT) PHILIP PERCIVAL, ERNEST HEMINGWAY AND GAME RANGER DENNIS ZAPHIRO. EARL THEISEN © ROXANN LIVINGSTON, COURTESY JFK LIBRARY 2018. 8. MARY HEMINGWAY WITH HER PET GAZELLE IN AFRICA. EARL THEISEN © ROXANN LIVINGSTON, COURTESY JFK LIBRARY 2018. 9. ERNEST HEMINGWAY WASHING HIS FEET AND MARY HEMINGWAY GETTING READY FOR BED. EARL THEISEN © ROXANN LIVINGSTON, COURTESY JFK LIBRARY 2018.

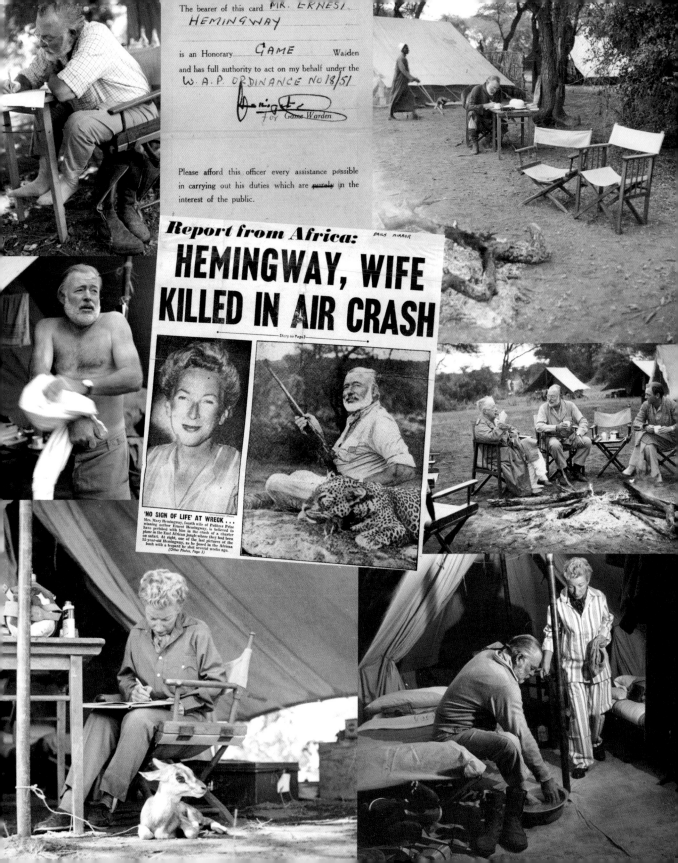

The bearer of this card MR. ERNEST HEMINGWAY

is an Honorary GAME Warden and has full authority to act on my behalf under the W.A.P. ORDINANCE NO 18/51

For Game Warden

Please afford this officer every assistance possible in carrying out his duties which are purely in the interest of the public.

Report from Africa:
HEMINGWAY, WIFE KILLED IN AIR CRASH

'NO SIGN OF LIFE' AT WRECK...

Mrs. Mary Hemingway, fourth wife of Pulitzer Prize winning author Ernest Hemingway, is believed to have perished with him in the crash of a charter plane in the East African jungle where they had been on safari. At right, one of the last pictures of the 55-year-old Hemingway, as he posed in the African bush with a leopard he shot several weeks ago. (Other Photos, Page 3)

NOTICE.

TO WHOM IT MAY CONCERN.

This is to certify that the bearers Mr. & Mrs. E.W.Hemingway, both United States Citizens were involed in an air crash at Butiaba in the Bunyoro District of Uganda on 24th January 1954 in which all their personal documents were destroyed. These included passport visitors immigration permits, driving licenses, arms licenses and all forms of identity.

I would be grateful if every assistance could be given to them until they can obtain fresh documents from the Immigration Authorities, United States Consul, and other departments in Entebbe and Nairobi.

ASSISTANT DISTRICT COMMISSIONER,
MASINDI.

Masindi
25th January, 1954.

Aircraft VP - KEF.

During Hemingway's trip, he is keeping up with voluminous letter writing. He's writing to Adriana Ivancich, his current female obsession, and to Bernard Berenson about the only woman who left him and who is never far from his thoughts, Martha Gellhorn. During this time, people are seeing that he is increasingly dismissive and abusive to his wife, Mary. Philip Percival prepares to guide the Hemingway party and on September 1, 1953, they leave Percival's farm in Kitanga for the Kajiado District's Southern Game Reserve, approximately forty miles to the south of Nairobi. The party would be in Africa until January 1954.

1954

In 1954, Hemingway's friend the photographer Robert Capa is killed after stepping on a landmine in Vietnam. Joe DiMaggio and Marilyn Monroe marry and divorce and journalist Edward R. Murrow criticizes Senator Joseph McCarthy on CBS's *See It Now*. Gamal Abdel Nasser seizes power in Egypt and Charles Lindbergh and John Patrick are awarded the Pulitzer Prize. The U.S. Supreme Court unanimously rules in favor of school integration in *Brown v. Board of Education of Topeka* and a meteorite strikes Mrs. Elizabeth Hodges in Alabama

while she is sleeping on her couch. She survives with minor injuries. Elvis Presley records "That's All Right (Mama)," his first commercial record, and in Montgomery, Alabama, Martin Luther King, Jr., becomes pastor of the Dexter Avenue Baptist Church. On November 1, General Fulgencio Batista is elected president of Cuba and on November 12, Ellis Island, after processing millions of immigrants since 1892, is closed. The Humane Society is created and the CIA overthrows the government of Guatemala. The head of United Fruit, Sam Zemurray, helps fund the overthrow.

Lassie premieres on CBS and J.R.R. Tolkien's *The Lord of the Rings* is published, as is Alice B. Toklas's memoir, *The Alice B. Toklas Cook Book*. Science fiction writer L. Ron Hubbard establishes the first church of Scientology.

THE GIFT

Mary Hemingway was an avid amateur photographer and loved sightseeing. Hemingway's 1954 Christmas gift to his wife was a plane trip over Lake Albert, the Serengeti Plain and Murchison Falls. The first day of the trip was one of beautiful landscapes and of memories of another safari with another wife. Roy Marsh was their pilot, the plane a Cessna 180. Marsh would fly low so Mary could take pictures, and Ernest identified the place where Pauline had shot her lion years before.

On the third day of the trip, January 23, 1954, Roy Marsh was flying around Murchison Falls when a large flock of birds flew in front of the plane. Marsh, trying to avoid a collision, dove and then struck an old telegraph wire. The plane crash-landed but did not catch fire. Unbelievably, no one was seriously hurt.

The party gathered essentials from the damaged plane, collected firewood and set up a rough camp for the night. The next day Hemingway said he had seen a boat. The boat was the *Murchison*. The Hemingways and Roy Marsh were allowed on board and traveled to the port of Butiaba on Lake Albert. Upon arrival another plane and pilot were waiting to fly them to Entebbe. The plane was a de Havilland Rapide of older vintage.

With Ernest, Mary and Marsh aboard, the pilot taxied and took off. The plane struggled, ascending and dropping, rising and dropping again, finally crashing to a stop at the end of the runway. This time the plane did catch fire. Mary was able to free herself and escaped through a window but Hemingway, too big for such an exit, used his head as a battering ram against the plane's frozen door. Repeated head butts finally had the door give way. Just as in the previous crash, everyone had gotten out alive but this time not unharmed. Hemingway's injuries were serious. Using his head as he did, Hemingway had fractured his skull and had a concussion. His other injuries were extensive but would not be diagnosed until the party arrived in Venice weeks later. There was temporary loss of vision in one eye, first-degree burns, a crushed ver-

tebra and some hearing loss. His kidney, spleen and liver were ruptured and his sphincter was temporarily paralyzed. Mary Hemingway suffered some broken ribs.

Amazingly, news of the crash had already traveled around the world with headlines announcing that the Hemingways were missing and another declaring that Mary and Ernest had been killed in the crash.

After the accidents Hemingway's behavior becomes troubling even to himself. He seems unable to break his repetitive and destructive habits and it worries him. To Bernard Berenson he writes, ". . . Due to the cerebral thing I say terrible things and hear myself say them. It is no good."

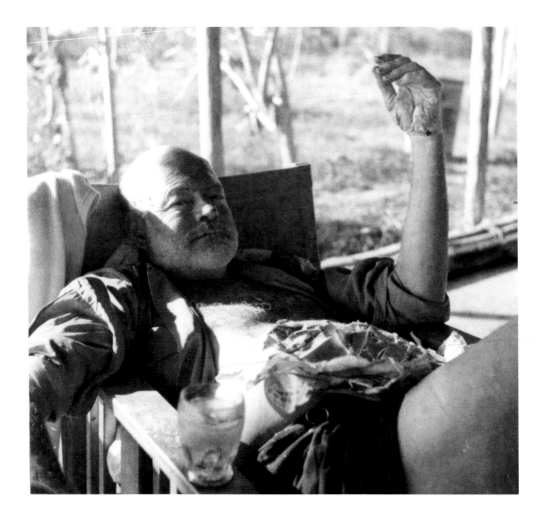

ERNEST HEMINGWAY AFTER FALLING INTO BRUSH FIRE, SHIMONI, KENYA. COPYRIGHT HEMINGWAY COLLECTION, JOHN F. KENNEDY PRESIDENTIAL LIBRARY AND MUSEUM, BOSTON.

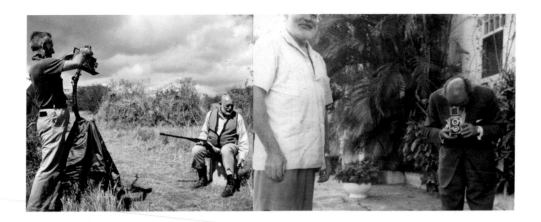

Patrick Hemingway, who is with him at the time, sees a change and worries that something has happened to his father's mind. Hemingway is drinking heavily, probably self-medicating because of pain. His doctors advise him to stop drinking because of his concussion and fractured skull. He seems more agitated and prone to arguments, one of which he has with Patrick. A short time later, at the south end of camp, a fire starts and Hemingway, in spite of his condition, goes to help. He loses his balance and falls into the fire, suffering serious burns to his torso and legs.

From Mombasa the Hemingways sail for Italy, arriving in Venice. Adriana, upon hearing of their return, goes to the Gritti Palace. She is reunited with an old man with white hair who is twenty pounds lighter and seems a shadow of the man she remembered. He looks like a different man. He is a different man.

In 1955 back in Cuba, Hemingway turns fifty-five and is trying to follow his doctors' advice. He reduces his drinking and slowly there is some improvement. In October it is announced that he has been awarded the Nobel Prize in Literature. All of Mary's efforts to protect his privacy are sabotaged by the crush of worldwide press and the many telegrams and letters of congratulation that must be answered, as well as Hemingway himself, who invites any and all to the Finca Vigía to visit. Some do, not just for hours, but days or weeks. Mary is increasingly exhausted, not just by Ernest but by the sudden death of her father and attending to the needs of her widowed mother. The pace of people and press, of lunches and drinking, finally becomes too much and in the autumn of 1955 Hemingway takes to his bed for two months, suffering from hepatitis and nephritis.

1. ERNEST HEMINGWAY POSES WITH RIFLE AS A PHOTOGRAPHER SNAPS A PICTURE. AFRICA. COPYRIGHT JFK LIBRARY. 2. YOUSUF KARSH PHOTOGRAPHS ERNEST HEMINGWAY OUTSIDE THE FINCA VIGÍA, CUBA, LATE 1950S. COPYRIGHT UKNOWN, HEMINGWAY COLLECTION, JOHN F. KENNEDY PRESIDENTIAL LIBRARY AND MUSEUM, BOSTON.

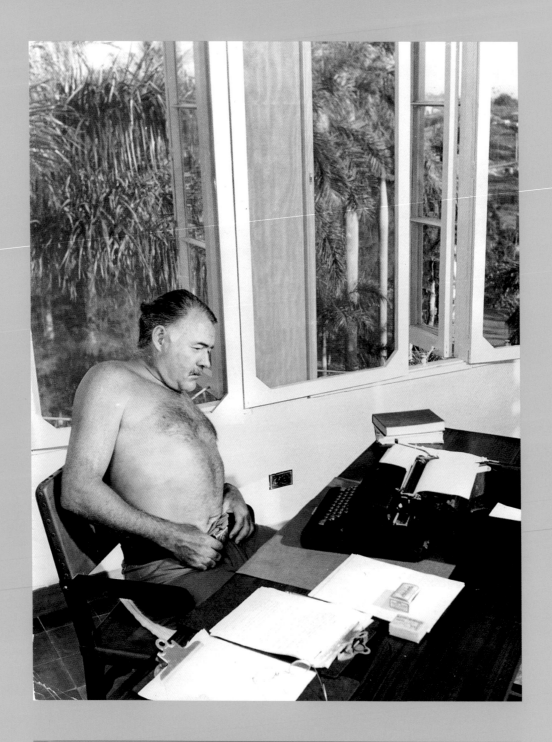

ERNEST HEMINGWAY AT TYPEWRITER, THE FINCA VIGÍA, SAN FRANCISCO DE PAULA, CUBA. HEMINGWAY COLLECTION, JOHN F. KENNEDY PRESIDENTIAL
LIBRARY AND MUSEUM, BOSTON.

1956

President Eisenhower orders "under God" to be added to the Pledge of Allegiance. Nelson Mandela is arrested and charged with treason in South Africa and Fidel Castro, along with Che Guevara and other armed men, travels to Cuba from Mexico aboard the ship *Granma*. The ship runs aground in Cuba and after being confronted by Batista's army, some of the men escape to the Sierra Maestras.

A crew from Hollywood arrives in Cuba in March to film some sequences for *The Old Man and the Sea*. It is a time of much commotion that will continue throughout the year. In June, *Look* magazine's Earl Theisen arrives for a photographic essay. The $5,000 Hemingway is paid helps fund his planned trip to Spain in August. The trip is one of remembrances and of extremes. Hemingway is visiting places and friends but his natural state of overexuberance has him drinking heavily again. His uncontrolled blood pressure and cholesterol are dangerously high. Again, Hemingway tries to reduce his drinking. The Hemingways return to Paris and, after New Year's 1957, travel back to the United States.

REVOLUTION AND THE END OF THINGS

In Montgomery, Alabama, on January 10, 1957, two church leaders' homes and four African American churches are bombed. Albert Camus wins the Nobel Prize in Literature, Senator Joseph McCarthy dies and Fidel Castro and his men are engaged in guerrilla activities in Cuba. In September 1958 the Hemingways travel to Idaho while Batista's government strictly enforces censorship, hoping to hide the fact that the government is under tremendous pressure from the rebels. In December, Batista flees Cuba and on January 8, 1959, Fidel Castro enters Havana to cheering crowds. President Eisenhower's administration officially recognizes Cuba's new government, and on January 13 Castro's regime executes former Batista associates who have been accused of war crimes.

The Hemingways return to Cuba in March 1959, but not before Ernest Hemingway purchases a home that overlooks the Wood River in Ketchum, Idaho. He buys the home as insurance in the event he will be unable to remain in Cuba. Mary Hemingway finds the home depressing.

In conversation with Patrick Hemingway, he has said that Cuba had been his father's home for decades. His books, friends and boat were there, and the sea. Ernest and Mary loved their home and Patrick believes that leaving his life and possessions deepened his father's depression and hastened his end. Patrick Hemingway, no fan of Sun Valley, once told this writer with a wry smile, "Can you imagine my dad dying in Sun Valley? A place like that? That's like Tolstoy dying in Cleveland. It doesn't seem to fit, does it?"

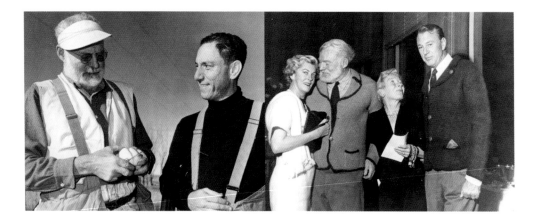

TO PATRICK HEMINGWAY, FROM KETCHUM, IDAHO, NOVEMBER 24, 1958

Dear Mouse;

. . . Cuba is really bad, Mouse. I am not a big fear danger pussy but living in a country where no one is right-both sides atrocious-knowing what sort of stuff and murder will go on when the new ones come in-seeing the abuses of those in now-I am fed on it. We are always treated OK as in all countries and have fine good friends. But things aren't good and the overhead is murder. This is confidential completely. Might pull out of there. Future looks very bad and there has been no fishing in the Gulf for 2 years-and will be eventually no freedom coastwise and all the old places ruined.

TO L. H. BRAGUE, JR., FROM KETCHUM, IDAHO, JANUARY 24, 1959

Dear Harry

. . . Things are OK with us in Cuba. A friend I was in Spain with is one of the new govt. He called me up here to say everything OK. Had been out at the Finca. Officer commanding Havana Garrison is an old S.F. de Paula boy who used to play ball on local team I used to pitch for. Jamie Bofils who called me said they were waiting to give us a big welcome. With all the vested U.S. interests they will be bucking to try and give the Cubans a square shake for the first time ever. It will be a very rough time. I knew Phil Bonsal the new Ambassador when he used to work for I.T.T. before he went to the State Dept. He and Pauline and her sister Jinny and I went to the Feria in Salamanca together in 1953 [1933]. He is a very sound able guy but will naturally be working for our interests some of which are run OK (like United Fruit) and some very un-OK with terrific deals made with [Fulgencio] Batista. [Fidel] Castro is up against a hell of a lot of money. The Island is so rich and has always been stolen blind. If he could run a straight government it would be wonderful. Batista looted it naked when he left. He must have 600 to 800 millions and that will buy a lot of newspapermen- and has.

1. ERNEST HEMINGWAY AND AARON HOTCHNER IN KETCHUM. HEMINGWAY COLLECTION, JOHN F. KENNEDY PRESIDENTIAL LIBRARY AND MUSEUM, BOSTON.
2. ROCKY COOPER, ERNEST HEMINGWAY, MARY HEMINGWAY AND GARY COOPER AT SUN VALLEY, IDAHO, 1950s. HEMINGWAY COLLECTION, JOHN F. KENNEDY PRESIDENTIAL LIBRARY AND MUSEUM, BOSTON.

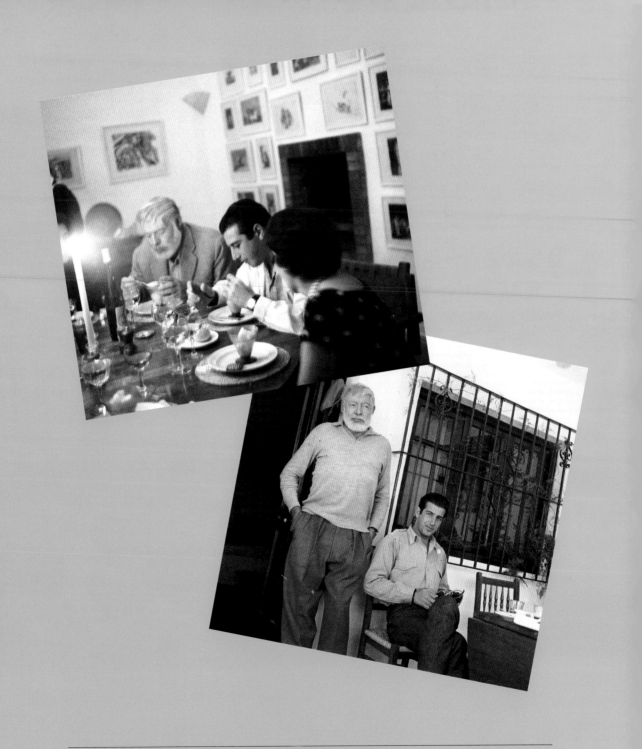

1. ERNEST HEMINGWAY, ANTONIO ORDÓÑEZ, ADRIANA IVANCICH AND OTHERS DINING AT VALCARGADO, ORDÓÑEZ'S RANCH NEAR CÁDIZ, SPAIN. HEMINGWAY COLLECTION, JOHN F. KENNEDY PRESIDENTIAL LIBRARY AND MUSEUM, BOSTON. 2. ERNEST HEMINGWAY VISITS WITH SPANISH MATADOR ANTONIO ORDÓÑEZ AT VALCARGADO. HEMINGWAY COLLECTION, JOHN F. KENNEDY PRESIDENTIAL LIBRARY AND MUSEUM, BOSTON.

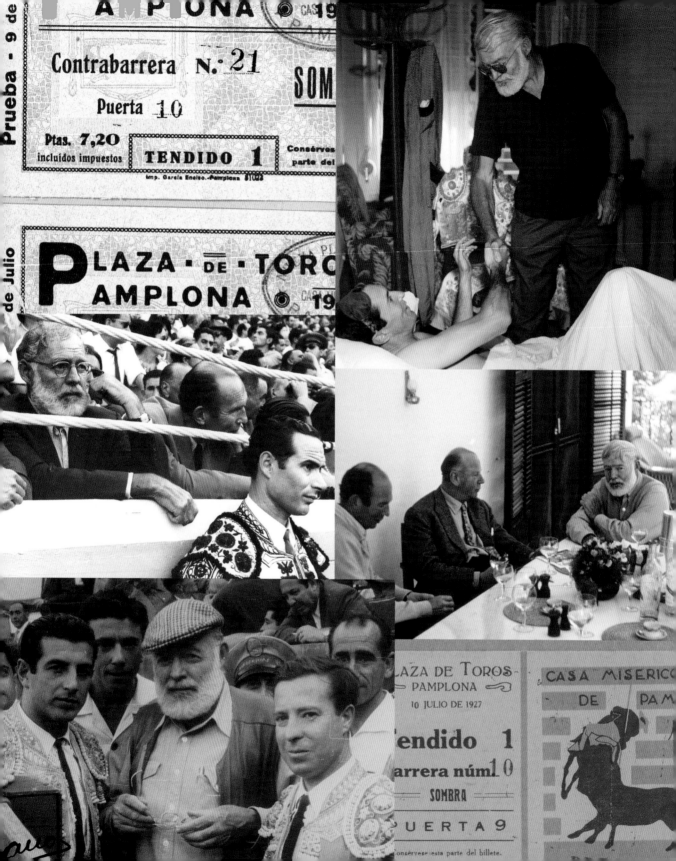

Contrabarrera N.° 21

Puerta 10

Ptas. 7,20
incluídos impuestos

TENDIDO 1

Consérves
parte del

Imp. García Enciso.-Pamplona 81022

PLAZA · DE · TORO
PAMPLONA

PLAZA DE TOROS
PAMPLONA

10 JULIO DE 1927

endido 1

arrera núm 10

SOMBRA

UERTA 9

conservese esta parte del billete.

CASA MISERICO
DE PA

1959 AND ONE MORE GOOD TIME

In 1959 singer Billie Holiday dies at age forty-four. Alaska becomes America's forty-ninth state and on January 21, after some international criticism, Fidel Castro addresses a crowd in Havana's Central Park requesting support for the executions of what he terms Batista's "henchmen." The crowd is reported to have burst into applause that goes on for two minutes. On February 16 Castro becomes prime minister of Cuba. By March 19 the Castro government has executed 483 people.

In April, the Hemingways sail from New York to the port of Algeciras. Hemingway's friend Bill Davis meets them. Hemingway will travel through Spain with friends, attend the *ferias* and record the competition between matador brothers-in-law Antonio Ordóñez and Miguel Dominguín. The result will be Hemingway's *The Dangerous Summer*. During the trip, Hemingway displays a youthful enthusiasm and revels in the bullfights, publicity, picnics and friends. He will celebrate his sixtieth birthday at Bill and Annie Davis's home, La Consula, outside of Málaga. During this time, tensions between Mary and Ernest intensify. People close to them realize that something is very wrong with Ernest. Mary Hemingway works hard to create an elaborate birthday celebration for him with friends arriving from around the world.

He is nice, then apologizes for his bad behavior only to turn abusive and critical again. The abuses followed by apologies and then round again leave Mary Hemingway exhausted, and for

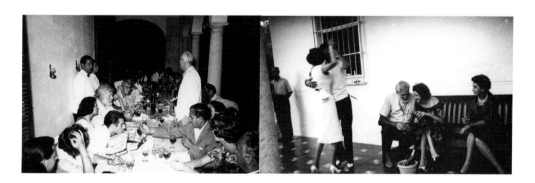

1. (LEFT TO RIGHT) TWO BULLFIGHTING TICKET STUBS, PLAZA DE TOROS, PAMPLONA. HEMINGWAY COLLECTION, JOHN F. KENNEDY PRESIDENTIAL LIBRARY AND MUSEUM, BOSTON. 2. ERNEST HEMINGWAY GREETS THE MATADOR LUIS MIGUEL DOMINGUÍN DURING DOMINGUÍN'S REST, SPAIN, 1959. HEMINGWAY COLLECTION, JOHN F. KENNEDY PRESIDENTIAL LIBRARY AND MUSEUM, BOSTON. 3. ERNEST HEMINGWAY, NATHAN "BILL" DAVIS, PAT SAVIERS AND OTHERS SPECTATING A BULLFIGHT AT PLAZA DE TOROS, BILBAO, SPAIN. HEMINGWAY COLLECTION, JOHN F. KENNEDY PRESIDENTIAL LIBRARY AND MUSEUM, BOSTON. 4. BILL DAVIS, RUPERT BELLVILLE AND ERNEST HEMINGWAY DINING AT LA CONSULA, NEAR MÁLAGA, SPAIN, 1959. HEMINGWAY COLLECTION, JOHN F. KENNEDY PRESIDENTIAL LIBRARY AND MUSEUM, BOSTON. 5. ANTONIO ORDÓÑEZ, ERNEST HEMINGWAY AND PEPE LUIS VÁZQUEZ AT A CORRIDA IN ZARAGOZA, SPAIN. HEMINGWAY COLLECTION, JOHN F. KENNEDY PRESIDENTIAL LIBRARY AND MUSEUM, BOSTON. 6. HEMINGWAY COLLECTION, JOHN F. KENNEDY PRESIDENTIAL LIBRARY AND MUSEUM, BOSTON. ABOVE: 7. ERNEST HEMINGWAY OPENING GIFTS WITH CARMEN ORDÓÑEZ, ANTONIO ORDÓÑEZ, CHARLES "BUCK" LANHAM, U.S. AMBASSADOR DAVID BRUCE, MAHARAJA JAGADDIPENDRA NARAYAN AND OTHER GUESTS DURING HEMINGWAY'S SIXTIETH BIRTHDAY PARTY AT LA CONSULA. FRANCISCO CANO PHOTOGRAPH, HEMINGWAY COLLECTION, JOHN F. KENNEDY PRESIDENTIAL LIBRARY AND MUSEUM, BOSTON. 8. ANTONIO DANCING WITH HIS WIFE, CARMEN ORDÓÑEZ, ERNEST HEMINGWAY TALKING TO VALERIE DANBY-SMITH, ADRIANA IVANCICH AND OTHER UNIDENTIFIED GUESTS DURING HEMINGWAY'S SIXTIETH BIRTHDAY PARTY AT LA CONSULA. FRANCISCO CANO PHOTOGRAPH, HEMINGWAY COLLECTION, JOHN F. KENNEDY PRESIDENTIAL LIBRARY AND MUSEUM, BOSTON.

the first time she considers that her marriage may be over. Though people see that something is not right, Mary will remain in denial about the possibility of her husband's mental illness. In one ugly exchange Hemingway accuses his wife of being just like his mother and brings up the old charge that she had driven his father to suicide. Mary Hemingway will take some time from her husband in October, traveling back to Cuba. Ernest travels to Paris. Mary writes to her husband, questioning if he loves her or if there is any need for them to stay together. The pattern is the same. Hemingway responds that he loves her and once again Mary believes that perhaps things will improve.

GOODBYE TO ALL THAT

In the new year of 1960 Mary and Ernest are in Ketchum. Mary notices that Ernest seems more agitated, is not sleeping well and having some difficulty writing. She feels that the brisk air and beautiful country will pull him from his mood. Then, one evening while dining with friends, Hemingway looks out the window and sees a light in a building he believes to be his bank. He becomes agitated and starts to say that people are checking his accounts. When pressed, he says it is the FBI.

As the days pass the delusions and mood swings intensify. Mary's denial begins to evaporate. Fear and confusion start to take hold.

On November 30, 1960, Hemingway is flown to Rochester, Minnesota, in secrecy. Mary travels on a separate flight with both assuming the names of Mr. and Mrs. George Saviers. At the Mayo Clinic doctors hope to find answers, regarding not only his elevated blood pressure, but reasons and treatment for his mental difficulties. Mary keeps the real reason of the visit from her husband's sons, saying he is just there for a checkup and all is going well. As test results come in, a possible link between Hemingway's depression and delusions are thought to be caused by the drug reserpine, which he is taking for high blood pressure. The drug is discontinued. The delusions continue and Dr. Howard Rome, a psychiatrist at the Mayo Clinic, advises, and then administers, electric shock treatments. Hemingway is released from the Mayo Clinic on January 22, 1961. He says that he is eager to get back to work and while he is still experiencing some depression and delusions, the doctors feel he is well enough to return to Idaho. Back in Ketchum, Hemingway becomes more agitated and fearful. He sits at his desk day after day but the words do not come. His paranoia deepens with growing fears of FBI surveillance. Dr. Saviers, Hemingway's personal physician, keeps a close eye on his friend, visiting every day to check on Hemingway's blood pressure and mood. On one such visit the doctor finds his patient in tears as he confides that he can no longer write. Hemingway becomes more abusive to Mary, especially in the evenings. On the morning of April 21, Mary discovers Hemingway in the living room with a shotgun in his hands. He is silent and withdrawn. She speaks to him

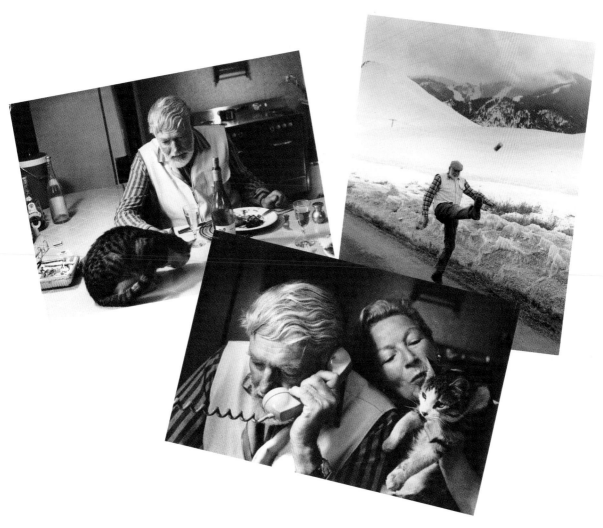

softly and continuously, hoping to buy time until Dr. Saviers's arrival. When he does arrive, he convinces Hemingway to give him the gun. After he is sedated it is decided that he will return to the Mayo Clinic. He will attempt suicide two more times before arriving in Rochester.

While taking treatment in Rochester, Ernest Hemingway learns that Dr. George Saviers's nine-year-old son, Frederick, known as Fritz, is in a Colorado hospital suffering from the viral heart disease that will end his young life on March 11, 1967. In spite of Hemingway's deteriorating condition he takes time to write the boy a beautiful and moving letter that demonstrates an innate and sincere kindness.

TO FREDERICK G. SAVIERS, JUNE 15, 1961

Dear Fritz:

I was terribly sorry to hear this morning in a note from your father that you were laid up in Denver for a few days more and speed off this note to tell you how much I hope you'll be feeling better.

It has been very hot and muggy here in Rochester but the last two days it has turned cool and lovely with the nights wonderful for sleeping. The country is beautiful around here and I've had a chance to see some wonderful country along the Mississippi where they used to drive the logs in the old lumbering days and the trails where the pioneers came north. Saw some good bass jump in the river. I never knew anything about the upper Mississippi before and it is really a very beautiful country and there are plenty of pheasants and ducks in the fall.

But not as many as in Idaho and I hope we'll both be back there shortly and can joke about our hospital experiences together.

Best always to you, old timer from your good friend who misses you very much.

(Mister) Papa

Dr. Rome again attends to Hemingway and at the end of June releases his patient. Mary Hemingway believes her husband has fooled the doctors and is not well enough to return home. Ernest's old friend George Brown flies to Minnesota from New York to drive Mary and Ernest back to Ketchum. It does not take long for Mary's fears to be realized. Driving back, Hemingway becomes agitated and fearful, believing police will stop and arrest them all for having wine in the car. Hemingway remains agitated as Mary and George attempt to keep things as calm and comfortable for Ernest as possible. They arrive in Ketchum on June 30, 1961.

The following evening Ernest and Mary Hemingway take Dr. and Mrs. Saviers to dinner. Hemingway is at first calm but soon becomes convinced that some people in the restaurant are FBI agents who are watching him.

Returning home, Ernest is in an upbeat mood. On this night, husband and wife will sleep in their separate bedrooms. They begin singing Italian songs and then Ernest calls out to Mary, "Good night, my kitten." The moment is lovely.

The next day Ernest Hemingway rises early, puts on the robe Mary had made for him years before and descends the stairs to the basement to retrieve a shotgun and shells. He climbs the stairs, walks to the front hall and ends his life.

1. ERNEST HEMINGWAY DRINKING FROM A BOTA BAG, KETCHUM, IDAHO. BRYSON PAPERS, HEMINGWAY COLLECTION, JOHN F. KENNEDY PRESIDENTIAL LIBRARY AND MUSEUM, BOSTON. 2. HEMINGWAY WALKING IN KETCHUM. JOHN BRYSON © 2017 BRYSON PHOTO. HEMINGWAY COLLECTION, JOHN F. KENNEDY PRESIDENTIAL LIBRARY AND MUSEUM, BOSTON.

Sag Harbor
July 1961

Dear Pat,
. . . The first thing we heard of Ernest Hemingway's death was a call from the London Daily Mail, asking me to comment on it. And quite privately, although something of this sort might have been expected, I find it shocking. He had only one theme-only one. A man contends with the forces of the world, called fate, and meets them with courage. Surely a man has a right to remove his own life but you'll find no such possibility in any of H's heros. The sad thing is that I think he would have hated accident much more than suicide. He was an incredibly vain man. An accident while cleaning a gun would have violated everything he was vain about. To shoot yourself with a shot gun in the head is almost impossible unless it is planned. Most such accidents happen when a gun falls, and then the wound is usually in the abdomen. A practiced man does not load a gun while cleaning it. H. had a contempt for mugs. And only a mug would have such an accident. On the other hand, from what I've read, he seems to have undergone a personality change in the last year or so. Certainly his last summer in Spain and the resulting reporting in Life were not in his manner. Perhaps, as Paul de Kruif told me, he had had a series of strokes. That would account for the change.

But apart from all that –he has had the most profound effect on writing-more than anyone I can think of. He has not a vestige of humor. It's a strange life. Always he tried to prove something. And you only try to prove what you aren't sure of. He was the critics' darling because he never changed style, theme nor story. He made no experiments in thinking nor in emotion. A little like Capa, he created an ideal image of himself and then tried to live it. I am saddened at his death. I never knew him well, met him a very few times and he was always pleasant and kind to me although I am told that privately he spoke very disparagingly of my efforts. But then he thought of other living writers, not as contemporaries but as antagonists. He really cared about his immortality as though he weren't sure of it. And there is little doubt that he has it.

One thing interests me very much. For a number of years he has talked about a big book he was writing and then about several books written and put away for future publication. I have never believed these books exist and will be astonished if they do. A writer's first impulse is to let someone read it. Of course I may be wrong and he may be the exception. For the London Daily Express, I have two lines by a better writer than either of us. When they call this morning, Elaine will dictate them over the cable. They go-
He was a man, take him all in all,
I shall not look upon his like again. . . .

Prosit
John

ERNEST HEMINGWAY STANDS ON A ROAD AND LOOKS INTO WOODS IN KETCHUM, IDAHO. JOHN BRYSON © 2017 BRYSON PHOTO. HEMINGWAY
COLLECTION, JOHN F. KENNEDY PRESIDENTIAL LIBRARY AND MUSEUM, BOSTON.

July 26, 1955

Mr. Ernest Hemingway
c/o Charles Scribner's Sons
597 5th Avenue
New York, New York

Dear Mr. Hemingway:

I am completing a book on political courage--the stories
of Senators who risked their careers by speaking out for principles
which were extremely unpopular among their constituents. I am most
anxious to use in the text a definition of "courage" as "grace under
pressure" which I recall was attributed to you. I am planning to
open the book by quoting this definition and stating that the book
contains the stories of the pressures operating on eight courageous
Senators, and the grace with which they endured those pressures.

Unfortunately, I am unable to find the source of this
quotation or verify your authorship of it. I wonder if you recall
the phrase and would be kind enough to let me know so I might use
it in the manner suggested.

Thank you in advance for your help in this matter.

Sincerely,

John F. Kennedy

JFK:gl

It was some thirty years after the fact that I recalled my introduction to Ernest Hemingway. The assignment was to read the story "Soldier's Home" before watching its film adaptation in class the next day. I was a senior in high school in a small town in Maine. At seventeen, I was not prepared to understand what it meant for Harold Krebs, the story's protagonist, to return to his midwestern home after service in World War I. Yet the character made a lasting impression.

Twenty-five years later, when I landed a job at the Kennedy Library, it was all I could do initially to familiarize myself with the history of John F. Kennedy and his presidency. And though my office was on the same floor as the Hemingway Room, where scholars come to study the great writer, I gave it a wide berth—aware of how little I knew about the Nobel Prize winner, his oeuvre, and the treasures held beyond the room's intimidating threshold.

A few years later, when I became the Library's deputy director (and ironically left the Hemingway floor), I realized it was time to educate myself. I began steadily reading Hemingway biographies and as much of his work as possible. For years my daily commute consisted of listening to our local library's audio recordings of Hemingway's novels, short stories and essays.

I recall one particular late afternoon, driving as the actor Stacy Keach read from the *Complete Short Stories* collection, when I heard these opening words:

Krebs went to the war from a Methodist college in Kansas. There is a picture which shows him among his fraternity brothers, all of them wearing exactly the same height and style collar. He enlisted in the Marines in 1917 and did not return to the United States until the second division returned from the Rhine in the summer of 1919.

There is a picture which shows him on the Rhine with two German girls and another corporal. Krebs and the corporal look too big for their uniforms. The German girls are not beautiful. The Rhine does not show in the picture.

By the time Krebs returned to his home town in Oklahoma the greeting of heroes was over. He came back much too late. The men from the town who had been drafted had all been welcomed elaborately on their return. There had been a great deal of hys-

teria. Now the reaction had set in. People seemed to think it was rather ridiculous for Krebs to be getting back so late, years after the war was over.

The passage was familiar and as the plot unfolded I was transported back to my high school years. I listened to the story a few times, found a library copy of the same 1970s film adaptation and, watching it at home, tried to reconnect to my earlier incarnation, wondering what I, as a teen, had made of this tale.

I was a complete innocent in those days, having lived a blissfully protected life. Hemingway's references to sex and violence would certainly have escaped my understanding. Krebs's sense of dislocation on returning home from war was similarly unfathomable. Though perhaps his itch to be part of the wider world, beyond the confines of one's insular community, may have resonated with my former self as I readied for college.

As the opening words portend, the story is premised on Krebs having arrived home later than all the other veterans whose war stories have begun to grow old. As the plot unfolds Krebs finds himself embellishing his battlefield experiences to impress family and friends. In so doing, he grows more disillusioned—finding himself becoming a fraud.

The story's ending is devastating for Krebs's mother, whom he tells he does not love her anymore, as he does not know how to love anyone anymore. Krebs instantly regrets having hurt her feelings and decides it is best for him to leave home immediately and begin life anew in Kansas City. Before he goes, he stops to watch his kid sister play baseball—a game he taught her before the war.

There's hope at the story's end. Despite the horrors he has experienced, Krebs will persevere, the reader surmises, if he remains true to himself. His future decisions will not be driven by the external institutions of his childhood—family, church and country. Instead, like many of Hemingway's characters, he needs only to find the courage to follow his moral compass and remain true to his convictions.

Much of Hemingway's work is semiautobiographical. As a nineteen-year-old, he had his own experience in World War I in which he was gravely injured. His homecoming to Oak Park, after recuperating for months in a hospital in Italy, was also fraught with tension as he discovered the troubles of coming home again. He had difficulties living with his parents, spent a summer at his family's camp in Michigan (where the disagreements continued), fell in love, married and forged a new life for himself as an expatriate living and writing in Paris.

Despite the turmoil he experienced with his own family, in "Soldier's Home," Hemingway paints a sympathetic portrayal of Mrs. Krebs. The reader empathizes with her attempts to engage with her son—offering him the keys to the family car, making him his favorite breakfast, encouraging him to find a job and a girl. But those efforts are doomed.

March 20 – 1925

Dear Dad —

Thanks for your fine letter enclosing the K.C. Star review. I'm so glad you liked the Doctor story. I put in Dick Boulton and Billy Tabeshaw as real people with their real names because it was pretty sure they would never read the Transatlantic Review. I've written a number of stories about the Michigan country — the country is always true — what happens in the stories is fiction.

This Quarter — a new quarterly review is publishing a long fishing story of mine in 2 parts called Big Two Hearted River. It should be out the first of April. I'll try and get it for you. The river in it is really the Fox above Seney. It is a story I think you will like.

The reason I have not sent you any of my work is because you or Mother sent back the In Our Time books. That looked as though you did not want to see any.

48

(2)

You see I'm trying in all my stories to get the feeling of the actual life across - not to just depict life - or criticize it - but to actually make it alive. So that when you have read something by me you actually experience the thing. You can't do this without pulling in the bad and the ugly as well as what is beautiful. Because if it is all beautiful you can't believe in it. Things aren't that way.

It is only by showing both sides - 3 dimensions and if possible 4 that you can write the way I want to.

So when you see anything of mine that you don't like remember that I'm sincere in doing it and that I'm working toward something. If I write an ugly story that might be hateful to you or to mother the next one might be one that you would like exceedingly.

49

The final scene when she asks Harold to kneel and pray with her—a request he, being true to himself, refuses—offers a fictional parallel to Hemingway's own falling-out with his parents. Biographers have plenty to say on this matter. For me, insight into Hemingway's relationship with his parents can best be found in the letter he wrote to his father at just the time "Soldier's Home" was initially published. This was the letter in which, as a young man, Hemingway declared his independence from his parents after the publication of *In Our Time*.

The letter is one among thousands that are housed at the Kennedy Library, and seeing it in Hemingway's own hand makes a profound impression. We know him now as a budding author on the cusp of literary immortality. Yet here we see him as a hopeful son expressing his artistic credo and seeking his father's approval. And one can imagine those very sheets of paper being held in his parents' trembling hands as they try to understand their talented son's emerging artistry tempered by their displeasure with the taboo topics he has chosen for his stories.

In my role as the Kennedy Library director, I was involved in forging a partnership with the Morgan Library & Museum to mount an exhibit—"Hemingway: Between Two Wars"—which opened in New York City in 2015 and traveled to Boston for a 2016 run. The curation of the show was left to the experts. I had no hand in it and did not know which items would be selected for display. So I was delighted when first viewing the show to see mounted on the wall a piece of 1924 telegraph-office stationery with these words in Hemingway's iconic handwriting:

"After he was discharged from the Marine Corps Krebs went home to Kansas. He got home too late. The young men from his town who had enlisted in the National Guard or been drafted had all come home months before. The war was well over. The reaction to the war time hysteria (feelings) had set in."

When we read a great novel or short story it is in finished form. One can easily forget the drafts and proofs that preceded it. Seeing those up close, especially when handwritten, with phrasing that, while similar, is not quite the same as the final publication, reminds us of the creative process that crafted the words we have come to know. And most important it allows a unique connection to the author from whose imagination and fingertips these characters and scenes have sprung.

Such is the power of manuscripts. As one looks at Hemingway's early drafts on Western Union or Red Cross stationery it is as if one were "there at the creation," glancing over Hemingway's shoulder as he wrote words that would exist for all time. The real jewel of the Ernest Hemingway Collection are these original manuscripts, for it was through his works of fiction that Hemingway revolutionized world literature and captured snapshots of the early twentieth century that will forever serve as touchstones of his era. But the collection includes much more. It is a treasure trove for researchers, filmmakers and aficionados who come to Boston to learn about the man and his works.

The letters he wrote to his family, lovers, friends, rivals and publishers provide an incomparable glimpse of Ernest Hemingway and the world as he experienced it. The photo collection allows us to see him as a boy in Oak Park, recuperating with wounded soldiers in Italy, at his first wedding in Michigan, with friends in the cafés of Montparnasse, in the bullrings of Pamplona, on the savanna in Africa, in New York City with other literati, with his children on the quayside, on his boat off the coast of Havana and scattered among all of these images, always: Hemingway, the writer—at his desk, camp table or typewriter.

And there are also myriad artifacts and ephemera that bring his encounters with the world to life. Hemingway saved everything, ranging from a listing of his personal property at age fifteen (including mention of "1 pair of disreputable pants") to bullfight tickets, antelope heads and five original paintings that once hung in his homes in Paris, Key West and Cuba.

The Ernest Hemingway Collection is the greatest literary treasure held by the United States National Archives. It is the only major twentieth-century literary collection that is owned by the American people. What an honor it was to serve as the Kennedy Library director and be responsible for its stewardship and for making the materials accessible to students, teachers, researchers and the general public.

In 1964, when describing the future of the Kennedy Library, Jacqueline Kennedy stated: "Because John Kennedy was so involved in life, his library will be not just a repository of papers and relics of the past. It will also be a vital center of education and exchange and thought, which will grow and change with the times. . . . I hope that in the years to come the Kennedy Library will be not only a memorial to President Kennedy but a living center of study of the times in which he lived, which will inspire the ideals of democracy and freedom in young people all over the world."

At the time she likely did not have in mind dedicating a room to Ernest Hemingway at her late husband's library, which would become the home to the most comprehensive Hemingway archive in the world. Yet what better way to survey the years in which JFK and his generation lived and to inspire the ideals of personal freedom that Hemingway grappled with so masterfully in his work.

By coincidence it was also in 1964 that Mrs. Kennedy was first contacted by Hemingway's widow, Mary, who was looking for a repository for the Hemingway materials. Mary Hemingway wanted the various drafts—many written in what she described as Hemingway's "big sprawling hand"—available so people could see the writing process from initial idea "to the point where it is finally published the way the author thinks is the best." And she wanted to give the collection "to some place where Hemingway would be to himself and have a little personal distinction."

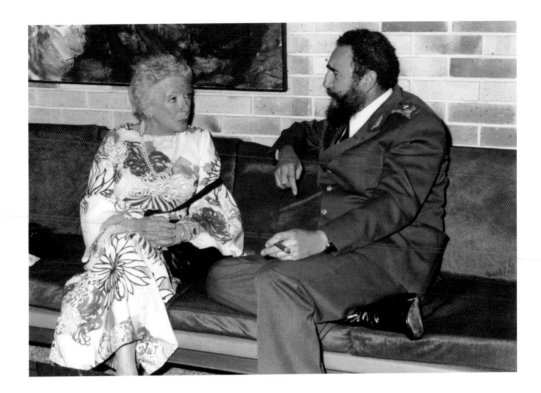

By way of history the Kennedy administration had been instrumental in facilitating Mary Hemingway's travel to Cuba after her husband's death in 1961, despite the ban on Americans doing so at the time, so that she might retrieve the materials that Hemingway had unwillingly left behind when fleeing their home after the Castro revolution.

A year later, in April 1962, Mrs. Hemingway was a guest of President and Mrs. Kennedy at a White House dinner for past American Nobel Prize winners where Ernest Hemingway was honored, posthumously, as one of this nation's distinguished laureates in writing.

Ernest Hemingway and John F. Kennedy never met but they were mutual admirers. President Kennedy more than once expressed his respect for Hemingway's works. In the opening sentence of *Profiles in Courage*, then senator John Kennedy cited Hemingway's description of courage, writing, "This is a book about the most admirable of human virtues—courage. 'Grace under pressure,' [as] Ernest Hemingway defined it."

Once elected president, JFK invited Hemingway, among other American artists, to attend the 1961 inauguration, but the author was too ill to travel. Instead, after viewing JFK's inaugural address on TV from his room at the Mayo Clinic, Hemingway sent a handwritten note to the White House, stating:

MARY HEMINGWAY WITH FIDEL CASTRO, HAVANA, CUBA. HEMINGWAY COLLECTION, JOHN F. KENNEDY PRESIDENTIAL LIBRARY AND MUSEUM, BOSTON.

MA267 PB439

P WWY684 WWZ20 NL PD AR=WASHINGTON DC 12= 1961 JAN 12 PM 9 21

ERNEST HEMINGWAY=

MAYO CLINIC ROCHESTER MINN=

DURING OUR FORTHCOMING ADMINISTRATION WE HOPE TO SEEK A PRODUCTIVE RELATIONSHIP WITH OUR WRITERS, ARTISTS, COMPOSERS, PHILOSOPHERS, SCIENTISTS AND HEADS OF CULTURAL INSTITUTIONS. AS A BEGINNING, IN RECOGNITION OF THEIR IMPORTANCE, MAY WE EXTEND YOU OUR MOST CORDIAL INVITATION TO ATTEND THE INAUGURAL CEREMONIES IN WASHINGTON ON JANUARY 19 AND 20.

RESERVATIONS FOR INAUGURAL CONCERT, PARADE, BALL ARE HELD FOR YOU. ROOM ACCOMMODATIONS AND HOSPITALITY

WILL BE ARRANGED FOR YOU BY A SPECIAL SUB-COMMITTEE. RSVP WHICH EVENTS DESIRED AND WHAT ACCOMMODATION NEEDED BY TELEGRAPHING KAY HALLE, 3001 DENT PLACE, NORTHWEST, WASHINGTON. SINCERELY=

PRESIDENT-ELECT & MRS KENNEDY.

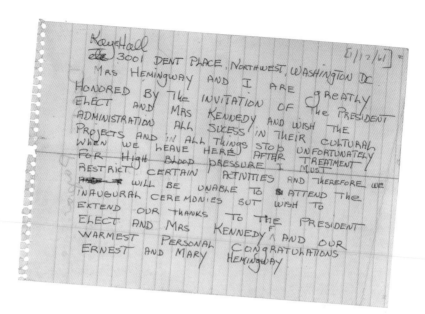

Kaye Hall
etc.) 3001 DENT PLACE, NORTHWEST, WASHINGTON DC.
5/12/61
MRS HEMINGWAY AND I ARE GREATLY
HONORED BY THE INVITATION OF THE PRESIDENT
ELECT AND MRS KENNEDY AND WISH THE
ADMINISTRATION ALL SUCESS IN THEIR CULTURAL
PROJECTS AND IN ALL THINGS STOP UNFORTUNATELY
WHEN WE LEAVE HERE) AFTER TREATMENT
FOR HIGH BLOOD PRESSURE I MUST
RESTRICT CERTAIN ACTIVITIES AND THEREFORE WE
WILL BE UNABLE TO ATTEND THE
INAUGURAL CEREMONIES BUT WISH TO
EXTEND OUR THANKS TO THE PRESIDENT
ELECT AND MRS KENNEDY AND OUR
WARMEST PERSONAL CONGRATULATIONS
ERNEST AND MARY HEMINGWAY

Watching the inauguration from Rochester there was the happiness and the hope and the pride and how beautiful we thought Mrs. Kennedy was and then how deeply moving the inaugural address was. Watching on the screen I was sure our President could stand any of the heat to come as he had taken the cold of that day. Each day since I have renewed my faith and tried to understand the practical difficulties of governing he must face as they arise and admire the true courage he brings to them. It is a good thing to have a brave man as our President in times as tough as these are for our country and the world.

Hemingway died during the first months of President Kennedy's term in office, and upon learning of his death the White House issued the following statement: "Few Americans have had a greater impact on the attitude and emotions of the American people. He almost single-handedly transformed the literature and the ways of thought of men and women in every country in the world." But that transformation did not come without its costs. It took courage for Hemingway to be true to himself and to make from his encounters with the world a measure of art.

So when I think of these two men, the words that echo in my mind are those JFK delivered at what would prove to be his last visit to his home state of Massachusetts. On that occasion, he gave an address on the importance of the arts while dedicating a library

at Amherst College in the name of Robert Frost. The words he spoke that day underscore our thirty-fifth president's belief in the importance of the artist in a democratic society—especially during tumultuous times. Specifically, he noted that the writer's contribution "is not to our size but to our spirit, not to our political beliefs but to our insight, not to our self-esteem but to our self-comprehension. The great artist is a solitary figure [who] in pursuing his perceptions of reality, must often sail against the currents of his time. This is not a popular role. But [in a] democratic society, the highest duty of the writer, the composer, the artist is to remain true to himself and to let the chips fall where they may. In serving his vision of the truth, the artist best serves his nation."

One could say about Hemingway (as JFK said that day about Frost) that "he brought an unsparing instinct for reality to bear on the platitudes and pieties of society. His sense of the human tragedy fortified him against self-deception and easy consolation. . . . And because he knew the midnight as well as the high noon, because he understood the ordeal as well as the triumph of the human spirit, he gave his age strength with which to overcome despair.

"Too often in the past," JFK remarked, "we have thought of the artist as an idler and dilettante and of the lover of arts as somehow sissy and effete. We have done both an injustice. The life of the artist is, in relation to his work, stern and lonely. He has labored hard, often amid deprivation, to perfect his skill. He has turned aside from quick success in order to strip his vision of everything secondary or cheapening. His working life is marked by intense application and intense discipline."

Both John F. Kennedy and Ernest Hemingway reshaped the world through their global encounters with humankind and as a result of successful public careers fueled by intense application and discipline.

How fitting that their papers have found the same home in an iconic and quintessentially American institution. For their words continue to speak to us. And their courageous examples—leading lives in which each displayed remarkable grace under pressure—inspire us anew and give our age strength to overcome despair.

Watching the inauguration from Rochester there was the happiness and the hope and the pride and how beautiful we thought Mrs Kennedy was and then how deeply moving everyone was by the inaugural address. Watching on the screen I was sure our President would stand any of the heat to come as he had taken the cold of that day. Each day since I have renewed my faith in the inaugural address and tried to understand the practical difficulties of governing he President must face as they arise and admire the true courage he brings to them. It is a good thing to have a brave man as our President in times as tough as these are for our country and the world

10

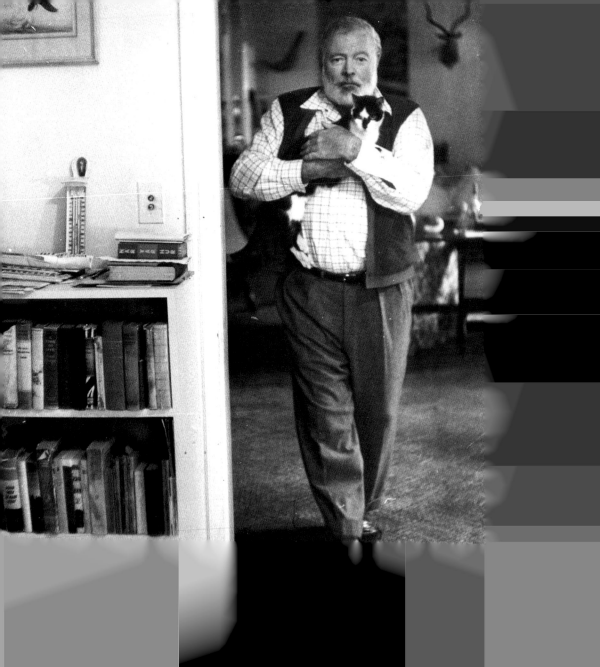

NOTES ON THE RESEARCH ROOM FOR
THE ERNEST HEMINGWAY COLLECTION HOUSED AT
THE JOHN F. KENNEDY PRESIDENTIAL LIBRARY
By Carol Hemingway

 In 1981 Jacqueline Kennedy Onassis formally presented the fifth-floor triangular room in the handsome building designed by architect I. M. Pei as a research haven for scholars coming to view the many documents, photographs and memorabilia that make up the Ernest Hemingway Collection. Patrick Hemingway, Hemingway's middle son, represented Mary Hemingway, Hemingway's widow, who had given the collection of her husband's work to the National Archive of the United States to be housed at the John F. Kennedy Presidential Library.

In subsequent years, little had changed for the Research Room. There were shelves holding box files of an alphabetical catalogue available for viewing by scholars. Other shelves held the many books about Ernest Hemingway or people influential in his life. Not on view were the pieces of memorabilia and paintings that were secluded in the archive but not open to the public. There was no security.

In the 1980s Patrick Hemingway and I took stock of the situation, noting that Mary Hemingway's wish that the Research Room should reflect the atmosphere of her husband's way of life had not been put into effect. Patrick and I contacted an old friend, John MacGregor, a fine set designer and interior decorator. John was a perfect choice, as he had serious interests in history and literature.

Patrick gave two guidelines to John MacGregor: the room should call to mind the living room of Ernest Hemingway's beloved home outside Havana, Cuba, called the Finca Vigía. Also, the room should display Hemingway's significant art collection and include places for small items—artifacts—of Hemingway's daily life, all combining to create the ambiance of Ernest Hemingway's own home, so desired by Mary Hemingway.

"I didn't know that Hemingway was interested in art," a remark made by the top archivist at the Kennedy Library as he perused the open foyer surrounding the door to the Hemingway Research Room. The spacious white walls offered the perfect space for the large reproductions of Hemingway's spectacular painting collection—Paul Klee's *Monument Under Construction*; two prominent works by Juan Gris—*The Bullfighter* and *Man with a Guitar*; and finally, the large early realistic piece by Joan Miró—*The Farm*. (*The Farm*, or *Le Ferme*, was given to the National Gallery in Washington by Mary Hemingway.) This array of masterpieces provides an

awe-inspiring glimpse of Ernest Hemingway's precocious insight into the talents of twentieth-century painters whom he knew personally when living in the Paris of the 1920s.

Moving on through the door to the Hemingway Research Room, the visitor sees the three original André Masson paintings, the *Forest*, over the fireplace and dominating the room with their electrifying brilliance. To the right on a lesser wall hangs Masson's *The Throw of the Dice*, also an original piece.

Immediately on the right wall, the Hemingway portrait by his friend Waldo Peirce looks directly at the viewer. Waldo Peirce titled the painting, completed in Key West in 1929, *Portrait of Ernest Hemingway (Kid Balzac)*.

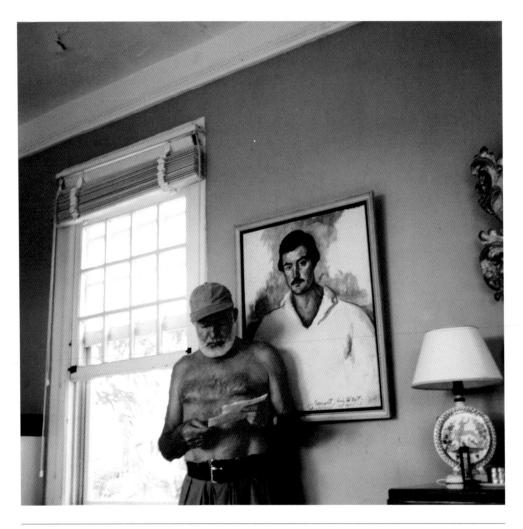

ERNEST HEMINGWAY IN FRONT OF A PORTRAIT OF HIMSELF BY WALDO PEIRCE, AT HIS HOME IN CUBA, CIRCA 1953. HEMINGWAY COLLECTION, JOHN F. KENNEDY PRESIDENTIAL LIBRARY AND MUSEUM, BOSTON.

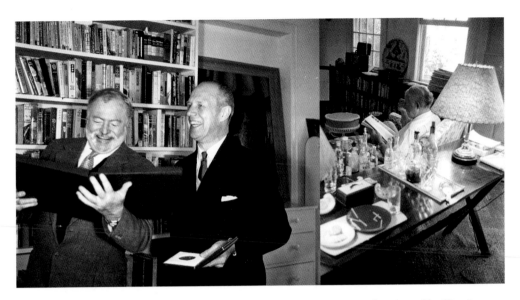

These five original paintings, owned by Ernest Hemingway, may be viewed by Hemingway researchers as they work, but always remain in the security of the Research Room.

All the paintings were dear to Hemingway's heart, as evidenced by their placement within his home in Cuba, the Finca Vigía, and by the references to each one in his literary work. In both the foyer and the Hemingway Research Room, alongside each piece I created labels with the quotation that refers to the painting. An example is a passage in *Green Hills of Africa*:

"By God, isn't it a great-looking country?" I said.
"Splendid," Pop said. "Who would have imagined it?"
"The trees are like André's pictures," P. O. M. said. "It's simply beautiful. Look at that green. It's Masson."

HOMEY

What did Mary Hemingway consider as the environment of her husband's way of life? The designer, John MacGregor, studied the photographs of the Finca Vigía. He began with a carpet selection that resembles the sisal rug of the Finca living room and continued by painting the ceiling a café au lait hue, which stands out in contrast to the omnipresent white both outside and in the Kennedy Library.

1. ERNEST HEMINGWAY AWARDED THE 1954 NOBEL PRIZE IN LITERATURE AT THE FINCA VIGÍA. HEMINGWAY COLLECTION, JOHN F. KENNEDY PRESIDENTIAL LIBRARY AND MUSEUM, BOSTON. 2. ERNEST HEMINGWAY AT THE FINCA VIGÍA, CIRCA 1956. HEMINGWAY COLLECTION, JOHN F. KENNEDY PRESIDENTIAL LIBRARY AND MUSEUM, BOSTON.

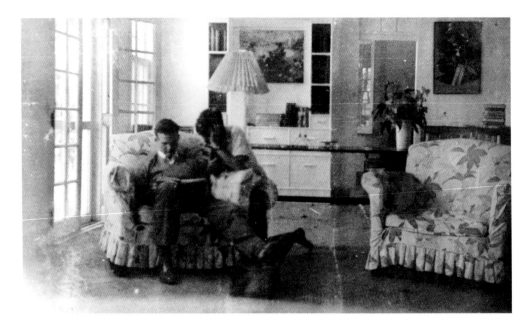

The designer took note of the trestle tables and simple straight chairs and commissioned three research tables and a bar table in tropical mahogany from an artisan furniture maker in western Massachusetts. Dominant to MacGregor's view of the room were the comfortable overstuffed chairs and love seat slipcovered in blue-and-white-patterned toile—a look initiated by Mary Hemingway in Havana.

Comfort and simplicity were the keynotes, made individual by touches of personal memorabilia: a metal footlocker from World War I became a coffee table; a handsome African head—an impala—a reminder of Hemingway's hunting trips.

Remembering the bar table at the Finca Vigía, Patrick Hemingway described glasses in two parts, glasses explained by Hemingway himself in his posthumously published short story "The Strange Country." These glasses were designed for drinking absinthe:

"The absinthe had come and from the saucers of cracked ice placed over the top of the glasses water, that Roger added from a small pitcher, was dripping down into the clear yellowish liquor turning it to an opalescent milkiness."

I was able to reproduce the glasses at a glass-blowing school and museum in New Orleans. A clear glass pitcher and an empty Pernod bottle were added to the display.

The ambiance of the living room at the Finca Vigía has been described as "homey." Patrick Hemingway's desire to suggest that atmosphere has inspired the décor of the Ernest Hemingway Research Room to appear modest, yet rich; simple yet detailed.

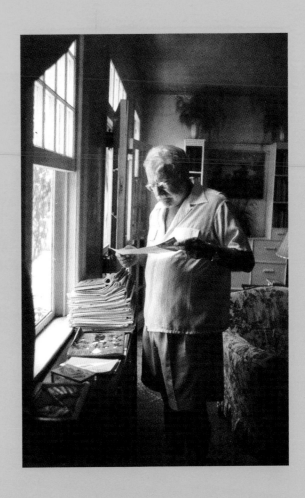

1. JACK HEMINGWAY (SEATED) AND PATRICK HEMINGWAY AT THE FINCA VIGÍA. HEMINGWAY COLLECTION, JOHN F. KENNEDY PRESIDENTIAL LIBRARY AND MUSEUM, BOSTON. ABOVE: 2. ERNEST HEMINGWAY AT HOME AT THE FINCA VIGÍA. EARL THEISEN © ROXANN LIVINGSTON, COURTESY JFK LIBRARY 2018.

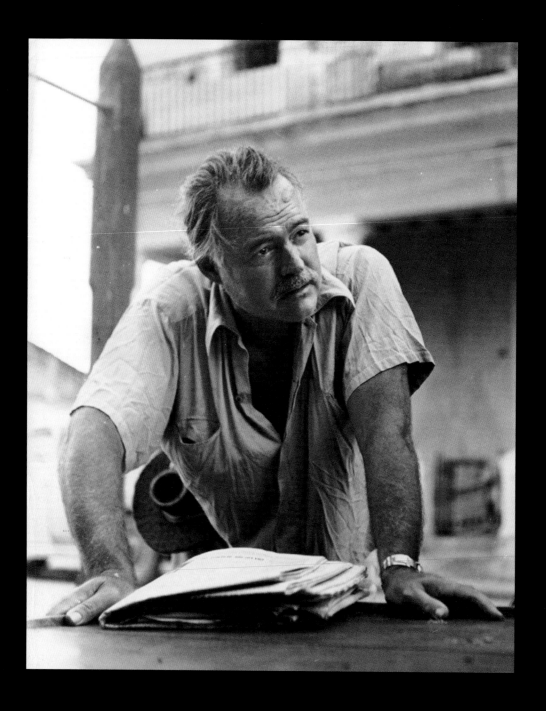

ERNEST HEMINGWAY, LEANING OVER A NEWSPAPER, IN CUBA. HEMINGWAY COLLECTION, JOHN F. KENNEDY PRESIDENTIAL LIBRARY AND MUSEUM, BOSTON.

AFTERWORD
By Seán Hemingway

Growing up as a young boy in New York City and later Bozeman, Montana, I never had the chance to know my grandfather. Ernest Hemingway died long before I was born. My father, his youngest son, Gregory, did not talk about him to me a great deal although he was a constant if distant presence in our lives. Instead my dad preferred to share experiences similar to those that he had as a boy with my grandfather, from deep-sea fishing and boxing to skiing, horseback riding, shooting and fishing in the American West. My uncle Patrick, ever the great outdoorsman and Renaissance man, has been a cherished mentor to me in the natural world and about literature, mathematics and especially my grandfather's life and work. All three of Ernest Hemingway's sons—Jack, Patrick and Gregory—developed their own prodigious talents but none of them sought out careers as a writer. Imagine what that would have been like for them. Nonetheless, like his father, my dad turned to writing to share the joys and complexities of being the son of a famous writer, which he eloquently captured in his poignant memoir *Papa*. My mother, Valerie M. Hemingway, also knew my grandfather well and when I would ask about him she often said if you want to know what he was like read his writing. This I did, eventually reading all his published works, fiction and nonfiction, as well as his journalism and many of his letters. My own advice in this regard echoes my mother's: read Hemingway's writing but also go and visit the Ernest Hemingway Collection at the John F. Kennedy Library.

My first visit to the Ernest Hemingway Collection was in 1997 when I also attended the PEN/Hemingway Award ceremony for a first work of fiction. The winner that year was a young writer, then relatively unknown, named Ha Jin for his novel *Ocean of Words*. I've gone to nearly every PEN/Hemingway Award ceremony since. The prize, awarded each year in the spring at the JFK Library and juried by a distinguished group of scholars and writers from the PEN Society, is widely recognized as one of the most prestigious for young writers in the United States. The event typically combines a refreshing presentation of the latest new talents emerging in contemporary fiction with reflections on the enduring influence of Ernest Hemingway's writings.

I have had the privilege of working closely with the Ernest Hemingway Collection at the John F. Kennedy Library for over fifteen years on seven books of my grandfather's writings.

③ drawer of the table and put any mandarines that were left in my pocket. They would freeze if they were left in the room at night.

It was wonderful to walk down the long flights of stairs knowing I had had good luck working. I always worked until I had something done and I always stopped when I knew what was going to happen next. That way I could be sure of going on the next day. But sometimes when I was starting a new story and I could not get it going I would sit in front of the fire and squeeze the peel of the little oranges into the edge of the flame and watch the splutter of blue that they made. I would stand and look out over the roofs of Paris and think, do not worry. You have always written before and you will write now. All you have to do is write one true sentence. So I would finally write the truest sentence that you know. So finally I would write one true sentence

As well as anyone alive, I can attest to the richness and extraordinary nature of this national treasure. I am fascinated by my grandfather's working process. I find it inspiring to see his original manuscripts. Some of the collection's most important treasures include manuscript pages from the drafts of *The Sun Also Rises*, *A Farewell to Arms* and *For Whom the Bell Tolls*, as well as nearly all of his short stories, including some of his finest, such as "Indian Camp," "Big Two-Hearted River," "The Short Happy Life of Francis Macomber" and "The Butterfly and the Tank."

There is something thrilling about seeing the actual pages he wrote in his handwriting. What comes across to me again and again, and I think that this is of great significance as we reflect on how Ernest Hemingway's legacy is relevant today, is how hard he worked at his craft. This is particularly apparent in the multiple drafts of the ending of *A Farewell to Arms*. Hemingway famously said that he wrote the ending thirty-nine times "to get the words right." I found when working on the Hemingway Library Edition of *A Farewell to Arms* some forty-seven attempts. To see such discipline and determination in a writer with such tremendous talent—he was a true genius—is inspiring. He strove again and again for perfection. In *A Moveable Feast*, he reflected on his writing process when he wrote short stories in his Paris studio in the 1920s: "I would stand and look out over the roofs of Paris and think, do not worry, you have always written before and you will write now. All you have to do is write one true sentence, the truest sentence that you know. So I would finally write one true sentence . . ."

It is hard for people today to appreciate the vast influence Ernest Hemingway has had on writing, since his direct, reductive prose style is so widespread. Furthermore, even writers with very different writing styles, such as Gabriel García Márquez, have acknowledged their debt to his work.

I have been to most of the places my grandfather visited in his lifetime and the houses where he lived. My wife, Colette, and I joined Congressman James McGovern and representatives from the Finca Vigía Foundation and the National Archives to visit the Finca Vigía and meet with Fidel Castro in November 2002 to inaugurate a collaborative project to preserve and archive the papers stored there, an initiative that was successfully completed in 2009. I found the Finca, now a museum, to be an extraordinary place where one can actually see my grandfather's home largely as it was when he lived and worked there for more than twenty years of his life. Still I would say that the most important physical legacy of my grandfather's life's work today is the Hemingway Collection at the John F. Kennedy Library.

Besides the manuscripts, what I find so exciting about the Ernest Hemingway Collection at the John F. Kennedy Library are the ephemera from his life, so well presented in this book. To give just one example from his early years, the scrapbooks lovingly assembled by his mother, Grace, are a rich visual and written testimony that contain everything from his baby teeth to "his first spelling lesson" in first grade at age six, written in that nascent fluid cursive hand, a

list of words, "Ernest, Wigwam, owlet . . . ," placed amid his own watercolor pictures of two trees in a forest and a snow-covered cabin by a wood. The Hemingway Collection thus extends literally from the very first words written by Ernest Hemingway through some of the finest literature ever penned to his final, heart-wrenching attempts in the midst of illness to finish *A Moveable Feast* at the very end of his life. As a curator at the Metropolitan Museum of Art in New York, I have devoted much of my life to the study and preservation of the art of ancient Greece and Rome, of which just a small fraction survives today. To have such a large archive of original manuscripts and ephemera of one of the greatest writers of the twentieth century preserved in the Hemingway Collection is an extraordinary resource for our understanding of the man and how he achieved his art.

No less remarkable is the vast archive of his personal photograph collection that evokes so powerfully what an amazing life Ernest Hemingway led. From his childhood in Oak Park, Illinois, and summers up in Michigan, to his injury in World War I when he was an ambulance driver for the Red Cross, to living in Paris in the 1920s among luminaries like Gertrude Stein and James Joyce, to mock bullfighting in the toreador's arena at Pamplona, marlin fishing with his sons in the Gulf Stream, big game hunting in East Africa and the American West and bearing witness to the Spanish Civil War and some of the bloodiest battles of World War II, such as the D-Day landing at Normandy and the Battle of Hürtgen Forest, Hemingway experienced life to the fullest, often writing about his experiences. He claimed never to have missed a sunrise, and I think that you will agree after finishing this book that he knew how to live well.

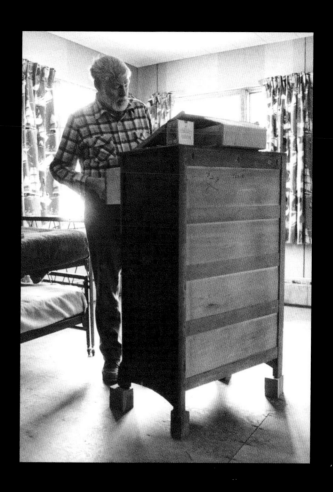

ERNEST HEMINGWAY AT HIS HOME IN IDAHO. JOHN BRYSON © 2017 BRYSON PHOTO. HEMINGWAY COLLECTION, JOHN F. KENNEDY PRESIDENTIAL LIBRARY AND MUSEUM, BOSTON.

ACKNOWLEDGMENTS

This book would not have been possible without the collaboration of scholars, curators, writers, historians, designers and administrators at public institutions.

First I wish to thank Susan Wrynn, former curator of the Hemingway Collection at the JFK Library, for her steadfast dedication and assistance to this project. I simply do not know how I would have navigated the entire collection without Susan at my side. Tom Putnam, the former director of the John F. Kennedy Library and Museum, was a driving force in wanting this book to be realized. His was a steady hand that made this book, and the JFK Library, better. It has been a pleasure to work with such dedicated people at the JFK. Karen Adler Abramson, director of archives, worked hard guiding me through National Archive rules and helped me avoid the pitfalls. Thanks to Stacey Chandler in Textual Reference and interns Katherine Crowe and Dana Bronson. In AV Reference, thanks to Laurie Austin, Maryrose Grossman and interns Connor Anderson, Aubrey Butts, Milo Carpenter and Jacqueline Gertner. In Digitization to Kelley Francis and Elyse Fox. To Christina Fitzpatrick in Processing and interns Joan Ilacqua and Bonnie McBride. Thank you to Stacey Bredhoff, curator at the JFK Museum, as well as Kathryn Dodge and Heather Joines.

I wish to thank Professor Kirk Curnutt of the Hemingway Society for clearing the way for domestic permission of Ernest Hemingway's letters. To Professor Sandra Spanier, editor of the Hemingway Letters Project, who graciously helped me along the way. She and her fellow editors of the published editions of Hemingway's letters with Cambridge University Press have created an invaluable resource in further understanding Ernest Hemingway and his work. To Krista Quesenberry, research and editorial associate for the Hemingway Letters Project.

I wish to thank my editor, Daniel Loedel, and Lisa Silverman, my copyeditor, for her detailed and incisive review. Both Daniel and Lisa have made this book better. Thanks to Katie Rizzo for her work, and to Fred Courtwright for his tracking down credit and caption information for photos; there were more than eleven thousand images to go through, and where such information was available, I included it. Thanks also to Susan Moldow at Scribner. To my friend Jeff Wilson at Simon & Schuster, who made this book possible with his ever intelligent and decent contractual magic. To Nan Graham and Carolyn Reidy.

To the editors at Everyman's Library. The chronology of Hemingway's life in their edition of Hemingway's short stories edited by James Fenton was of enormous help in pointing me in the right direction. To Jerry Takigawa and Mary Wilson of Takigawa Design and designer Jay Galster, who made this book come alive. Thanks to Steve Hauk for sharing his vast knowledge about John Steinbeck and Will Ray, editor of *Steinbeck Now*. To Declan Kiely for his help

with the text panels. (The initials "DK" signify his work and the initials "DK and MK" show when those sections were amended by the editor.) To Tanya Johnson. To Ian Chapman and Lou Johnson, who believed and were supportive and kind. To Suzanne Baboneau at Simon & Schuster UK. Thanks to Brian Belfiglio and Patrick Weir and to Bernard and Catherine Legé.

I have had the pleasure of working with Seán Hemingway, Ernest's grandson, for a number of years and have come to appreciate his scholarly work as acting curator in the Department of Greek and Roman Art at the Metropolitan Museum of Art, New York City, as well as his and Patrick Hemingway's collaborations on the Hemingway special editions. No one could have done a better or more insightful job. To the trustees of the Hemingway Foreign Rights Trust, Patrick Hemingway, Seán Hemingway and Angela Hemingway. For help acquiring needed books on short order, thanks to Brian Spence and the Abbey Bookshop, Paris.

To Kati Lewis, my Charlotte Shaw and Lynn Badertscher, and to my mother- and brother-in-law, Eleanor Hardin and Douglas Hardin, and in memory of Douglas Hardin, Sr. To my dear gang in London, especially the late and very dear Julian Davis. Many thanks to the lovely people at the Ritz Hotel, who have provided me with a calm oasis for many years, and to Mr. Cipriani and the very kind staff at Harry's Bar in Venice for their hospitality. Thanks to Giuseppe (Pino) and Betty Gargano for their friendship, hospitality and kindness. And to Chiara. To Lawrence Van Velzer and Peggy Gotthold of Foolscap Press. To Lisa Hollo of Bob McGinnis Travel, who, with her geographical magic and expertise, helped me navigate my way through thousands of miles. Thank you. To Michael and Helen Palin, dear friends who have always made a place for me at their table. To my friends Cary Porter and Peter Luff and to my friends Sandy Ford and his late dear wife, Christine Haska. To Wendy Ellis Smith, Jerry Fielder and Daniel Campbell-Benson. To Barbara Stone and Victoria. With appreciation to Dr. Olivier Prisant, Dr. Patrick Sabatier and nurse Benoit Prieur. To Myriam Batista, Dominique Le Guen, Jean-Michel Guenassia, Dennis High, Randell Bishop and Ralph Starkweather. To Dr. Susan Chang, Doug Wilkinson and Scott Bourne.

To Patrick and Carol Hemingway, who have always been kind and generous and with whom I have spent many wonderful times. Thank you for the fantastic conversations, meals, debates, fishing on the Missouri, hunting at Freeze Out and so much more. I look forward to many more in the future.

And to Patrick Hemingway, who years ago entrusted me with his father's work. It is not possible to express in words how important Patrick has been to me and to my late wife, Kris, and how important he remains. So, Patrick, thank you.

And finally to Melissa Sullivan, who came during the dark days and stayed.

SUGGESTIONS FOR FURTHER READING:

No one book can present the arc of an entire life. Because of that I have read a number of books that helped me along the way, books that I think the reader may enjoy and find illuminating in regard to Ernest Hemingway and the times in which he lived.

A Moveable Feast (The Restored Edition), Ernest Hemingway, foreword by Patrick Hemingway, introduction by Seán Hemingway

Green Hills of Africa (Hemingway Library Edition), Ernest Hemingway, foreword by Patrick Hemingway and introduction by Seán Hemingway

The Hemingway Women, Bernice Kert

The True Gen: An Intimate Portrait of Ernest Hemingway by Those Who Knew Him, Denis Brian

Ernest Hemingway Selected Letters 1917–1961, edited by Carlos Baker

The Letters of Ernest Hemingway 1907–1922, edited by Sandra Spanier and Robert W. Trogdon

The Letters of Ernest Hemingway 1923–1925, edited by Sandra Spanier, Albert J. DeFazio III and Robert W. Trogdon

The Letters of Ernest Hemingway 1926–1929, edited by Rena Sanderson, Sandra Spanier and Robert W. Trogdon

The Battle for Spain: The Spanish Civil War 1936–1939, Antony Beevor

Homage to Catalonia, George Orwell

Everybody Behaves Badly: The True Story Behind Hemingway's Masterpiece The Sun Also Rises, Lesley M. M. Blume

The Spanish Labyrinth, Gerald Brenan

West with the Night, Beryl Markham

The Autobiography of Alice B. Toklas, Gertrude Stein

Hemingway: The Paris Years, Michael Reynolds

Hemingway: The Final Years, Michael Reynolds

Ezra Pound: Poet, volume III, *The Tragic Years 1939–1972*, A. David Moody

Ernest Hemingway: A Life Story, Carlos Baker

How It Was, Mary Welsh Hemingway

True at First Light, Ernest Hemingway, edited with an introduction by Patrick Hemingway

Hemingway in Cuba, Norberto Fuentes

Hemingway: High on the Wild, Lloyd R. Arnold

Papa Hemingway: A Personal Memoir, A. E. Hotchner

"The Elephants of Tsavo," essay by Patrick Hemingway in *Sacred Trusts: Essays on Stewardship and Responsibility*, edited with an introduction by Michael Katakis

Papa: A Personal Memoir, Gregory H. Hemingway

With Hemingway: A Year in Key West and Cuba, Arnold Samuelson

Hemingway's Boat: Everything He Loved in Life, and Lost, 1934–1961, Paul Hendrickson

Profiles in Courage, John F. Kennedy

An Unfinished Life: John F. Kennedy, 1917–1963, Robert Dallek

Spain in Our Hearts: Americans in the Spanish Civil War, 1936–1939, Adam Hochschild

Everybody Was So Young: Gerald and Sara Murphy: A Lost Generation Love Story, Amanda Vaill

F. Scott Fitzgerald: A Short Biography, F. Scott Fitzgerald and James L. W. West III

Misadventures of a Fly Fisherman: My Life With and Without Papa, Jack Hemingway

The Bloody Forest: Battle for the Huertgen: September 1944–January 1945, Gerald Astor

A Soldier on the Southern Front: The Classic Italian Memoir of World War I, Emilio Lussu, afterword by Mark Thompson

As I Walked Out One Midsummer Morning: A Memoir, Laurie Lee

A Time of Gifts, Patrick Leigh Fermor

Poems from World War I:

"The Dead," Rupert Brooke

"Christ and the Soldier," Siegfried Sassoon

"Strange Meeting," Wilfred Owen

"MCMXIV," Philip Larkin

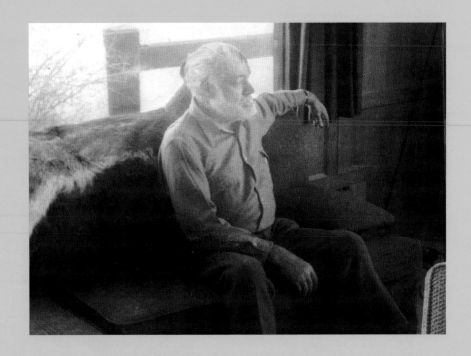

ERNEST HEMINGWAY AT HIS HOME IN KETCHUM, IDAHO. HEMINGWAY COLLECTION, JOHN F. KENNEDY PRESIDENTIAL LIBRARY AND MUSEUM, BOSTON.

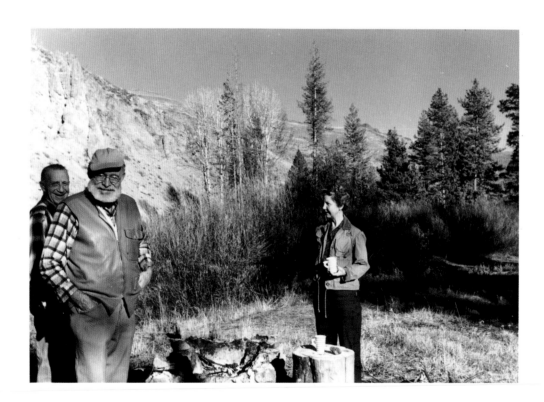

Organisations Pugilistiques " MANITOT "

CIRQUE DE PARIS
18 et 20, Avenue de La Motte-Picquet

3e

Grand Gala International
de BOXE - Saison 1926-1927

BALCON

100 fr.

305

00134

Service de Presse

nd Gala de Boxe

organisé par le
SPORTIF DES ANCIENS COMBATTANTS
AMÉRICAINS & FRANÇAIS

MARDI 10 AVRIL 1923
à 20 heures et demie

rque de Paris (Avenue de la Motte-Picquet)

au profit des Œuvres
ON NATIONALE DES COMBATTANTS FRANÇAIS
AMÉRICAN LEGION PARIS POST N°1

sous le Haut Patronage de
Monsieur le Maréchal Foch
ous l'Assistance de Rich-Rich, E. Erne & Berish